TO ALL OUR POSTER FRIENDS

STOP !

... LOOK !

before

CROSSING

RS/P/E 24-1 PUBLISHED BY RoSPA. PRINTED BY F.J.MORLEY LTD. LONDON.

MODERN BRITISH POSTERS
ART, DESIGN & COMMUNICATION

PAUL RENNIE

black dog
publishing
london uk

POSTER SIZES

The standardisation of poster sizes derives from the rationalisation of production and display in advertising. In Britain, posters sizes were made consistent from the 1880s onwards. The poster sizes are based on multiples of Crown and Royal proportions.

CROWN (C)
15 X 20"

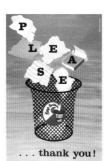

DOUBLE CROWN (DC)
30 X 20"

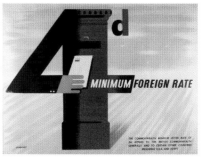

QUAD CROWN (QC)
30 X 40"

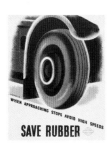

ROYAL (R)
25 X 20"

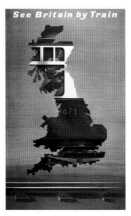

DOUBLE ROYAL (DR)
40 X 25"

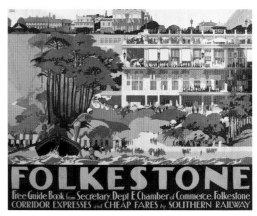

QUAD ROYAL (QR)
40 X 50"

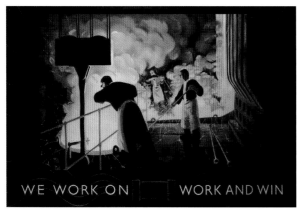

4 SHEET (4S)
40 X 60"

This is a book about British posters of the twentieth century. The choice of the title Modern British Posters has been made to allude, in a very straightforward way, to the artists associated with the category of Modern British painting. Anyone familiar with auction house catalogues and gallery exhibitions will understand this immediately. In brief, the category describes art in Britain of the mid-century. Since the major part of our story is about the interaction, in Britain, between art and design and from exactly this period, it made sense to use the term forthrightly and from the start.

In addition, our subheading attaches these posters to three distinct, but related, graphic forms. In the first instance we need only acknowledge that these posters are part of a shift from art to communication via design. Itemising this distinction is a major part of our project.

The exact dates of our project are from 1915 through to 1970. 1915 was the date that the Design and Industries Association (DIA) was formed. The DIA marked the beginning of a second-wave of design reform in Britain. This was associated with the post-World War One modernisation of British society and the related extension, of visual communication, to issues of service and values. The end-point of our story is 1969 and is marked by the publication of Cramer Saatchi's famous 'Pregnant Man' poster.

The choice of this end-point is not entirely arbitrary. The design and specification of this poster marked the end of the kinds of interaction between art and design that are at the heart of this story. The Saatchi poster represents the triumph, after a long struggle, of a different kind of technique in visual assembly. This is defined by the identification of an idea and realised through the process of reiteration made possible by the technology of mechanical reproduction.

This book provides an introduction to the development of the poster by reference to the many artists and designers that created these images. In addition, the book attempts to place these designers and their work within the specific contexts of art, design, patronage, technology and display that, together, define this kind of graphic communication in Britain. These interactions also begin to suggest, in the context of the social history of modern Britain, a specific sociology of communication, consumption and progress.

The terms of reference for this project are described in this essay. The text presents, in necessarily brief and simplified form:

- the general trajectory of social change in Britain,
- structures of patronage of the poster,
- art and design of the poster,
- production and display of the poster,
- issues of social identity and intelligence devolving from visual culture.

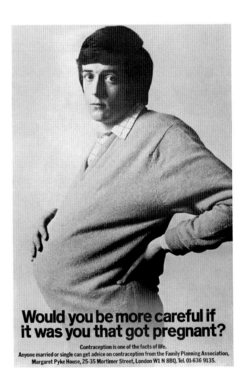

Would you be more careful if it was you that got pregnant?

Contraception is one of the facts of life.
Anyone married or single can get advice on contraception from the Family Planning Association, Margaret Pyke House, 25-35 Mortimer Street, London W1 N 8BQ. Tel. 01-636 9135.

INTRODUCTION

Above *Would you be more careful if it was you that got pregnant?*, Cramer Saatchi, 1969, DC (30 x 20"),

Family Planning Association.

Opposite *Back The Bayonets* (detail), CRW Nevinson, 1918, DC (30 x 20"), National War Savings Committee.

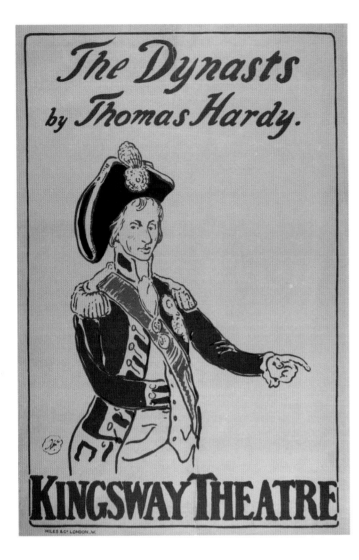

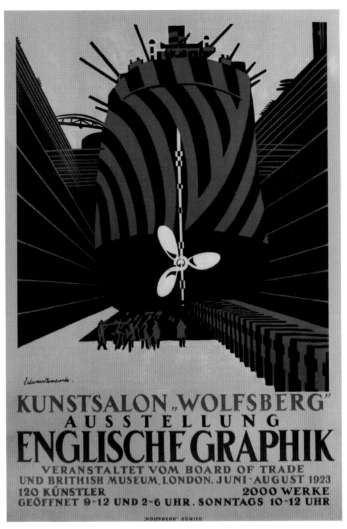

The trajectories of these themes have various points of contact. These may be described in terms of social transformation and reconstruction. Alternatively, they may be associated with artistic issues of abstraction, Surrealism and "pop" assembly. The big names attached to this story include those of patrons, artists and designers. The most significant are Frank Pick, Stephen Tallents and Jack Beddington; Edward McKnight Kauffer, Paul Nash, Abram Games, Tom Eckersley and Cyril Bird.

A concluding section provides information on collecting posters and indicates the various information resources available.

The impetus for this book results from an exhibition of posters held, in 2008, at Central Saint Martins, London. The exhibition, called Modern British Posters, showed some 70 examples from the collection of Paul and Karen Rennie. The show comprised the two rooms of the Lethaby Gallery at Southampton Row. The first room examined pre-World War Two artistic advertising and the second, post-World War Two graphic design. This book is an attempt to build and expand on the narrative presented in that exhibition.

Left *The Dynasts*, William Nicholson, 1914, DC (30 x 20") Kingsway Theatre.

Right *Englische Graphik*, Edward Wadsworth, 1923, Standard Swiss, 50 x 35", Kunstsalon Wolfsburg.

Opposite *it's a small world by Speedbird*, FHK Henrion, 1947, DC (30 x 20"), British Overseas Airways Corporation.

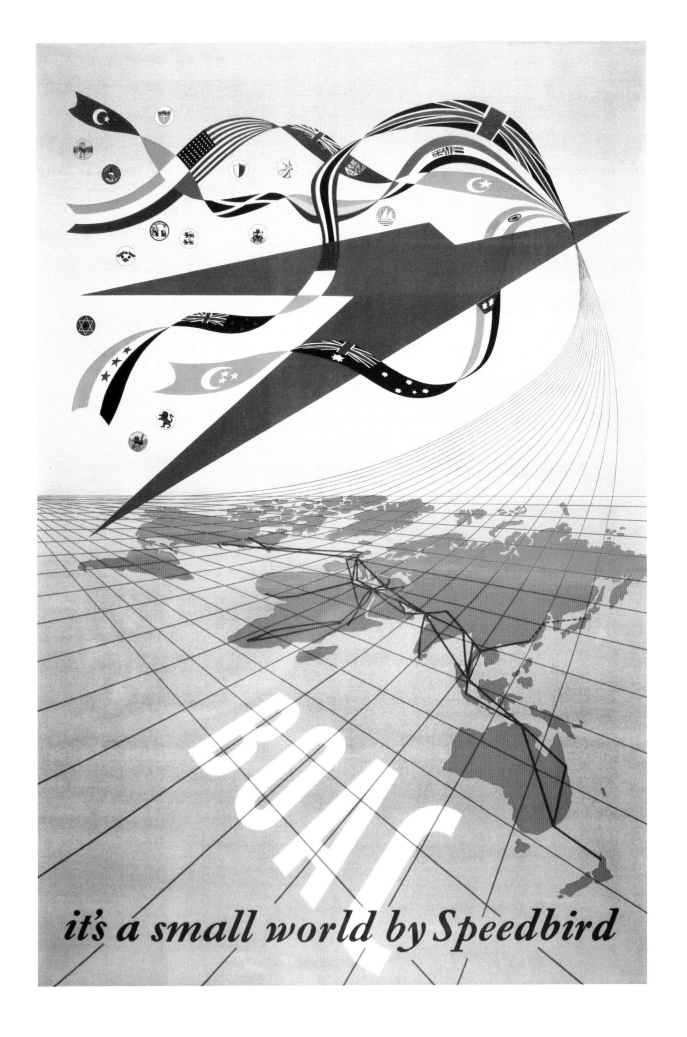

it's a small world by Speedbird

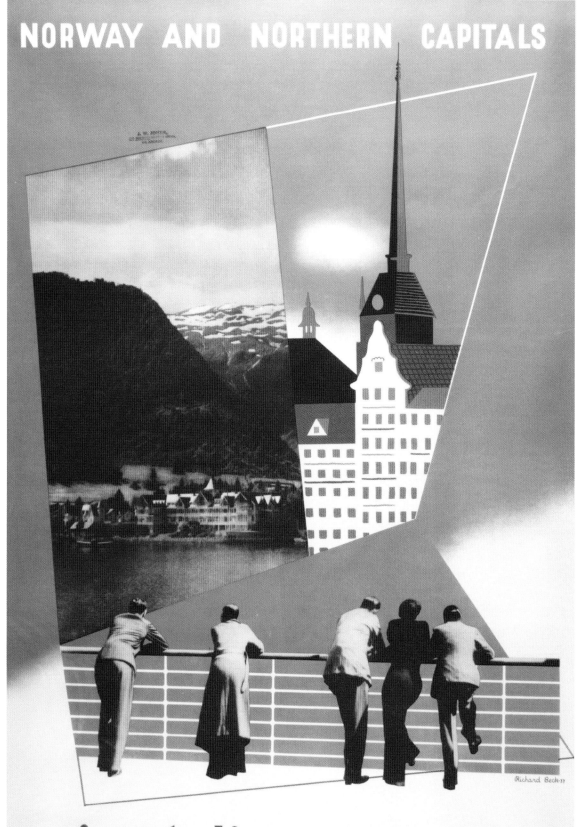

There are several reasons to do this in relation to British poster design. The first is that the story of this interaction remains, for the most part, unknown. There have been important exhibitions, in Paris and New York, that have examined the interactions between fine art and popular culture. Notwithstanding this omission, this book is neither a history of advertising, nor a definitive account of this interaction.

By aligning the phenomenon of Modernism with the practice of design and with the politics of social justice, these images provide modest but compelling counter-evidence to the prevailing narratives of national decline.

The narratives of poster history in Britain remain, for the most part and in general terms, relatively little known. Notwithstanding the recent and significant expansion of research within graphic design history, the story remains disjointed and conceptually fragmented. This book is an attempt to join these parts into a coherent narrative of visual communication, design development and social progress in Britain.

The present fragmentation may be explained, in part, by the organisation of research archives across Britain. Our biggest institutions are international in scope. For them, the British context is subsumed into the greater international narratives of the twentieth century. Elsewhere, poster archives are attached to more specialised interests. For example, railway posters, motoring posters and war propaganda all form specialised archives within separate institutions. Within the context of these distinct institutions, there is no urgent requirement to integrate the various and disparate parts into a history of visual communication. This fragmentation is also an expression of academic specialisation.

The institutionally fragmented poster archive in Britain means that, for practical purposes, combining these different elements of poster history would be complex. It is not obvious that, within the existing arrangement of academic specialisation, anyone would want to do this anyway.

The interaction between art and design forms the substantial part of this story and is a general characteristic of Modernist experiment in the 1920s and 30s. In order to understand the role of the poster as part of this phenomenon we need to understand the origins of the modern poster.

Norway And Northern Capitals, Richard Beck, c. 1938, DR (40 x 25"), Orient Line.

The origins of graphic design are not to be found in the ancient languages that combine writing and picture-making. Rather, graphic design has emerged as the visual, and most technologically enabled, expression of a specific set of cultural values. These values are associated in the forms of democratic and emancipatory modernity that result from the eighteenth century philosophical Enlightenment.

The philosophical association of democratic values and physical environments, implicit in these developments, were given popular visual expression through their attachment to powerful technologies of mass visual culture. It was the alignment of industrial organisation, political emancipation and visual communication that provided the space wherein, eventually, graphic design could develop. The exact date and place of birth of the modern poster remains unclear. However, it is usually accepted as Paris, France, and at some time during the 1860s. In its new form, the poster emerged more-or-less simultaneously in London, Berlin and New York. The modern poster was immediately distinguished from its predecessors by its large scale, use of colour, and by the visual integration of image and text.

A number of preconditions facilitated the creation of the modern poster. Broadly speaking, these determining factors attach to the technology of printing, the environment of display and the sociology of consumption.

It's worth noting, from the start, that the qualities of colour and scale distinguished the poster as the first type of image created to be viewed at speed. The dynamic point-of-view implied by the scale and colour of these images acknowledges the general acceleration of metropolitan life in the second half of the nineteenth century. The beginnings of a synthesis, between image and text, also anticipated a more sophisticated symbolic, or semiotic, understanding of images and their meanings.

The poster was just one of a number of forms, made possible through various technologies ranging from internal-combustion to cinema, that transformed the experience of modern life through the expression and facilitation of movement and acceleration. The multiplication of available viewpoints, implicitly facilitated by technology, became a statement and expression of an increasingly democratic range of perspectives. Elsewhere, this phenomenon was also expressed through the fractured perspectives of Cubism and in the dynamic approaches afforded by cinema and hand-held photography.

THE ORIGINS OF THE MODERN POSTER

The Poster, 1900, lithographic magazine cover.

The Poster, 1899–1900, a selection of lithographic magazine covers.

TECHNOLOGICAL BACKGROUND

The characteristics of scale, colour and integration evolve entirely from the technology of colour lithographic printing. All printing is a form of magic, but lithography is especially impressive. The print is produced from a flat surface, requiring only the briefest of contact between paper and stone. The process of lithography was discovered, and subsequently developed and refined, by Aloys Senefelder in 1794. Senefelder's experiments were an attempt to find an economical alternative to printing from cut, carved or engraved plates.

Previously, the development of letterpress printing through standardised letterforms allowed for only a limited use of imagery. Intaglio and relief printed images could be integrated into the page design of letterpress printing but remained correspondingly small-scale. Outside of letterpress printing, the engineering of the printing press for intaglio and relief printing placed definite limits on the size of the printable image. Briefly, the mechanics of the traditional printing press mean that the downward force required to assure an even printing, across the whole of a large engraved plate, would quickly destroy the plate.

The time and costs of engraving plates placed print publishing beyond the means of all but the most wealthy of printing entrepreneurs. Accordingly, visual print culture before lithography was characterised by relative scarcity. What pictures there were tended to be small-scale and printed in black and white. Coloured images were usually produced by stencil or hand-colouring the black and white image. They were always correspondingly more expensive.

Senefelder's efforts were entirely practical. As a playwright and music publisher, Senefelder was concerned to find a more economical means of printing the texts of plays and the musical parts of orchestration.

Through the discovery of lithography, derived from the antipathy of oil and water, Senefelder discovered that ink could be made to adhere to the greased parts of a flat plate and be washed away from the untouched parts.

Having established the principle, Senefelder began the search for a suitable plate material. A process of trial and error identified Solnhofen limestone as an ideal material.

Because lithography was conceptualised as a contact process, requiring minimal pressure, the area of printable surface was only limited by the size of the stone. Furthermore, the stone was resistant to the general wetness associated with the process of lithography. Large editions could therefore be just as easily printed as small editions and the stones could be wiped clean and reused more-or-less indefinitely. Stones marked up with enduringly popular subjects could even be stored and reused. The evident economy of reusable stones made lithographic printing immediately useful to a wide variety of business concerns.

The history of lithography was one of rapid technical development. The process was quickly extended to the reproduction of images. Lithographic drawing became a crucial workshop skill. The art of lithographic draughtsmanship combined the technical skills of colour separation and drawing in negative with the expressive potential of gestures and marks.

By working backwards, in steps, from the finished artwork, the image could be understood as a series of colour separations and over-printings. Developments in printing inks meant that, from about 1840 onwards, it became possible to

Girl Reading, J & W Beggarstaff, 1899.

reproduce every pictorial effect with complete accuracy. Opaque and transparent inks, in combination and overprinted, could be used to create any result.

Beyond the strictly pictorial, all kinds of information design were facilitated by lithography. Victorian railway timetables, for example, were drawn lithographically. The congested alignments of small figures in tabula form made the letterpress production of such material impossibly complex and time consuming. Beyond railways, an increasing amount of nineteenth century technical data was presented lithographically.

The impact of lithography was such that, by the second half of the nineteenth century, the process had become the dominant print medium of the market economy. The capacity implicit in this observation was fuelled by the increasingly industrial organisation of the printing works and of its machinery. By the 1860s, large-scale, powered presses had become available.

Chinaman, J & W Beggarstaff, c. 1894.

Technological developments led from flat-bed presses to rotary and offset presses with much greater speed and print capacity. The invention of halftone screens, in the 1860s, allowed for the mass production of photographic images as part of the print economy. In the first instance, halftone screens were relatively crude. The processes of enlargement associated with working at poster scales quickly led to a degrading of visual quality. In consequence, the poster and the photograph developed their own independent visual cultures during the latter part of the nineteenth century.

ENVIRONMENTS

The artistic and technological developments of lithography were especially useful to those printers working on an industrial scale in support of nineteenth century manufacturing. The mass production of consumer goods required labels, packages and point-of-sale advertising.

Lithography was ideally suited for the production of such printed ephemera. The stones could be prepared with repeats of a design. Thus, hundreds of labels could be produced by each turn of the press.

The organisation of the print workshop as part of a factory system began to synchronise activities of production, make-ready, printing and marketing. Within the factory system of the visual print economy, the printing press remained at the centre of everything. The relative expense of the industrial plant placed a premium on the continuous operation of the machine. The enormous productivity of the press contrasted with the relatively laborious make-ready of designs and stones. Accordingly, the arrangement of factory resources quickly developed around machines that kept operating with a constant supply of new work. In practical terms, these factories were distinguished by their unlimited capacity.

It was natural, in these circumstances, for visual print entrepreneurs to look at opportunities for new types of work.

One such opportunity became apparent to the French artist and lithographic printer, Jules Chéret. Chéret had learnt lithography in London and was amongst the first to import British printing machinery to Paris in the 1850s. He established a relationship with the cosmetics entrepreneur Eugene Rimmel, "the prince of perfumiers".

The modernisation and rationalisation of Paris promoted by Baron Haussmann, from 1865 onwards, involved the creation of wide boulevards and open vistas. The more-or-less continuous demolition and development of large parts of the city created the first billboards. Chéret realised that the unsightly construction workings could be made more acceptable by using them to display large-scale and brightly coloured advertisements.

Chéret used his own print factory to produce his first poster designs. The posters conveniently advertised his own expertise in printing and design along with the products of his clients.

The modern poster would not have existed without the specific environments of outdoor display advertising. Without opportunity, the technological possibility of the poster would have remained theoretical.

Above *The Poster, Modern Advertising Supplement*, 1900, lithographic magazine cover.

Opposite *Official Catalogue Advertisers' Exhibition*, 1900, lithographic magazine cover.

It is widely acknowledged that city planning, and Haussmann's schemes in particular, formed part of a plan to rationalise, or control, the increasingly chaotic politics of post-1848 France. The wide boulevards of Haussmann's redevelopment were conceptualised to replace the warren of narrow streets that were a remainder of medieval Paris.

The narrow streets were understood, by the bureaucratic powers of the administration, as an uncontrollable environment. The medieval street scene was interpreted, in these circumstances, as insecure and unsafe. In times of political hiatus, the narrow streets could easily be commandeered through the spontaneous erection of barricades. The forces of law and order were excluded from the chaotic environments of narrow streets and their tenements. This was clearly unacceptable. One of Haussmann's objectives was to make the city, as the expression of the system, unstoppable.

Interestingly, the new visual technology of photography was appropriated by the administration, at precisely this time, so as to provide evidential support for the new regimen of social order. So, the poster and the photograph may be understood as visual expressions of two, opposing, systems of representation in modern society—the regulatory regime and metropolitan spectacular.

In contrast to the technical precision of photographic processes and imagery, the lithographic poster offered an exciting and explosive visual expression of the Babylonian metropolis.

The rational ordering of society, implicit in Enlightenment republicanism, required a new kind of civic environment that spoke of liberal democracy. The balancing of rights and responsibilities around issues of individual freedom and social control became the distinguishing characteristics of the new civic environments. The relationship between civic planning and politics is well documented. For our purposes we need only add that, in these circumstances, the display of posters and advertising is equally significant. The political and ideological reading of these images cannot really be achieved without a consideration of this specific context.

THE SOCIOLOGY OF DESIRE

The technical and environmental preconditions that produced the modern poster are themselves part of a specific sociology. The sociology of modernity triangulates economy, production and education to align economic liberalisation with democratic freedom.

The division of labour described by Adam Smith leads to productive surplus. Smith presents productivity as a consequence of organisation. The efficiency gain, expressed as productivity, is made more permanent through the specialisation of labour. Industrial specialisation, in turn, demands new levels of education and discipline as a requirement for initiation into the system of production. The material surpluses of capitalism must, in their own turn, be utilised. Traditionally, war has been the mechanism whereby resources and their associated power were consumed.

After World War One, it became preferable to develop the mass market as the engine of consumption. These various parts come together to create, as noted by Thorstein Veblen in 1899, the beginnings of a leisure economy. The leisure economy flourishes in metropolitan areas where the concentrations of population, spending power and surplus goods are in convenient equilibrium. The poster is therefore both a practical visual consequence of productive power and a symbol of a specific ordering of society.

The new metropolitan environments were understood as emancipatory and constructive; earning power, democratic rights and personal freedoms became increasingly interwoven. In addition, the overwhelming experience of metropolitan modernity changed, from one of passive consumption to one distinguished by the active and participatory consumption of the leisure class. Modernity became synonymous with the sociology of desire expressed as something dynamic, continuous and interactive.

Beyond the metropolis, things remained less accelerated. This was reflected in the more static advertising environments of the rural countryside. More permanent painted signs and enamels distinguished these spaces. Provincial towns had neither the concentration of population or volume of demand, nor the competitive and voracious appetite for the new.

For You from Britain, Reginald Mount and Eileen Evans, c. 1967, 40 x 15", I'm Backing Britain Campaign.

The visualisation of community and environment have been crucial in presenting change in Britain as a social, and democratic, benefit. Through its attachment to modernist values and democratic communication, the poster has played an important role in the projection of these ideas. The appearance of the poster created a sensation. The colour, scale and expressive power of the images were greeted enthusiastically. The public responded, from the start, to the overt modernity of the poster and to the expressive visual representations made possible by lithography. At a more subliminal level, the public also attached feelings of excitement and renewal to these images.

It is worth, at this stage, briefly sketching out the visual development of the poster in Britain. The first stage of modern poster history, 1865–1915, was distinguished by the inclusion, in almost all posters, of a realistic depiction of the product being advertised. Artists such as John Hassall and Dudley Hardy became expert at placing realistically rendered products within a much more loosely painted field. This visual organisation became the default setting for much advertising and commercial art.

It is not surprising that, in the circumstances of the new cultural sociology of the late nineteenth century, posters should be attractive to many artists. The poster offered an alternative to the closed-off and aesthetically limited salon-type environment of art connoisseurship. For younger, more radical, artists, the poster offered a democratic and inexpensive way of making images. The avant-garde embraced the poster as a means of escaping the constricted bourgeois values of the museum and gallery.

Ironically, the creative and anarchic energy implied by the avant-garde embrace of the poster was quickly reined in. The success of the poster quickly created a market for display sites. The rents for display space were, from the first, carefully calibrated according to advertising demand and footfall. The lucrative

VISUAL COMMUNICATION AND SOCIAL PROGRESS

Above *new knowledge*, Abram Games, 1945, DC (30 x 20"), Army Education Services.

Opposite *Exhibition Of Science* (detail), Robin Day, 1951, DC (30 x 20"), Festival of Britain.

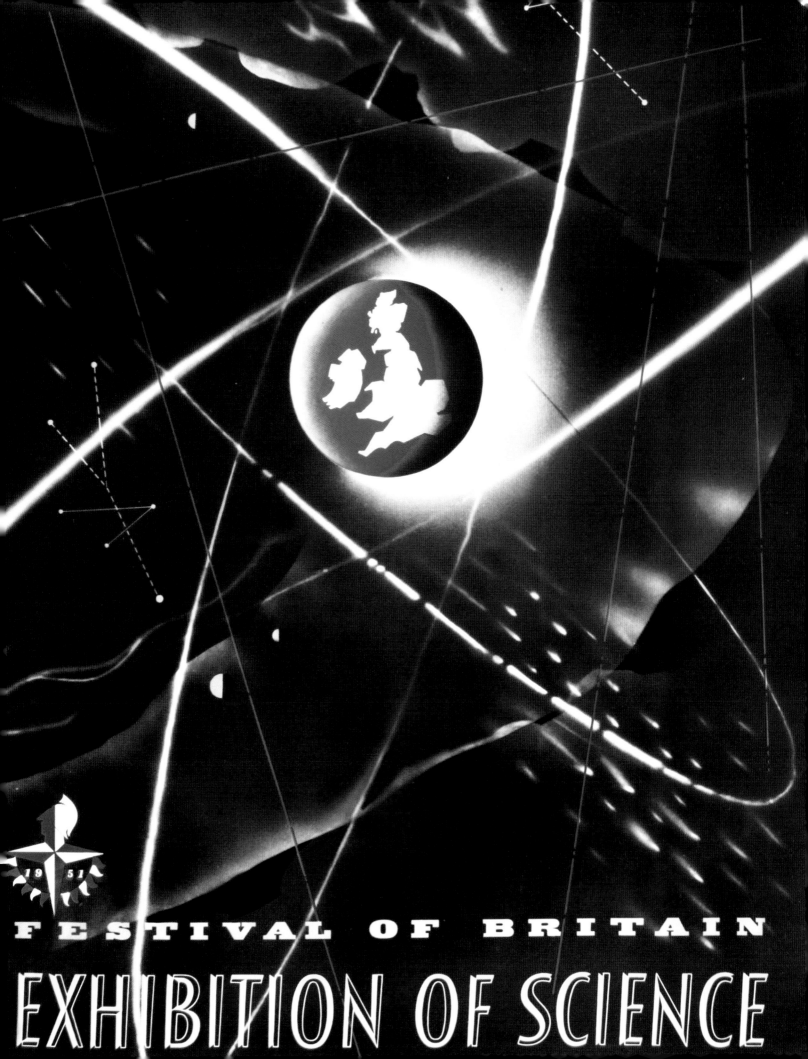

FESTIVAL OF BRITAIN

EXHIBITION OF SCIENCE

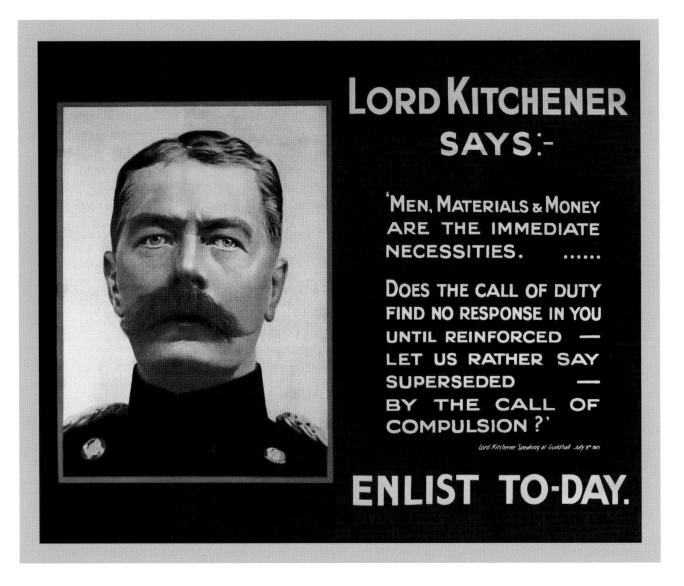

control of these sites, by commercial landlords, used legislation to support their business by outlawing the fly-posting of posters. The regulation of poster display appealed to social conservatives who considered the poster an environmental eyesore and associated its images with Babylonian excess.

In the context of the rapidly maturing commercial structure and progressively specialised organisation of the advertising display industry, the role of the artist, mythologised by the avant-garde as anarchic and chaotic, was marginalised in favour of more consistent outcomes of 'commercial art'.

The result was that, after a period of experimentation poster design became more conservative. The advent of World War One and the production of propaganda images marked the end of the first period of poster history.

The end of World War One was identified by a period of economic, political and social upheaval in all of the combatant nations. The consequences of war played themselves out differently within the various contexts of military defeat, economic ruin and political victory.

Above Enlist To-Day, Anon., 1915, QR (40 x 50"), Parliamentary Recruiting Committee.

Opposite The Dynasts, William Nicholson, 1914, DC (30 x 20"), Kingsway Theatre.

In Britain, these changes made themselves felt through the promises of "homes for heroes" and in the extension of democratic rights to women. Accordingly, design reform in the interwar years was an expression, through materials and technology, of combined commercial and social benefit.

With its 'Great Power' status confirmed by victory, the post-war period also saw the emergence, in Britain, of a new scale of enterprise with integrated systems and global reach. These organisations made use of the poster to communicate their services and intentions to an ever wider public. The availability of goods and services to a wider public, made possible through the benefits of productivity and economy, was equally understood as an expression of progress.

The cultural phenomenon of Modernism, in its twentieth century context, is usually associated with the specific period of post-World War One cultural and political realignment. The Modernist project expressed itself differently according to the circumstances devolving from the military and political experience of the Great War.

In material terms, Modernism is usually understood as a functional and utilitarian form of design resulting from technology, materials and fitness-for-purpose. The cultural phenomenon of Modernism is quite distinct from the feelings of modernity that have distinguished every period of Western social development from the Enlightenment onwards.

The advent of World War One created, as a consequence of conscription, a demand for recruiting posters and other types of propaganda. In the first instance, and due to the widespread and optimistic belief that the war would be brief, the Parliamentary Recruiting Committee (PRC) commissioned the posters. Later, the Ministry of Information (MOI) began to orchestrate the public relations of war.

The PRC was happy to outsource the production of recruiting posters to local printers. The printers undertook the work as an expression of patriotic duty.

In the circumstances, and without sufficient guiding intelligence, it is not surprising that the British propaganda posters of World War One appear prosaic and uncoordinated. The poster of Lord Kitchener, printed by David Charles of Belfast, Harrow and London, is typical of the kinds of posters produced as part of the war effort.

Nowadays, it is striking because it anticipates and establishes, through scale and colour, the visual language of the cult of political or military leadership. The portrait is based on a photographic halftone. However, the enlargement of the image has caused the portrait to degrade. This reminds us, subliminally at least, of the leader portraits associated the totalitarian politics of the inter-war years.

A number of themes emerge from across the range of posters produced during World War One. Not surprisingly, military leadership through the ages and from Saint George onwards, became a recurrent theme. The three posters for *The Dynasts* by Thomas Hardy, by William Nicholson, are part of this patriotic effort.

Nicholson was one of the most important artists of his generation. At the end of the nineteenth century he began to explore the potential of vernacular art and design based on his interest in the wood engravings of Thomas Bewick and the work of Joseph Crawhall. Nicholson began his artistic career in association with James Pryde, his brother-in-law. Together, they formed the

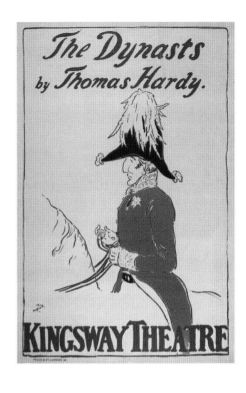

Beggarstaff brothers and produced dramatic poster designs based on the flat-colour and visual simplifications of woodcut printing. The Beggarstaff posters were generally too advanced for the commercial taste of the time. However, they were influential in terms of the subsequent evolution of poster design.

By the beginning of World War One, Nicholson was well established as a successful portraitist of London society. Nicholson was associated with the Ellen Terry and Gordon Craig sets of theatrical bohemians. William Nicholson was the father of Ben Nicholson. Nicholson's graphic style moved on from the simplifications associated with the Beggarstaffs towards something more free, expressive and speedy. Lithography allowed for a quick and expressive drawing. The results are obviously related to Nicholson's open air and impressionistic painting.

The circumstances of World War One created the conditions in which art and design began to converge. This was, in part at least, a consequence of avant-garde ideas. The avant-garde had, since its beginnings, rejected the art gallery and museum as institutional instruments of bourgeois cultural assimilation. The established artistic themes of beauty, order and calm were replaced by something more visceral.

In Britain, the Vorticists, under the guidance of Wyndham Lewis, sought to bypass the usual channels of patronage associated with the gallery. The Vorticist movement was a small, but influential, group of artists associated with the European Futurist movement, who broke away from the usual constraints of the art world by embracing the opportunity to design mural decorations, public sculpture and posters.

The Futurists, under the leadership of the charismatic Italian Filippo Tommaso Marinetti, had espoused an art devolving from the accelerating experience of modern life. Accordingly, they looked to the machine, and its associations with speed and power, as the wellspring of modern art. The sensations of excitement associated with this experience were presented through an increasingly fractured sense of perception.

In relation to the poster, the Vorticists' most significant contributions were towards the understanding of how colour contrast and the fractured geometry of speed could be combined to create dazzling effects of optical disturbance. The use of a diagonal triangulation in composition was understood, in this context, as especially dynamic. The pictorial simplifications implicit in the fractured and dynamic perspectives of Vorticism led, inevitably, to new levels of abstraction. In practical terms, the group also contributed to the development of camouflage patterns in World War One.

During World War One, the marine poster artist Norman Wilkinson led a series of experiments into the problem of camouflaging very large marine structures. The development of Dreadnought battleships dramatically changed the terms of engagement in marine warfare. Suddenly, shots could be fired in any direction and from great distance.

The problems of disguising the massive shapes of military and civilian shipping, especially when viewed against the horizon, were obvious. The ships could not be disguised, but the speed and direction could be dissembled by breaking up the shape, or outline, of the ship. Wilkinson and his assistants discovered that the geometric contrasts of dazzle were particularly effective in this regard.

Aldershot Tattoo, Andrew Power, 1934, DR (40 x 25"), London Transport.

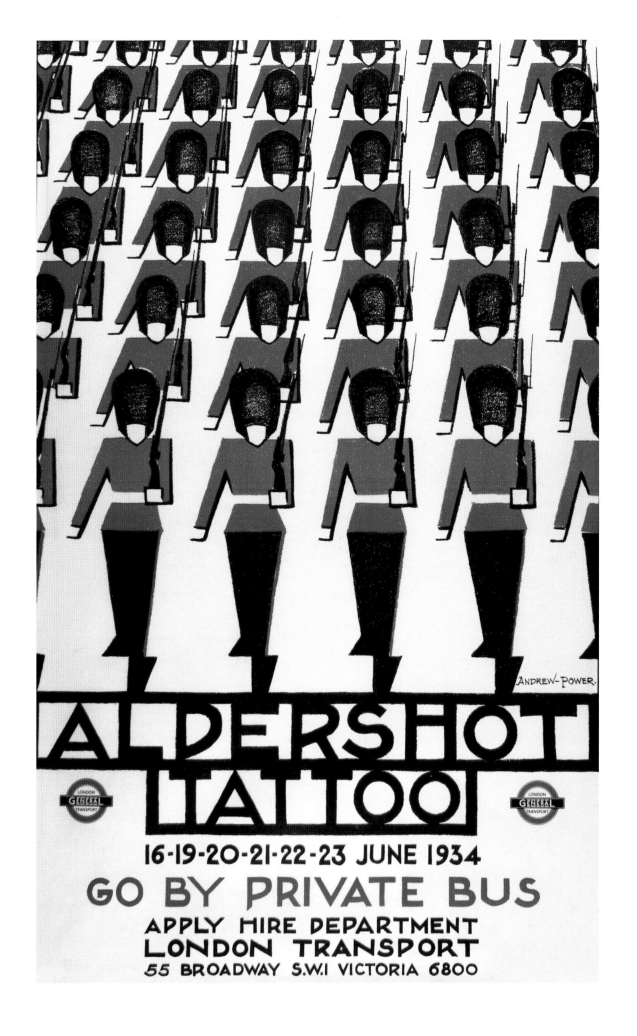

WE WORK ON WORK AND WIN

Later, the dazzle effects and abstractions of Vorticism contributed to the graphic style of the Grosvenor School in the 1920s and to the Op(tical)Art and the associated kinetic experiments of the late 1930s, 1950s and 1960s.

The Modernism of the 1920s and 30s was conceptualised as an international phenomenon of people and ideas that connected Moscow, Berlin, Paris and New York. The phenomenon was implicitly understood as dynamic and international. Culturally, the term attaches the utilitarian and functional elements of design to the social realignments provoked by World War One. The realignment was both a political modernisation and a form of repayment for the human cost of mechanised war. In practical terms this joined the demands of popular-front politics, for democratic representation, with those for improved standards of housing, health, education and safety.

The fitness-for-purpose and economy of materials associated with Modernism was also expressed through the visual culture of poster design. In their most simplified and economical form, the new posters, with their flat colour and geometric shapes, were understood as forms of abstraction. The ability, amongst ordinary people, to connect these abstracted shapes with the metropolitan experience of everyday life, suggested the possibility of a visual language with increased symbolic potential.

One of the most unusual cultural consequences of World War One was the rise in Britain of the coloured linocut during the 1920s. Claude Flight

Above *We Work On—Work And Win*, AV Pitchforth, 1940, 4S (40 x 60"), Ministry of Information.

Opposite *BEA to Britain*, Kenneth Rowntree, 1950, DR (40 x 25"), British European Airways.

popularised the linocut in his classes, from 1926 onwards, at the Grosvenor School of Art. The School had been established in 1925 and was based in Warwick Square, and offered, in addition to linocut printmaking, classes in lithography, etching, life drawing, painting and composition.

The School was a development that addressed, in a modest way, some of the various social consequences of World War One. The enormous death toll of the war was a catastrophe for the social equilibrium of Britain. Many women, for instance, were left without the usual prospects of marriage and its associated economic and social stability.

In the 1920s, the educational opportunities available to women and the range of possible employments were very limited. The Grosvenor School was established, in part at least, to address these issues and to offer a possible route towards economic independence and social respectability. Notwithstanding the precarious nature of the arts and crafts economy, the possibilities offered by an arts education looked attractive when viewed against the existing alternatives.

The Central School of Arts and Crafts, established by the London County Council, and Saint Martin's School of Art were equally active in addressing this urgent question of social equilibrium.

In this context, the linocut was an entirely pragmatic choice for students. The studio spaces and equipment resources required were minimal and, compared with more established techniques such as wood engraving, economical. Claude Flight promoted the linocut as something that could be done at home on the kitchen table. Furthermore, and following the Vorticists, the fluid cutting movements associated with the technique could be applied to the representation of metropolitan themes.

The patrons of the modern British poster were conscious of developments across London's art schools. The metropolitan themes of the Grosvenor School images, combined with the accessible nature of linocut image-making, made the relatively abstracted forms of Flight and his followers attractive to the wider public.

The visual language of Surrealism played a key role in developing the potential of graphic communication. The arbitrary and often incongruous connections presented by Surrealism, justified by an appeal to the subconscious, began to allow for a representation of the psychological experience of reality and of desire. This became especially useful to the advertising industry later on.

The hiatus of World War Two had an enormous impact on mass visual culture. The war quickly became an opportunity to express emancipatory political ideas and objectives that were presented as legitimate war aims, as part of Total War. The term Total War is used to describe the development of military conflict into something that attaches to the economic organisation of people and resources.

The alignment of duty, sacrifice and social democracy became mythologised as the egalitarian experience of the war. This was expressed, visually, through the cultural phenomenon of the 'illustrated war'.

For practical purposes, the advertising economy collapsed during the war. The diversion of resources toward military production and the rationing of goods meant that the normal rules of consumption were abandoned. Nevertheless World War Two was significant, in Britain at least, for advancing graphic communication in two notable ways.

The scale and urgency of the propaganda requirements of Total War effectively produced a paradigm shift within the visual print industry. The production of posters became a matter of urgency and the work moved to smaller firms equipped with the machinery of mechanical reproduction. The transition to mechanical reproduction also transformed the creative role of the artist into one of technocratic specification and direction. So 1939 marks the beginnings of a different type of creative activity in Britain.

The use of humour to engage the viewer was an important and unique development in the government propaganda of war, reconstruction and welfare. Of course, the use of humour in communication was not new. Within the context of war though, it allowed propaganda communication to move beyond the fear and anxiety associated with the default setting of atrocity propaganda.

The post-war period was one of austerity and economic reconstruction. Despite the utopian ambitions of the Festival of Britain in 1951, it took until the 1960s for post-war policy to work through and for economic prosperity to return.

Several things happened in the late 1950s and 60s that transformed the social fabric of Britain. For the first time since the war, young people had disposable income. The emergence of youth culture, founded on socially transgressive behaviour and principally expressed through music and fashion, opened a social space defined in the first instance by 'not becoming your parents'. The refusal to be limited by family finances or class origins was understood as an expression of social mobility. The ambitious scale of post-war meritocratic reform was exemplified by the extension of university education.

The end of military National Service transformed the university population. It immediately became younger and less deferential. Previously, in their first long period of development (lasting several hundred years), universities were a mechanism of assimilation into a social elite. Now, the massive expansion of the university sector began to change the student experience. Universities promoted education, through the methodologies of social science, as a process of interrogation rather than assimilation.

By far the most important change in the student population was derived from the equality of access given, for the first time, to female students. Suddenly the student population was gender balanced.

It is not entirely surprising that, in these circumstances, the 1960s should have ended in the great political upheavals of 1968 and the social experiments of sexual liberation and collective ownership.

The first person to understand the liberating and progressive significance of cultural production within this sociology of increasingly mass democratic spectacular was Walter Benjamin. Writing in the 1930s, Benjamin was aware that the political hiatus following World War One would require new forms of political discourse. The new political economy, framed through the expression of a popular visual culture, would be increasingly defined by the extension, beyond the metropolis, of new forms of dynamic vision. The success of this extension, suggested Benjamin, would depend on the economies of scale, associated with industrial production and distribution.

Benjamin understood this visual and experiential extension as a powerful force for democracy. The industrial multiplication of images, anticipated by

Benjamin, undermined the established systems of political control implicit in the highly regulated visual economy of power. It achieved this by overwhelming the mechanisms of censorship operated through ownership and price.

In addition, the new visual economy was distinguished through its decisive and irreversible impact on ways of seeing. The industrial multiplication of images would, in spectacular fashion, create a new psychological reality. The new vision would, necessarily, create a new cognitive perception of the world. The cognitive transformations that evolve from the acceleration and multiplication of visual images would, in the end, create a new kind of intelligence based on perception.

More recently, James Flynn has substantiated these interactions and they are now recognised as forming the basis for the "Flynn effect" of increased intelligence across metropolitan populations in developed economies.

For Benjamin, and in the context of mid-century mass participatory democratic movements, the individual work of art had become redundant.

properly packed parcels please, Negus Sharland, c. 1967, QC (30 x 40"), General Post Office.

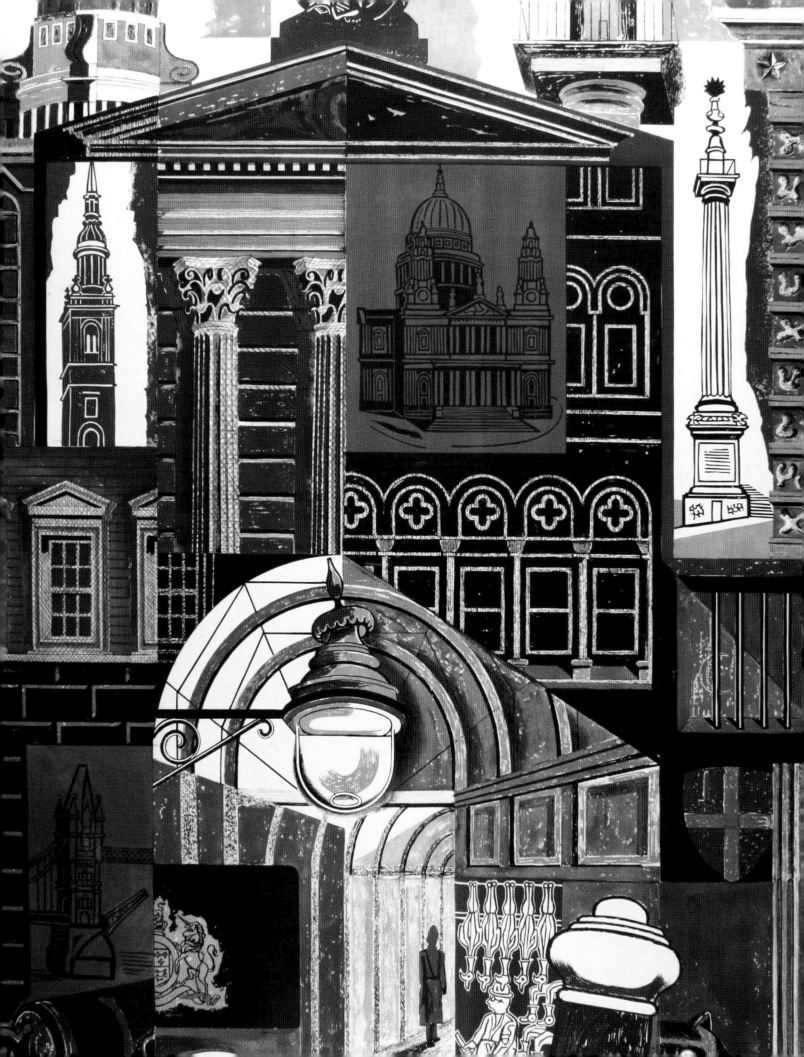

The commercial status of the poster is supported by an elaborate system of patronage. This section will examine the major patrons of the poster and chart how the process changed in relation to the development of organisations and administration within the design economy.

The economic hiatus associated with World War One and its aftermath created the conditions for a round of business consolidation. Fortunately, the military experience of World War One had perfected the control systems and chain-of-command structures, which were required by the new, larger-scale, organisations of the 1920s.

The Design and Industries Association (DIA) was formed in 1915 as a group of industrialists, business people and designers committed to the promotion and application of design to industrial manufacturing. This project sought to apply the benefits of good design to the largest number of people through the embrace of the scaling effects of industrial organisation. The DIA made the conceptual triangulation of education, design and social progress a practical reality.

The DIA was established as a response to growing anxieties about maintaining British industrial competitiveness. The industrialists, designers and educators that comprised the founding members of the Association understood that, in the context of twentieth century international competition and in relation to the extension of democratic reform, issues beyond price-point would increasingly differentiate products. The DIA was responsible, to some extent at least, for attaching philosophical values to everyday objects. These values ranged beyond price and practicality.

PATRONS OF THE MODERN POSTER

City (detail), Edward Bawden, 1952, DR (40 x 25"), London Transport.

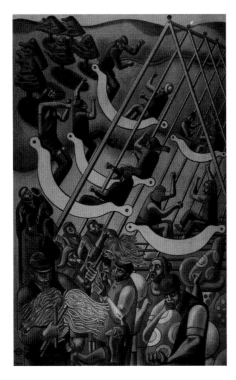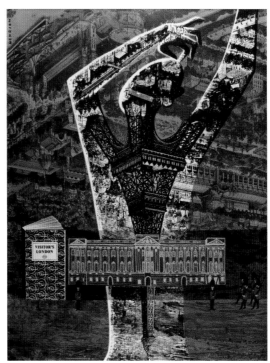

The first wave of Victorian reformers, gathered around John Ruskin and William Morris, had attempted to improve standards in British industrial design by rejecting industrialisation and promoting the Arts and Crafts.

The political and social objectives attached to design reform were impossible to achieve in this context. Making things by hand produced exquisite and expensive objects. The market for the handcrafted remained small and was limited to a tiny fraction of the social elite. The overall number of people involved in the Arts and Crafts Movement remained small and, although it was profoundly influential in a cultural sense, it remained democratically insignificant within the broader political scene.

The Kelmscott Press, founded by William Morris in 1891, set new standards in book production by considering books as both objects and texts. This was in contrast to the prevailing standards within the industry that viewed books merely as a means of presenting text. Morris considered that this entirely functional and utilitarian tradition produced limited and prosaic, if inexpensive, objects.

At Kelmscott, the choice of historical typefaces and the choice of paper stock became issues of significant judgement. The overall composition of each page, with its combination of text, image and paper became carefully considered as a matter of both aesthetics and assembly. Implicit in this change was an acknowledgement that design was about choices, decisions and technical specification. The elaboration of standards, as a consequence of specification, came to determine the activity of design in relation to industrial production. The combination of detailed specification and agreed standards allowed for increasing automation in the production of visual print. By the 1930s, this was understood as mechanical reproduction.

The books produced by Morris set a standard beyond the Private Press Movement. Their influence became felt across the whole industry as attempts

Left *London's Fairs*, William Roberts, 1951, DR (40 x 25"), London Transport.

Right *Visitor's London* (detail), FHK Henrion, 1956, DR (40 x 25"), London Transport.

Opposite *The Cutty Sark*, Tom Eckersley, 1963, DR (40 x 25"), London Transport.

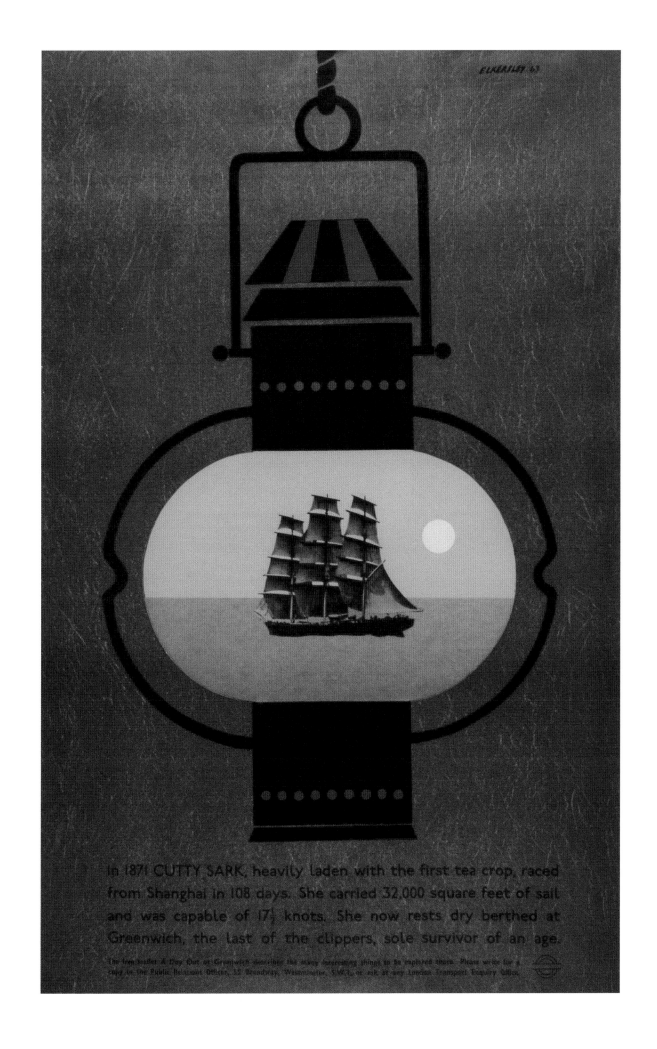

In 1871 CUTTY SARK, heavily laden with the first tea crop, raced from Shanghai in 108 days. She carried 32,000 square feet of sail and was capable of 17½ knots. She now rests dry berthed at Greenwich, the last of the clippers, sole survivor of an age.

The free leaflet A Day Out at Greenwich describes the many interesting things to be explored there. Please write for a copy to the Public Relations Officer, 55 Broadway, Westminster, S.W.1, or ask at any London Transport Inquiry Office.

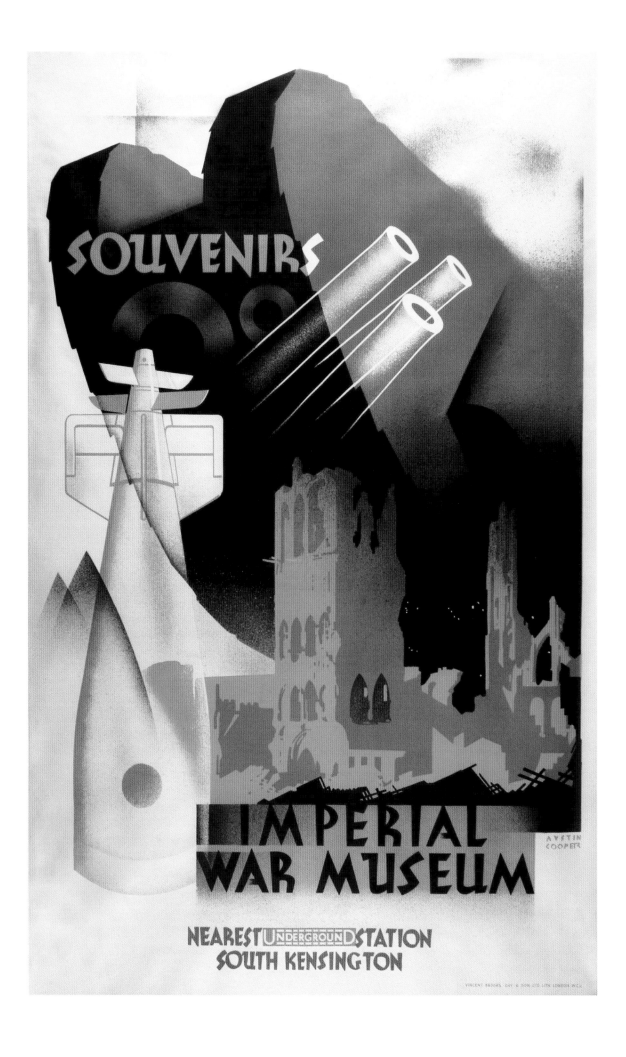

were made to apply the lessons of design reform to industrial scale book production. A number of figures played a key role in advancing standards in the visual culture of print across the wider industry. Francis Meynell, Gerard Meynell, Harold Curwen, Oliver Simon, Stanley Morison, Eric Gill, Noel Carrington and Allen Lane each transformed the British print environment by applying Arts and Crafts principles of design to industrial manufacturing in book production and publishing.

By simultaneously addressing issues of quality and quantity, these second-wave reforms transformed the general visual characteristics of print culture in Britain. The reformers effectively established a print environment defined by issues of judgement in graphic design.

The promotion of services, rather than products, required a new kind of advertising image. These new posters abandoned the exact reproduction of products that had characterised the first period of poster design, in favour of more allusive forms of visual association. It was natural, in these circumstances, for advertising managers to turn to artists.

However, and as noted earlier, the worlds of business and creativity remained separate from each other. In order to facilitate the new advertising, a new kind of patron was required.

The new patron was part scientific manager, technocrat and visionary. The development of the modern British poster cannot really be understood without reference to these personalities. It is worth, at this point, taking the time to introduce some of the major figures of the new patronage.

FRANK PICK

Frank Pick (1878–1941) was the most important and significant figure amongst the new patrons. Pick was born in Spalding, Lincolnshire and raised in York where he attended school and chapel. The nonconformist background of the Salem Chapel formed Pick's fastidious sense of moral conscience and social duty.

In 1903, Pick took a job with the North Eastern Railway (NER), whose headquarters were in York, in their newly established traffic statistics office. The NER was not the largest of railway companies, but it had a reputation for efficiency and progressive management. Pick worked as assistant to the General Manager, George Gibb.

In 1905, George Gibb, was headhunted to be in charge of the Underground Electric Railways of London (UERL). Gibb invited Pick to join him in London. The Underground Railways were in a difficult position—modernisation and new building had greatly indebted the firm. Gibb's task was to stabilise the financial situation and to build traffic on the new lines.

Gibb also appointed Albert Stanley to the company. Stanley, later Lord Ashfield, was an American transport manager with an astute appreciation of the value of marketing and public relations. Pick realised, from the very first, that the financial situation and marketing were connected. The poor levels of trade were, in some sense, an indictment of the Underground's publicity. Pick was invited to do better and in 1908, Stanley gave Pick responsibility for all the Underground's publicity.

Opposite *Souvenirs*, Austin Cooper, 1932, DR (40 x 25"), London Transport.

Above *Enjoy Your London*, Betty Swanwick, 1949, DR (40 x 25"), London Transport.

"The busy woodpecker
Made stiller by her sound
The inviolable quietness."

GENERAL

"I climb your crown, and lo! a sight surprising......"

GREEN-LINE

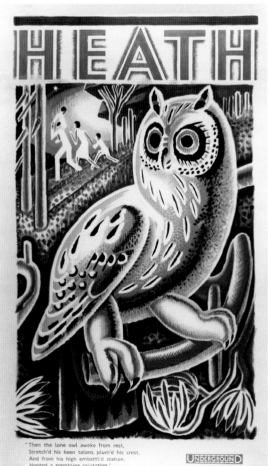

"Then the lone owl awoke from rest,
Stretch'd his keen talons, plum'd his crest,
And from his high embattl'd station,
Hooted a trembling salutation."

UNDERGROUND

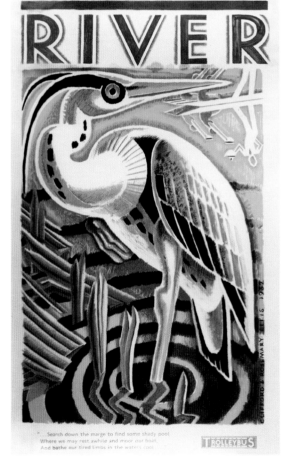

".. Search down the marge to find some shady pool
Where we may rest awhile and moor our boat,
And bathe our tired limbs in the waters cool."

TROLLEYBUS

Pick's background and influences combined to give him a meticulous approach to business analysis and, at the same time, allowed him to see the broader, more expansive picture. Accordingly, he was able to integrate the various activities of the business as it expanded.

Albert Stanley became Managing Director in 1910 and drove the business forward through a series of audacious take-overs and mergers. The Underground Electric Railway of London engineered a take-over of the General Omnibus Company in 1912. The combination of underground railways and buses created a much larger group with a variety of services. Pick began to conceptualise the advertising of this group so as to integrate and co-ordinate the different services. This integration was expressed through a more consistent graphic style in communication with the public.

The first part of this process was to find a typeface that could be used, across the entire system and for each of the wide variety of communications required by the organisation. Pick commissioned Edward Johnston to create a clear and easy-to-read typeface for the Underground Railway in 1913. Pick's brief was a letterform suitable for signage. Within the specific context of the Underground, it was especially important that the resulting signage should be clearly legible. Obviously, it was especially important that the signage should contribute to the smooth flow of large numbers of people within the relatively constricted environments associated with public transport.

The genesis of the Underground type was not straightforward. Johnston was widely acknowledged as an authority of letterforms. However, he was a calligrapher, skilled in penmanship and considered himself a craftsman. In some ways, he was antipathetic to the concept of design, which he associated with tools and manufacturing.

Johnston elaborated the typeface using squares, circles and diagonals. Johnston based his designs on the historical precedents of a family of early nineteenth century display types called 'sans serif'. The new letters were a rational and consistent expression of form and function. The relatively austere presentation of the letters provided the perfect expression of functional modernity.

There was a further expansion of the UERL throughout the 1920s and 1930s as the Northern, Central and Piccadilly Lines were each extended. The suburban expansion of the system allowed, from the start, for a combination of architecture, lettering and signage that was consistent and progressive. The visual alignment of these various elements produced a solid foundation of values that expressed, through a framework of environment and service, a practical example of civic progress.

In 1928 Pick was made Managing Director of the company. In 1933, the UERL became a single, unified, public authority and was renamed London Passenger Transport Board (LPTB). The LPTB was later renamed London Transport. Speaking to the Royal Society of Arts, in 1935, Pick described his activities:

> beneath all the commercial activities of the Board, underneath all its engineering and operation, there is the revelation and realisation of something which is in the nature of a work of art... it is, in fact, a conception of the metropolis as a centre of life, of civilisation; more intense, more eager, more vitalising, than has ever so far obtained.

Wood, Heath, Down and River, Clifford and Rosemary Ellis, 1933, each DR (40 x 25"), London Transport.

The association between design, progress and improvement described by Pick was characteristic of the design reform movement of the 1920s and 30s. The lessons of Arts and Crafts design reform were that, without economy and convenience, the provision of goods and services could only be assured to a small, and wealthy elite.

On a practical basis, Pick understood that the accelerating expansion of the metropolis, facilitated by his own organisation, created a palpable anxiety amongst some of its citizens. The flux and speed of Modernity was as destabilising as it was exciting. Nowhere was this more evident than in the constricted environments of the deep Underground. The posters were there, in these circumstances, to provide information and direction. A good poster distinguished itself, believed Pick, by being useful.

The poster environment conceptualised by Pick became the expression of something practical, safe and harmonious. The poster helped normalise the unusual behaviour of going deep beneath the surface of the streets. It was even possible to imagine that the pictorial alignment of images, along the platforms of Underground stations, became for many passengers a vista, more dynamic or poetic depending on the direction of travel, between the comforts of rest and the excitements of metropolitan pleasure.

It was entirely natural that Frank Pick should have been a founder member of the DIA. Pick's achievements at the UERL were, in 1915, already substantial and Pick was immediately recognised as a senior figure within the DIA. The esteem and respect in which he was held were reflected in his appointment as President of the DIA in 1928 and as Chairman of the Council for Industrial Design in 1934. Pick rejected the public honours that were offered to him.

Over the course of his long career in management and design politics, Pick formed a number of crucial and creative friendships. The membership of the DIA comprised a number of artists and educators. These associates helped guide Pick to new and interesting artists.

Obviously, Pick had long working relationships with Charles Holden, the architect, and with Edward Johnston, the calligrapher. The sheer scale of the poster campaign and its near 50-year length under Pick's guidance, make it much harder to identify the key creative relationships that defined the campaign. Nevertheless, the names of Edward McKnight Kauffer and Paul Nash recur sufficiently to suggest significance.

The poster environment promoted by Pick at London Transport, and in underground stations in particular, has always been recognised as important. The poster displays of the London Underground became significant with the development of electric railways and the creation of the deeper underground environments. The posters proved to be an effective way of normalising environments that would usually be associated with uncomfortable feelings of anxiety and claustrophobia.

The posters for London Transport have helped transform the experience of London for many millions of inhabitants and visitors. The cultural significance of these images cannot be overstated. In the days before a widespread interest in art and culture, the poster displays on station platforms provided a rare introduction to visual culture.

Out and About (detail), James Arnold, 1950, DR (40 x 25"), London Transport.

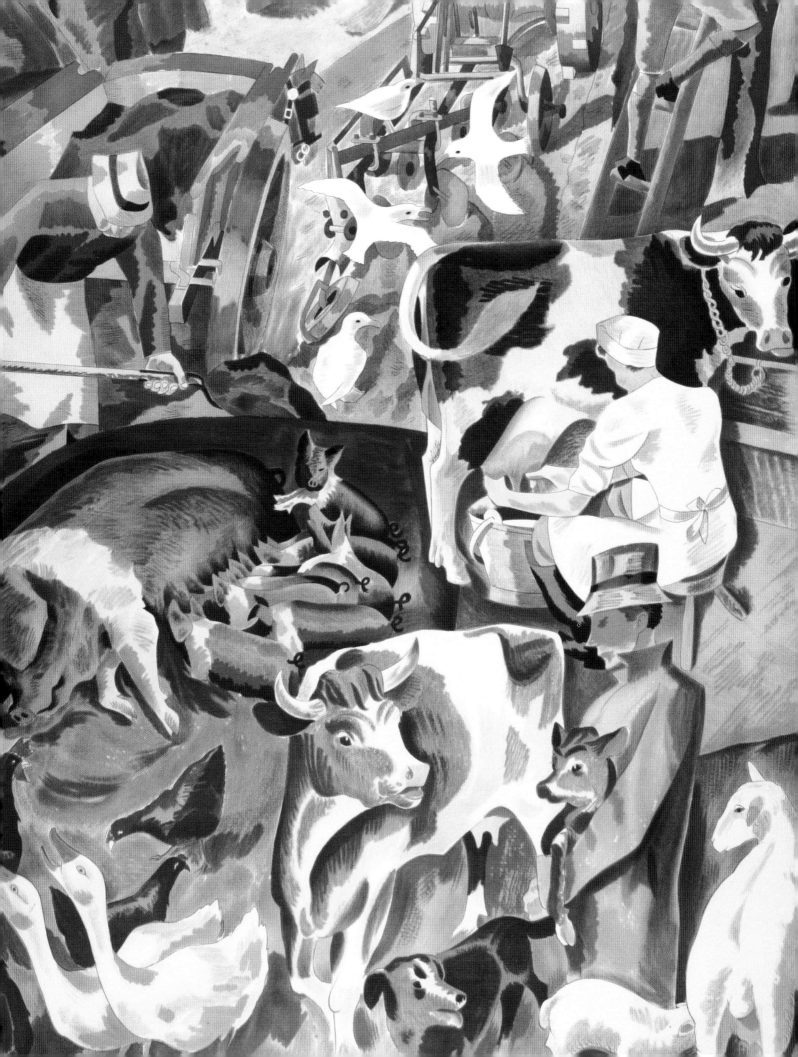

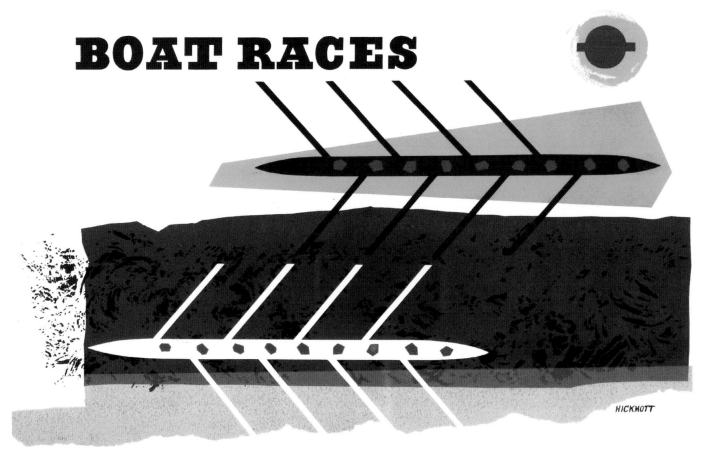

BOAT RACES

HEAD OF THE RIVER Mortlake to Putney 21 March 3 p.m.

OXFORD v CAMBRIDGE Putney to Mortlake 28 March 3.15 p.m.

By UNDERGROUND to
PUTNEY BRIDGE HAMMERSMITH RAVENSCOURT PARK STAMFORD BROOK TURNHAM GREEN

259/259M/17,000 The Baynard Press

In addition to platform advertising, Pick also commissioned a large number of smaller panel posters. These were smaller-scale posters designed for internal display within buses, trams and underground railway carriages. The panel posters measure 10 x 12 inches.

Issues of economy and productivity suggest that these images would have been printed as repeats and then trimmed to size. The edition sizes for these smaller posters were much greater than for the platform posters in double crown or double royal size. This was due to the much greater number of display spaces available within the trains, buses and trams of London Transport. The serial numbers on each poster reveal editions that may be measured in the several thousands compared with those in the hundreds for platform posters. Notwithstanding these larger editions, and because these posters were all pasted up, these images survive in relatively few cases.

Boat Races, Anne Hickmott, 1959, panel poster, 10 x 12", London Transport.

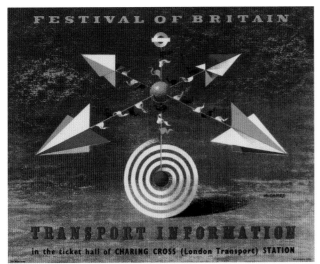

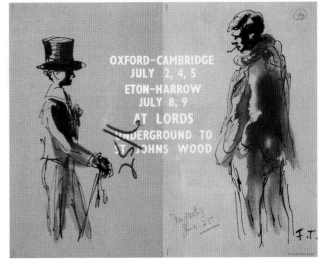

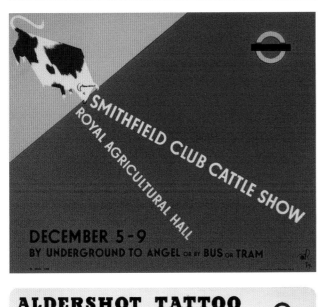

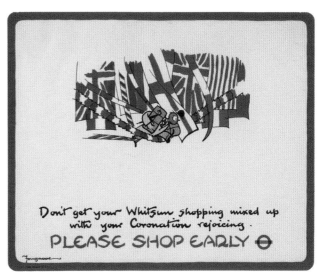

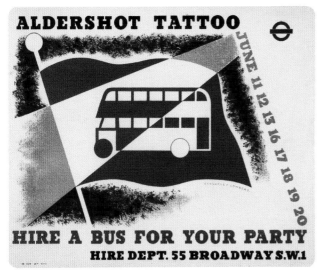

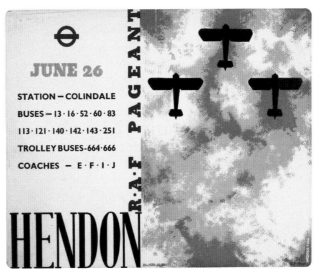

Top left *Festival of Britain Transport Information*, Abram Games, 1951, panel poster, 10 x 12", London Transport.

Top right *Varsity Cricket at Lords*, Feliks Topolski, 1938, panel poster, 10 x 12", London Transport.

Middle left *Smithfield Club Cattle Show*, Reimann School Studio, 1938, panel poster, 10 x 12", London Transport.

Middle right *Please Shop Early*, Fougasse, 1937, panel poster, 10 x 12", London Transport.

Bottom left *Aldershot Tattoo*, Tom Eckersley and Eric Lombers, 1936, panel poster, 10 x 12", London Transport.

Bottom right *Hendon RAF Pageant*, Middleton, 1937, panel poster, 10 x 12", London Transport.

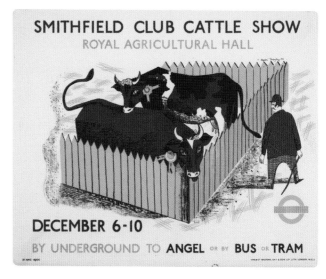
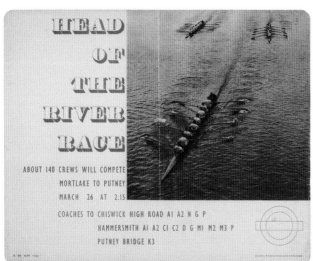
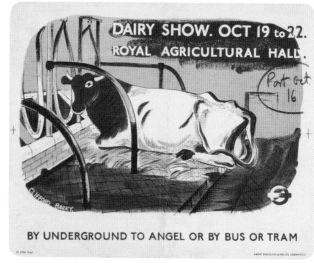
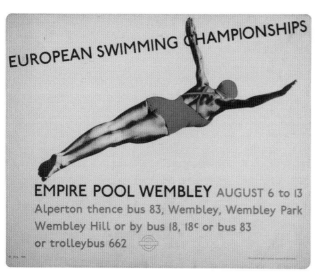
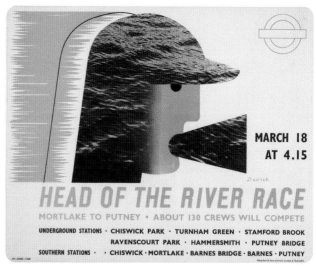

Top left *Modern Silverwork*, Edward McKnight Kauffer, 1938, panel poster, 10 x 12", London Transport.

Top right *Smithfield Club Cattle Show*, Charles Mozley, 1937, panel poster, 10 x 12", London Transport.

Middle left *Head of the River Race, March 26*, Anon., 1938, panel poster, 10 x 12", London Transport.

Middle right *Dairy Show*, Clifford Barry, 1937, panel poster, 10 x 12", London Transport.

Bottom left *European Swimming Championships*, Anon., 1938, panel poster, 10 x 12", London Transport.

Bottom right *Head of the River Race, March 18*, Davies, 1939, panel poster, 10 x 12", London Transport.

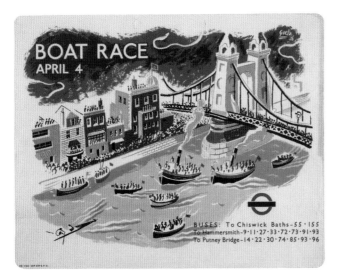

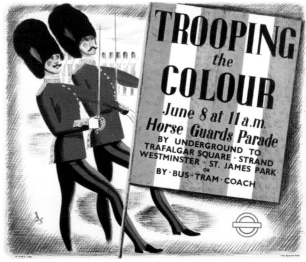

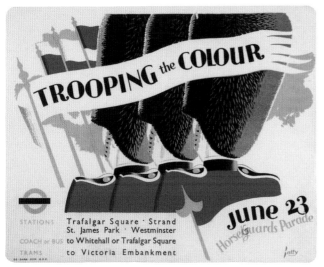

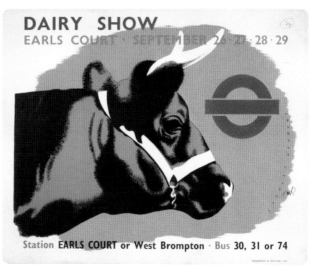

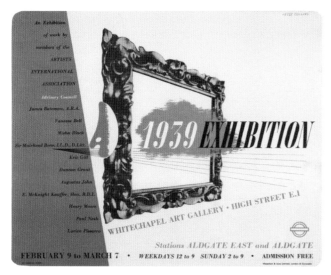

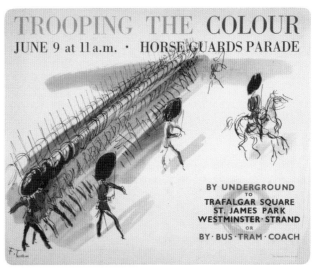

Top left *Boat Race*, Walter Goetz, 1936, panel poster, 10 x 12", London Transport.

Top right *Trooping the Colour*, Charles Mozley, 1939, panel poster, 10 x 12", London Transport.

Middle left *Trooping the Colour*, Dora Batty, 1936, panel poster, 10 x 12", London Transport.

Middle right *Dairy Show*, Stanley Herbert and Reimann Studio, 1939, panel poster, 10 x 12", London Transport.

Bottom left *AIA 1939 Exhibition*, Jesse Collins, 1939, panel poster, 10 x 12", London Transport.

Bottom right *Trooping the Colour*, Feliks Topolski, 1938, panel poster, 10 x 12", London Transport.

The smaller format of the posters, and their association with internal display on buses, trams and trains, made them especially useful in promoting events around London. Accordingly, they provide for a sort of cultural calendar of the capital.

It is worth noting that London Transport was not the only transport company in Britain to commission poster advertising. The railway companies had been at the forefront of pictorial advertising since the end of the nineteenth century. In the first instance, their advertising reflected the many different companies that provided railway services in the 1890s. This produced an eclectic, but often incoherent display.

Increased visual coherence was the natural consequence of the rationalisation of the railways, in 1923, into the four regional systems. These were Southern Railway (SR); Great Western Railway (GWR); London, Midland and Scottish Railway (LMS) and the London and North Eastern Railway (LNER).

The geographical spread of the companies' activities defined their advertising activities to a certain extent. The Southern, for example, served the London commuter belt of south-eastern England and provided services to the Continent. In these circumstances it operated, more-or-less, as a monopoly and saw little virtue in using valuable display space to advertise its own efforts.

The Great Western had a similar situation with regard to the traditional holiday destinations of Cornwall and Devon. The sheer number of available destinations created a more varied advertising environment, but the images remained, for the most part, ordinary.

The London, Midland and Scottish and the London and North Eastern were, from the first, locked in competition on the west and east coast routes to Scotland. The LNER, under the publicity management of William Teasdale, quickly secured the services of five highly regarded poster artists. These were Fred Taylor, Frank Mason, Frank Newbould, Austin Cooper and Tom Purvis. Teasdale offered these artists a retainer to assure their exclusive services to the LNER. During the 1920s and 30s this produced a series of uniformly excellent designs.

In graphic terms, these designers were pioneers of simplification and scaling effects. The dramatically simplified designs combined with the larger, quad royal size (40 x 50 inches) to create real impact. Unfortunately, the subject matter of seaside resort and bathing beauties remained in dominance.

In contrast, the LMS produced a more obviously artistic range of posters by recruiting senior Royal Academicians to their cause. The marine painter Norman Wilkinson directed these efforts.

In 1940, Pick left London Transport. His appointment as Director General of the Ministry of Information was short-lived. He retired, in ill health, and died at his home in 1941. In 1942, and as part of an appreciation published in *The Architectural Review*, Nikolaus Pevsner, the émigré architectural historian, described him as a "modern Medici".

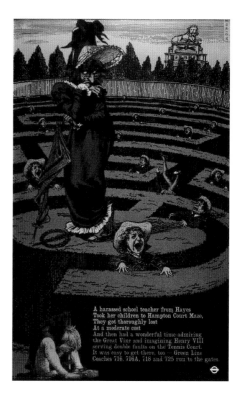

Opposite *London's River*, John Minton, 1951, DR (40 x 25"), London Transport.

Above *Hampton Court Maze*, FHK Henrion, 1956, DR (40 x 25"), London Transport.

SIR STEPHEN TALLENTS

In 1926, Pick was invited to chair the Publicity Committee of the newly formed Empire Marketing Board (EMB). The Board, under the stewardship of Sir Stephen Tallents (1884–1958), was an attempt to manage, in terms of public relations, the issue of trade and commerce across the Empire.

In the course of its industrial development Britain, the world's workshop, became not just the centre of an economic system of imperialism, but also the centre for world trade. It was surprising that, in these circumstances, only 30 per cent of imports to Britain after World War One originated from the Empire: less than 50 per cent of grain and dairy and only 25 per cent of meat and fruit imports.

In the face of increased competition from a growing number of industrial competitors, and with the imposition of import tariffs likely to diminish Britain's export markets further, it was natural to look at the Empire as a means of supporting Britain's trading economy. The Empire Marketing Board was established to promote trading relations, at consumer and wholesale levels, between Britain and the Empire.

The task was familiar to Pick. The economic benefit and practical convenience of imperial trading relations had to be made evident to many people for whom, and for whatever reason, the origins of products remained mysterious.

It is not surprising that, having understood the task as one of informing and educating, Tallents and Pick should conceptualise a series of posters and prints. In large size, the posters were displayed on specially constructed frames. In a smaller size, they were distributed to schools.

In addition to the poster images, Tallents was quick to recognise the potential of cinema for public relations. He established the Empire Film Unit, under the technical guidance of John Grierson, and began to make documentary films about the peoples and communities of the Empire.

Grierson had gone to North America in 1924 to study the pioneering work of Walter Lippmann and Edward Bernays in public relations. Lippmann was famously sceptical about the possibilities of the ordinary person being able, within the workings of mass democracy, to make an informed judgement about the complex and varied problems of policy.

The entrenched cynicism implicit in Lippmann's view provoked Grierson to address the problem of public relations through information and education. Following a suggestion from Lippman, Grierson began to investigate film and cinema as a way of addressing the problems of mass communications. Grierson immersed himself in the film and cinema industry at a time of rapid and ceaseless experimentation. He became aware of the documentary experiments of Robert Flaherty through his film *Nanook of the North*, 1922, and also of the Soviet experiments of Sergei Eisenstein and Dziga Vertov's *Man with a Movie Camera*, 1929.

When Grierson returned to the UK in 1927, he approached the EMB with a view to developing his ideas about mass communication. Tallents had already begun to use films to promote the EMB's ideas to young children. He recognised, however, that Grierson would bring a greater precision to their efforts through his highly specialised expertise.

Grierson did two things at the EMB. First, he established a theoretical and critical framework in which the documentary genre could flourish. Secondly, he

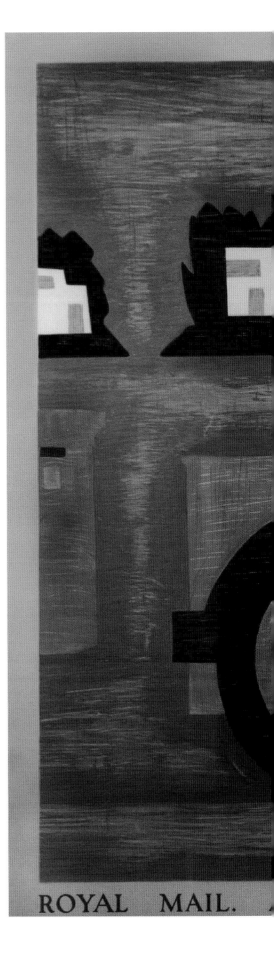

ROYAL MAIL.

Messenger, John Armstrong, 1935, QR (40 x 50"), General Post Office.

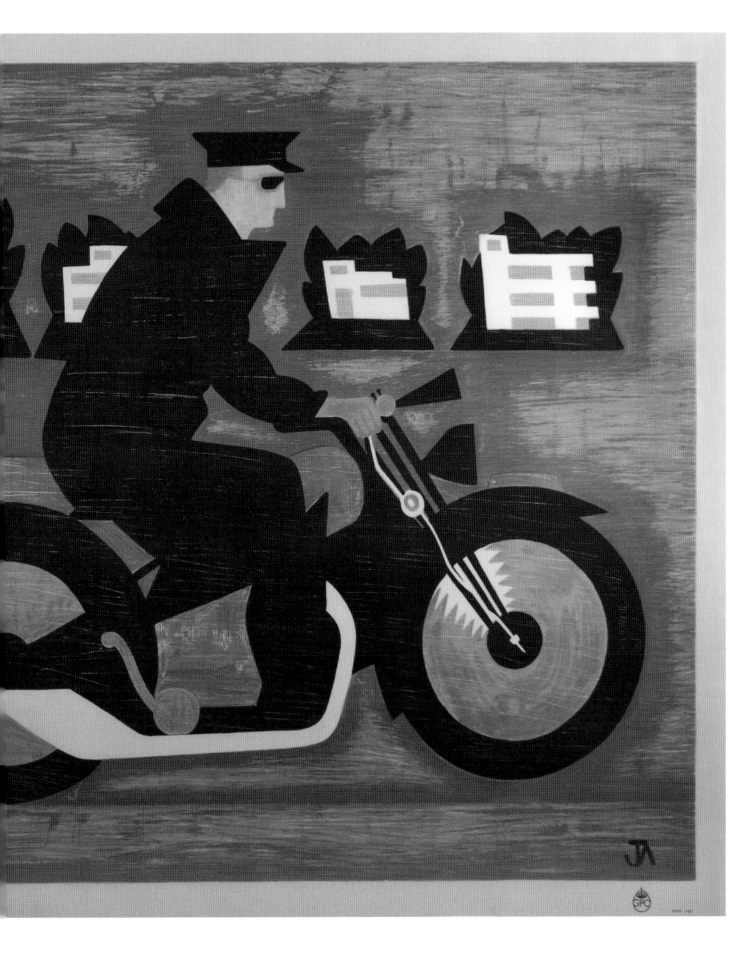

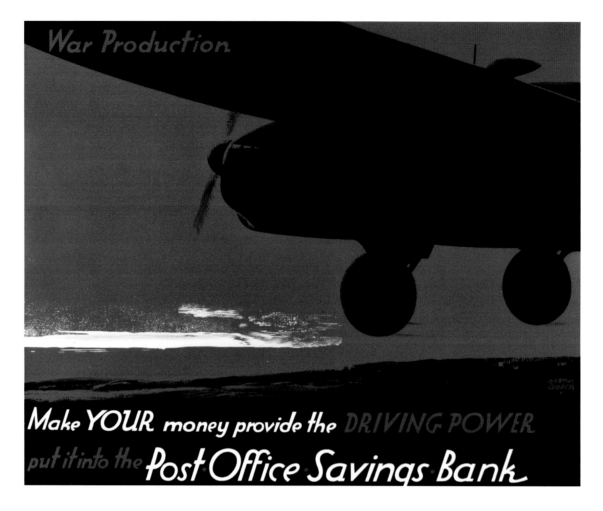

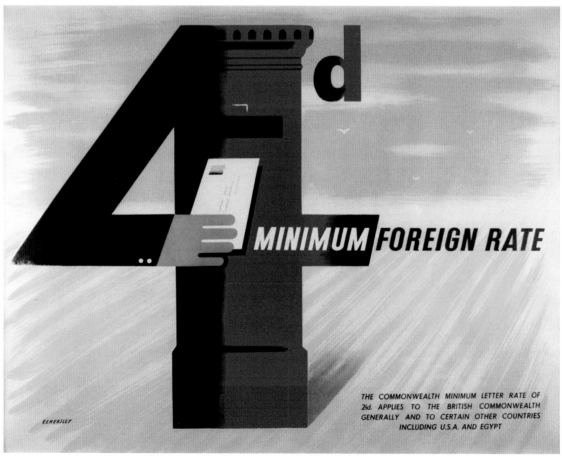

created an administrative and commercial structure that facilitated the making of these films. Grierson also made sure that the films were seen by circulating the films to schools, film societies, trade unions and various women's organisations.

The EMB also made wide use of newspaper and print media to promote its message. However, it is the posters and films that form its enduring legacy. When the EMB was closed in 1933, Stephen Tallents moved to the General Post Office (GPO).

The modern GPO had grown, from Rowland Hill's initial proposal for pre-paid penny postage in 1837, to become the single largest organisation in Britain. For most of the nineteenth century it had grown and developed organically as new technologies and new systems of organisation were introduced.

For the Post Office, the consequences of World War One were complex and wide-ranging. In the first instance, the war accelerated the process of mechanisation throughout the service. The process of integrating motorised transport into the logistics of the postal service was based on the military experience of logistics during World War One. The scale and complexity of the war effort helped develop new command structures and disciplines that could extend over great distance. The war also helped introduce new ideas of discipline and responsibility to the workplace. The increasing use of mechanisation was a constant characteristic of the service between about 1920 and 1950, when full operational mechanisation was finally achieved.

The pace of mechanical and administrative modernisation increased, in turn, the capacity of the service. Larger loads of letters and packets could be moved by motorised traction and those loads could be moved more speedily. In logistical terms it became easier, with telephone and telegraph services co-ordinated, to accurately locate men, machines and post within the greater system. So, the major consequence of World War One was a substantial increase in the mechanical capacity and administrative efficiency of the GPO.

Despite these greater capacities, a combination of inflation and economic recession greatly reduced the profit margins of the postal service and pushed the Post Office into deficit. Suddenly, the convenient arrangements by which the Post Office could raise revenue for the Treasury no longer held.

Accordingly, the Treasury and political administration began to look more closely at issues of efficiency within the Post Office system. The simplest measure of efficiency, in these circumstances, was simply to look at the volumes of service achieved as a percentage of the maximum possible and within the limits of resources provided. Maximising the volumes of each service suddenly became a priority. Having understood the importance of increasing the volumes of service achieved, it was not surprising that the Post Office should attempt to promote its services through the use of public relations and poster publicity.

In simple terms, and as long as the service raised revenue for the Treasury, there had been no need for the Post Office to actively promote its services or to solicit extra custom. The management of the Post Office had been quite happy, in this benign environment, for the service to grow more-or-less organically. It was natural, in these different circumstances, for the Post Office to draw benefit from previous example of the EMB.

Opposite top *War Production*, Austin Cooper, 1944, QC (30 x 40"), General Post Office.

Opposite bottom *4d Minimum Foreign Rate*, Tom Eckersley, 1950s, QC (30 x 40"), General Post Office.

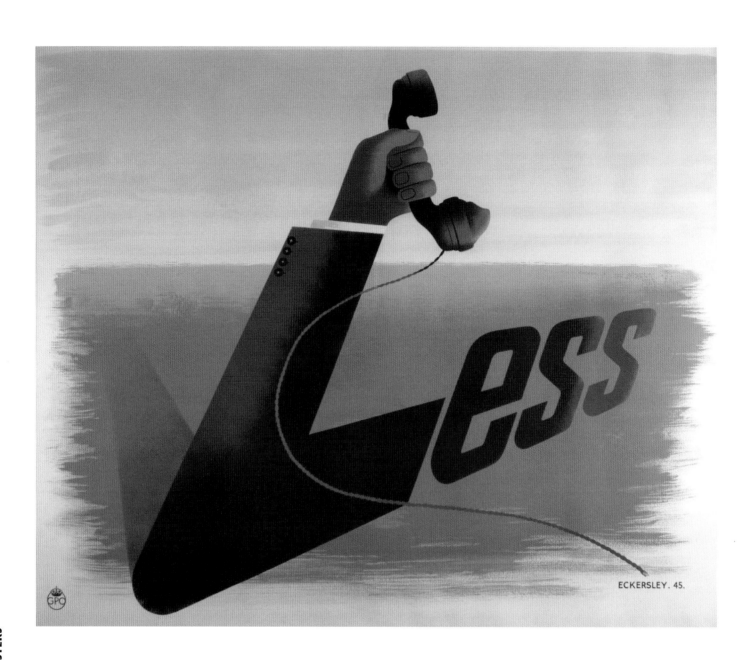

Less, Tom Eckersley, 1945, QC (30 x 40"), General Post Office.

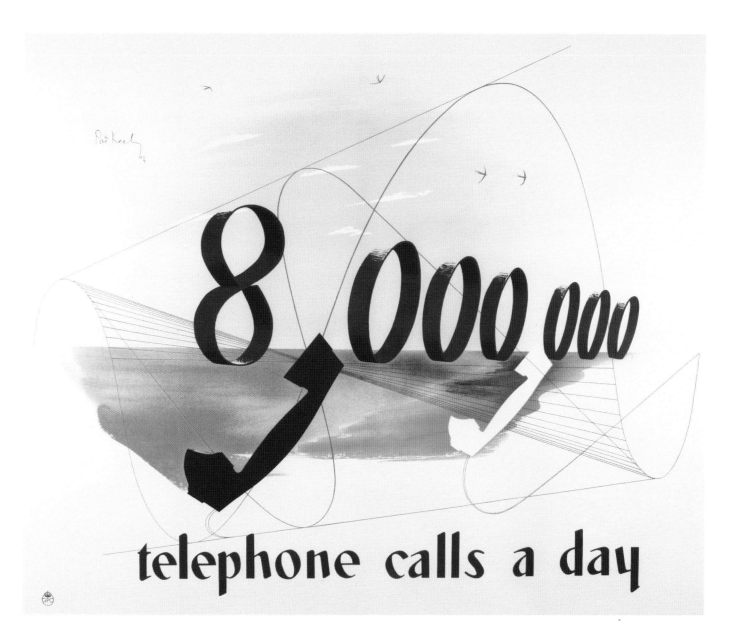

8,000,000 telephone calls a day, Pat Keeley, 1946, QC (30 x 40"), General Post Office.

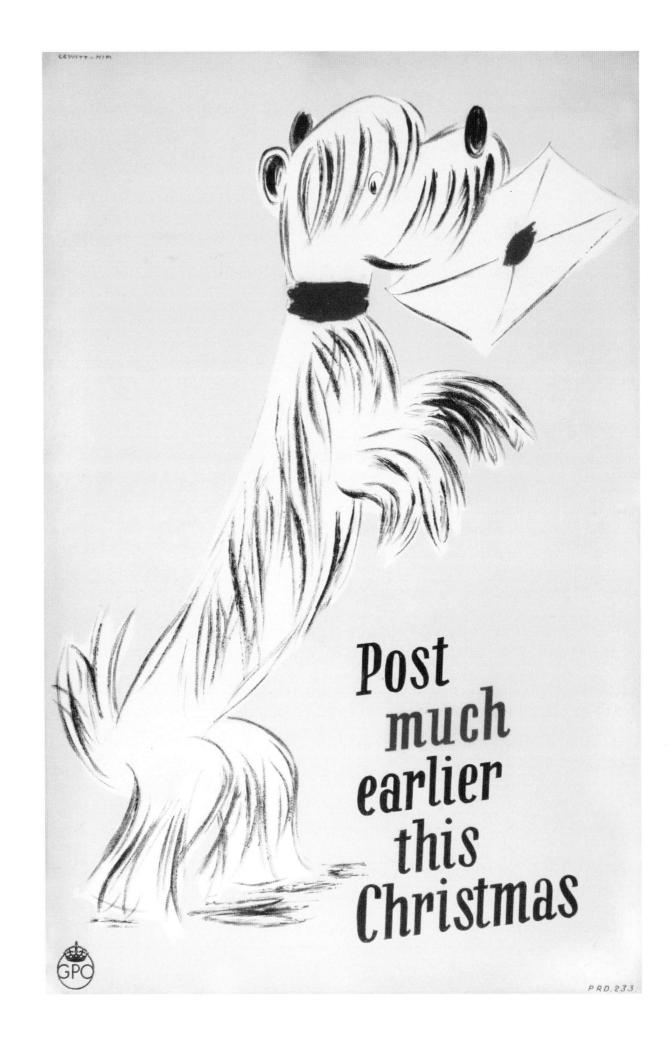

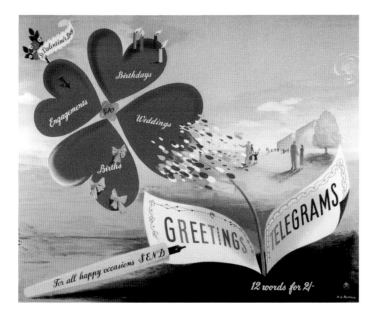
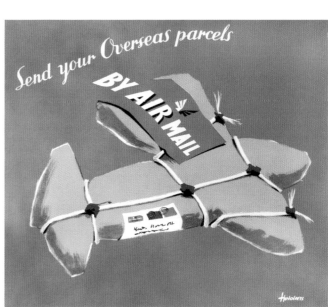

The various forces, within the Post Office, of economic pressure and organisational inertia created peculiar and contradictory conditions. From 1921, the Post Office began to exploit the space within its public offices for commercial advertising. The revenue streams derived from this activity necessarily compromised the Post Office's own efforts at publicity. This conflict of interest was only resolved in 1935, when the commercial contracts were withdrawn.

At the GPO, Tallents simply resolved to continue the good work he had begun at the EMB. A Post Office Film Unit was set up under Grierson. A publicity committee was established which added the expertise of Jack Beddington and Kenneth Clark to that of the various GPO representatives.

Tallents established a framework of relations between artist and organisation that gave the artists and designers every opportunity to engage with the great machinery of progress. The first GPO posters were produced as educational posters for schools. Later, posters were displayed in post offices and on GPO vehicles.

Stephen Tallents identified a number of themes, like Pick at the UERL, that needed more-or-less continuous expression to the public. One such theme addressed the widespread tendency for people to post letters and parcels at the last minute. Accordingly, a disproportionate volume of work came to the GPO late in the day. This made the effective use of the workforce and the working day more complicated than needed. By smoothing out the volumes of traffic across the whole day, the system could be made to work more efficiently. Other campaigns promoted the correct parcelling up of packages and the accurate addressing of letters and labels.

The posters produced for the GPO between 1933 and about 1970 are relatively little known today. The Post Office began to use posters as a means of informing the public about the many improvements to the services of post, telephone and airmail that followed from the modernisation and mechanisation of the service. The promotion was an attempt to increase volumes across all parts of the organisation's activities.

Opposite *Post much earlier this Christmas*, Jan Lewitt and George Him, 1943, 15 x 10", General Post Office.

Left *Greetings Telegrams*, HA Rothholz, 1950, QC (30 x 40"), General Post Office.

Right *Send your Overseas parcels by Air Mail*, Peter Huveneers, 1950, QC (30 x 40"), General Post Office.

Overleaf *Your Christmas Packets & Parcels*, Jan Lewitt and George Him, c. 1950, 10 x 15", General Post Office.

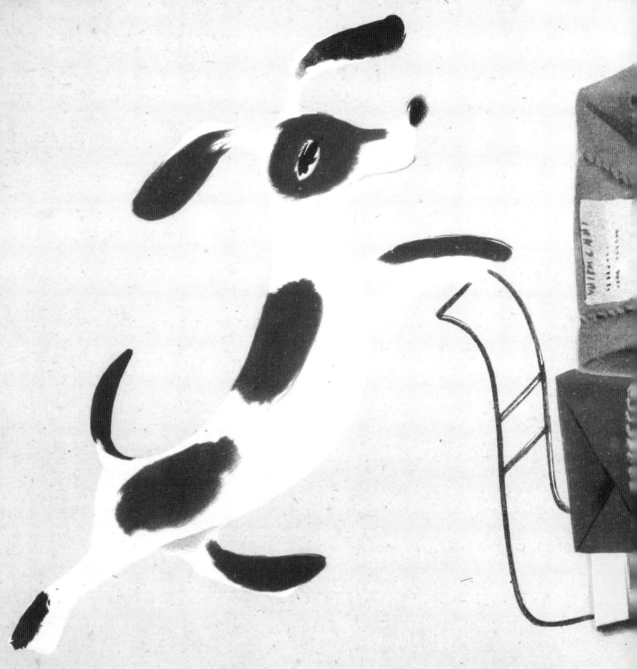

YOUR CHRISTMAS PA[RCEL]

SHOULD BE POST[ED]

KETS & PARCELS

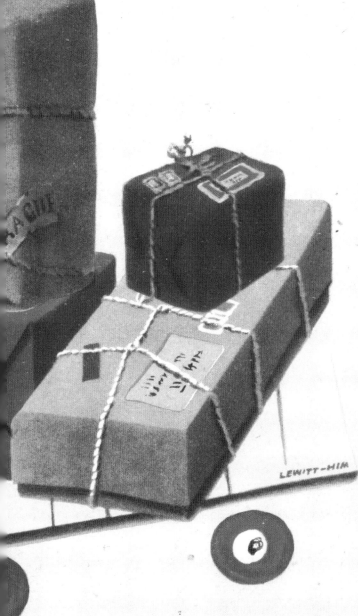

LEWITT-HIM

BY DEC. 18

OFFICE

PRINTED FOR H.M. STATIONERY OFFICE BY JAMES HAWORTH & BROTHER LTD., LONDON (51/2088)

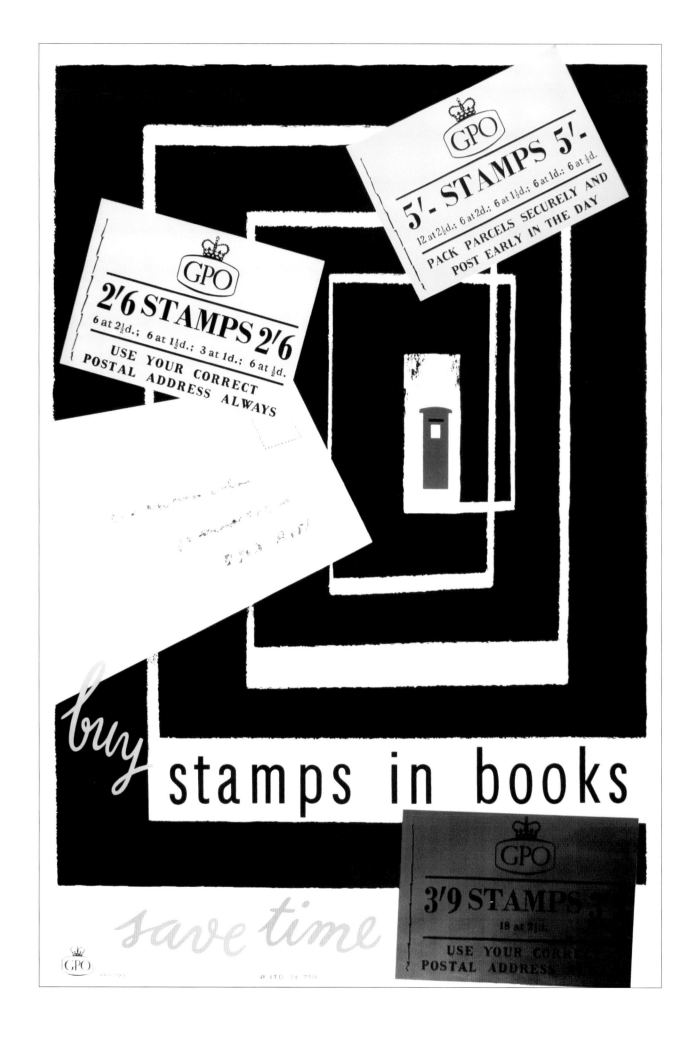

Nowadays, much of the Post Office public relations work has been displaced into the work of postage stamp design. The liberalisation of stamp design began in the 1960s and has become a significant part of British visual culture at the end of the twentieth century.

The GPO Film Unit continued the work begun at the EMB. Amongst the films made was Henry Watt and Basil Wright's remarkable story of the night-time travelling post office service between London and Glasgow. The film was called *Night Mail*, 1936, and incorporated a verse commentary by WH Auden and a musical score by Benjamin Britten. Later, the Unit produced avant-garde short films by Len Lye and others. The specific difficulties of stamp design were addressed in the short documentary film *The King's Stamp*, 1935, directed by William Coldstream. Co-incidentally, the film features Barnett Freedman as the designer of the stamp.

Kenneth Clark had hoped to help the GPO by encouraging artists to engage with various aspects of national life and to find a wider range of subjects than the traditional landscape, portrait and still-life. Clark's scheme produced some exciting projects for the GPO. Generally though, the GPO and the artists remained slightly wary of each other. It was only later, in the more urgent and heightened circumstances of World War Two, that Clark's ideas bore fruit.

Stephen Tallents became Director of Public Relations at the BBC in 1933. He left behind him a series of structures and systems that assured the continuity of GPO advertising for the next 30 years. The ability and willingness of Tallents to delegate within a system is one of the characteristics that distinguish his contribution to patronage. As organisations became bigger, and as their activities became more complex, it was increasingly important to establish clear guidelines for the principles of the organisation's work. This became especially important during World War Two when issues of consistency and clarity became attached to those of national survival. In addition, Tallents should be acknowledged as a pioneer of film and moving image. The willingness to embrace technology and to use it creatively to promote the organisation was, within the civil service at least, remarkable.

buy stamps in books, HA Rothholz, 1955, DC (30 x 20"), General Post Office.

JACK BEDDINGTON

Jack Beddington (1893–1959) was invited to advise the Poster Committee of the GPO in his capacity as Publicity Manager of Shell Mex and British Petroleum Ltd (BP).

Beddington had come to publicity and public relations almost by accident. Like Frank Pick many years earlier, he had been rewarded with responsibility for publicity after expressing forthright criticism of the existing efforts in that domain.

Shell had already, in the course of the 1920s, established themselves as a commercial enterprise with global reach. Their efforts in trading, oil exploration and refining remained mostly hidden from the public. Conversely, their presence in garage forecourts and in the rapidly developing world of motoring had made them a familiar name.

The glamour of motoring made it attractive to a wider public. The beginnings of mass-market motoring, during the 1920s, also gave many more people access to the countryside. Cultural conservatives tried to resist the new mechanical phenomenon by contesting the ribbon development and billboard advertising associated with the new road network. It was against this background of cultural conservatism that Beddington was invited to develop Shell's publicity and public relations.

Jack Beddington came from a very well connected family with wide ranging cultural interests. He was, accordingly, able to direct work towards promising artists and designers.

The posters produced during the 1930s, as part of the Shell campaign, are probably the most consistent examples of the integration of art and design in Britain. In part, this is a reflection of Shell's relatively limited objectives in relation to advertising. These objectives were further circumscribed by Shell's decision to display their posters responsibly. In practical terms, this limited their advertising to the sides of delivery lorries and to the spaces adjacent to their service stations.

Beddington orchestrated the campaign around his interests in fine art, film and literature. The poster campaign was organised into two major groups. The first, and by far the most extensive, group of posters were those featuring landmarks. These posters were landscape format and showed architectural follies, landmarks and views. These subjects gave British artists every chance to play to their strengths.

From the mid-1930s onwards, the landmark posters were complemented by the publication of Shell County Guides. The editor of the guides was John Betjeman. John Piper and Paul Nash were contributors to the early development of the series.

In addition to the landmark posters, Beddington also commissioned a second series of posters that presented the various users of Shell petrol. These images were collected under the rubric of conchophiles (shell lovers) and gave artists and designers a slightly more open brief.

The Neo-Romantic movement flourished in Britain between about 1933 and 1953. The origins of the movement are a consequence of the environmental catastrophe of World War One. The blighted landscape associated with the

BP Controls Horse-Power, Edward McKnight Kauffer, 1933, 30 x 45", Shell Mex & BP.

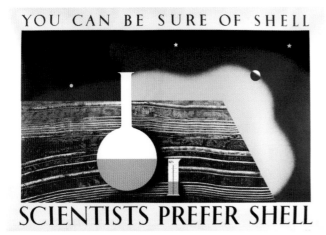

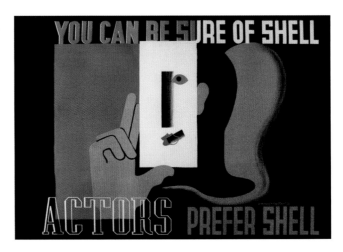

Western Front was understood to exemplify the destructive and alienating power of the war machine. In this context, the neo-romantics began to investigate ancient landscapes in which man and nature had co-existed in sustainable harmony.

For Paul Nash, the experience of World War One was traumatic. His first response to the war was to paint large-scale, retrospective and symbolic pictures of the northern French landscape. Upon his return to Britain, Nash was drawn to the ancient landscapes of Romney Marsh in Dorset, the ancient stone-circles of Wiltshire and the distinctive tree-topped hills of Wittenham Clumps. For Nash, these landscapes were both familiar and mysterious.

Paul Nash was amongst those artists and writers chosen by John Betjeman to prepare the famous Shell Guides at the end of the 1930s. Nash wrote about Dorset, John Piper about Oxfordshire, and Betjeman himself, about Cornwall.

The combination of antiquarian engagement with landscape and building with the evident interest in the found, accidental, haphazard and contingent provided a wide repertoire for those artists who rejected the austere simplifications and over intellectualisation of abstraction.

The landscape posters commissioned by Jack Beddington for Shell provided a space in which a neo-romantic engagement with the British landscape could flourish. Many artists and designers contributed fine images to the Shell campaign including Graham Sutherland and both Clifford and Rosemary Ellis.

In some ways, the emergence of neo-romanticism during the 1930s, alongside its more clearly modernist contemporaries, is evidence of how, in Britain, contradictory ideas could be held simultaneously. Both Paul Nash and Edward Kauffer were perfectly happy to work in both modern and romantic modes.

During World War Two, Neo-Romanticism became a powerful channel for the expression of feelings about national identity, landscape and history. In addition to painting, the movement also found outlets in the films of Michael Powell and Emeric Pressburger and in the poetic response to war as evidenced, for example, in Frederick Muller's *New Excursions into English Poetry*.

The synthesis between feeling and form, promoted by Nash in the 1930s, allowed for a modernism that, in Britain at least, became inflected by the small-scale, locale and ad-hoc. The rejection, amongst artists and writers, of the usual systemic associations of modernism led to forms of modernity based on garden sheds, village halls and beach huts. The traditional decorations of

Left *Scientists Prefer Shell*, Tom Eckersley and Eric Lombers, 1936, 30 x 45", Shell Mex & BP.

Right *Actors Prefer Shell*, Edward McKnight Kauffer, 1933, 30 x 45", Shell Mex & BP.

Opposite top *The Rye Marshes*, Paul Nash, 1932, 30 x 45", Shell Mex & BP.

Opposite bottom *Brimham Rock*, Graham Sutherland, 1937, 30 x 45", Shell Mex & BP.

EVERYWHERE YOU GO

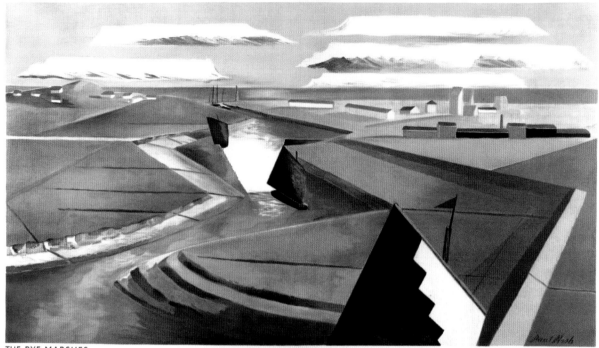

THE RYE MARSHES

PAUL NASH

YOU CAN BE SURE OF SHELL

TO VISIT BRITAIN'S LANDMARKS

BRIMHAM ROCK, YORKSHIRE

GRAHAM SUTHERLAND

YOU CAN BE SURE OF SHELL

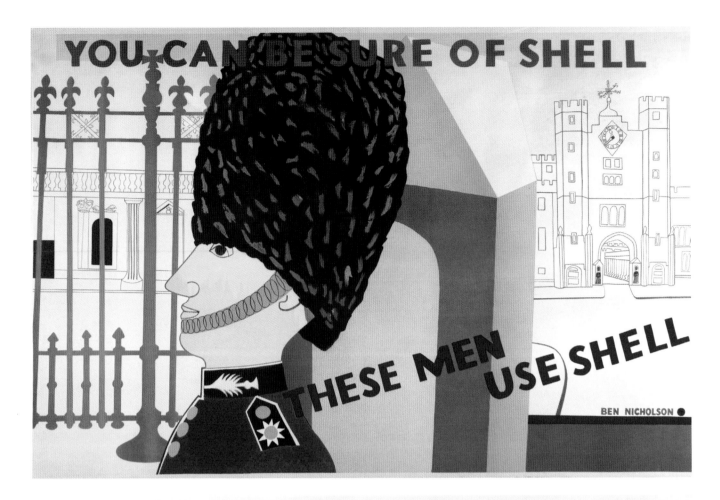

the village fete were, as a consequence, evident throughout the celebrations of peace, reconstruction and coronation. The relative artistic sophistication of these advertising images was also expressed in the black and white press advertising for Shell by Edward Bawden and Rex Whistler amongst others.

Beddington's instinct was to combine parts of what Frank Pick had achieved at the UERL with those successful elements of what Stephen Tallents had done at the EMB and, later, at the GPO. Accordingly, Beddington began to commission posters and print media advertising. In addition, Shell began to publish motoring guides and to make documentary films.

Jack Beddington's contribution to advertising and organisational public relations was, perhaps, not as detailed as Frank Pick's, nor as extensive and structural as that of Stephen Tallents. However, Beddington brought a sophistication and alignment of activities, across poster design, book publishing and film-making, that distinguished his contribution.

Beddington's enthusiasm for film provided him with a key role in the propaganda efforts of World War Two and helped to establish a new kind of film culture for moving image in Britain. The range and sophistication of his interests created a broad template, during the 1950s, for public service broadcasting.

Pick, Tallents and Beddington formed a triumvirate of patrons who, between them and across their various organisations, transformed the visual language of the poster. They made it possible, in practical terms, for the poster to communicate beyond the established rhetoric of advertising and to promote new forms of national life. It was precisely these kinds of communication, expressed as the 'illustrated war' that mythologised the egalitarianism of the Home Front in World War Two. As such, the trio transformed the activities of design management and patronage, each establishing clear principles for their activities which were systematic, coherent and consistent—that would later be associated with the emergence of corporate identity after World War Two.

Pick, Tallents and Beddington created a system of design patronage suitable for organisations of much larger scale and scope. The attachment of commercial values to those of social progress, and not merely convenience, along with the promotion of service and communication as benefits was entirely new.

The outbreak of World War Two made it a matter of urgency that effective communications should be established across the entire social spectrum. It was hardly surprising that Pick, Tallents and Beddington should be invited to contribute to this new government venture. In many ways, the new patrons established the template for the Ministry of Information.

Opposite top *These Men Use Shell—Guardsmen*, Ben Nicholson, 1938, 30 x 45", Shell Mex & BP.

Opposite bottom *Theatre-Goers Use Shell*, John Armstrong, 1938, 30 x 45", Shell Mex & BP.

MINISTRY OF INFORMATION

The formation of the Ministry of Information (MOI) in 1939 provided an administrative framework for the production of propaganda at both national and international levels. Pick, Tallents and Beddington were, by virtue of their experience, the senior figures in public relations in Britain. The chaotic atmosphere of the war proved uncomfortable for the three pioneers. The scale and urgency of war propaganda required a larger administrative framework than had been the case, even at London Transport, the GPO and Shell.

The experience of Pick, Tallents and Beddington had introduced issues of promotion and communication to large organisations. The publicity departments, within each of these organisations, began to systematise their relations so as to account for their actions and decisions.

The circumstances of war allowed the bureaucratic administration of the State to grow. The mobilisation of the entire military industrial complex, as part of Total War, required a great planning that balanced productive effort and efficiency. In order to maximise both of these, and as a means of assuring military victory, the State was allowed much greater scope in its relations with ordinary citizens. Accordingly, and as the scale and extent of the administration increased, communications became ever more important.

The administrative control of design management was a crucially important legacy of the Ministry. In the specific circumstances of post-war reconstruction and development, the administrative direction of information and communications became a priority.

This was especially the case in relation to the new areas of activity associated with the extension of welfare provision across the population. The scale and scope of all of these activities altered their form. The purpose of posters changed from presentation to information and communication. The implicit dialogue, between organisation and audience, was brokered through new forms of design.

In 1951, for example, the Festival of Britain provided a template for the integration of art, architecture and design into a single coherent expression of post-war reconstruction. The new environments made explicit the changes in society that devolved from the war and its political aftermath. The work of co-ordinating all of these activities became increasingly one of multi-disciplinary co-operation.

The creation of the Design Research Unit (DRU) in 1943 began the consolidation of design activities into larger, co-ordinated and multi-disciplinary studios. The scale and scope of opportunity for the DRU had begun to emerge during the late 1930s. Marcus Bramwell, managing director of Stuart's Advertising Agency, had already noticed that clients were increasingly asking the agency for work that was, strictly speaking, beyond the scope of advertising. The co-ordination of parts, for example, and the consistent expression through design of the organisation had become a concern following the successful examples of London Transport, the GPO and Shell, for smaller scale enterprise.

Herbert Read established the DRU in 1943 so as to take full advantage of the opportunities of post-war reconstruction. The DRU was subsequently able to make substantial contributions to the Britain Can Make It exhibition in 1946 and the Festival of Britain in 1951. The DRU was defined, to a very large extent,

Above *Mess-age*, FHK Henrion, 1962, DC (30 x 20"), Keep Britain Tidy.

Opposite *Please Keep Britain Tidy*, Reginald Mount, 1958, DC (30 x 20"), Keep Britain Tidy.

KEEP BRITAIN TIDY

 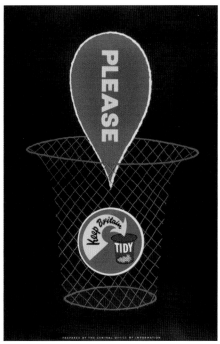 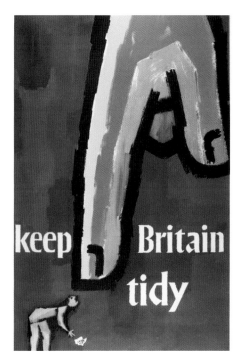

by the talents of Misha Black and Milner Gray. Both had been involved, in 1935, with the formation of the Industrial Design Partnership. Their direction led the DRU away from the relatively simple and uncomplicated production of posters.

The consolidation of creative enterprise into bigger, collaborative units was a response to the increasing complexity, in scale and scope, of design issues. The process of consolidation was also a reflection of the economic circumstances after 1945. In the context of post-war austerity, economies of scale had to be achieved through sharing resources.

The transformation of the MOI into the Central Office of Information (COI), in 1946, acknowledged that government communications would remain central to post-war planning.

The period of post-war austerity, during which the usual workings of consumerism practically collapsed, was superseded from about 1953 onwards with a period of accelerated consumption. This has continued, more-or-less continuously, until the present. The expansion of the consumer economy, through aggressive price-cutting and the wide availability of credit, has greatly increased the environmental impact of littering. The widespread use of plastics in packaging has simply compounded this problem. Nowadays, the problem is most evident on the verges of Britain's major roads.

From the late 1950s onwards, the COI produced posters to direct the public towards a more socially responsible approach to littering.

The Keep Britain Tidy campaign was first started as an initiative of the Womens' Institutes (WI). It is not surprising that the WI should be most alive to the associations between consumerism, waste and environmental degradation.

The campaign made use, over the years, of many of Britain's best poster designers. Abram Games, Tom Eckersley, Hans Unger and FHK Henrion each made distinctive contributions to this campaign.

Opposite *Keep Britain Tidy*, Royston Cooper, 1963, DC (30 x 20"), Keep Britain Tidy.

Left *Keep Britain Tidy*, Abram Games, 1963, DC (30 x 20"), Keep Britain Tidy.

Middle *Please Keep Britain Tidy*, Reginald Mount, 1959, DC (30 x 20"), Keep Britain Tidy.

Right *Keep Britain Tidy*, Hans Unger, 1962, DC (30 x 20"), Keep Britain Tidy.

It took a while for the consumer economy to expand to pre-war levels. The formation, in 1962, of Fletcher Forbes Gill marked the beginning of a new stage in graphic communication. This was associated with the explosion of consumerism across all of the developed economies of the world.

The social transformations of the 1960s created the opportunity for many new kinds of graphic communication. The enormous expansion of the university sector and the transformation of research, through the application of social science methodologies, into an ongoing and critical engagement with the structures and systems of society helped to create and support a wide-ranging counter-culture. The visual styles associated with these alternatives were quickly assimilated into the social and consumerist mainstreams of society through fashion, pop music and youth culture.

The emergence of Pop Art in the aftermath of World War Two reflected the transformations of social alignment in Britain that had resulted from the experience of World War Two. The social egalitarianism of the war and the promotion of social justice and meritocracy as post-war political objectives made it acceptable for artists and writers to look towards ordinary people.

The military victory against the massed ranks of totalitarianism was interpreted as a victory for liberalism and social democracy. In cultural terms, this was taken to imply a rejection of the conformity, neatness and "good taste" that had prevailed in British culture before World War Two.

The enormous and decisive impact of American troops during World War Two had left an indelible legacy of American popular culture. The established, mandarin class of cultural commentators usually interpreted the energy and hedonism implicit in the mass-market modernity of America as a powerful but insubstantial form of low culture. The explicit expression of this cultural snobbery made American consumer culture especially attractive to younger iconoclasts. It was not surprising that, in these circumstances, the young baby-boomers should look to America, and its abundant consumer culture, for their cultural references.

The Pop Art phenomenon was first conceptualised through the Independent Group and their meetings at the Institute of Contemporary Arts (ICA). In 1952, the artist and sculptor Eduardo Paolozzi showed a series of collage images made from scraps of popular American magazines. The ICA was founded, in 1946, by Peter Watson, Herbert Read, Roland Penrose, Geoffrey Grigson and ELT Mesens. The venue was conceptualised so as to provide a location for the discussion of modern art and the ideas behind it. The early period of the ICA was influenced, by virtue of the personalities behind it, in the direction of the Surrealist and Mass Observation movements of the 1930s.

The Independent Group comprised a diverse group of artists, writers and architects. The best known amongst them are Paolozzi, Richard Hamilton, Rayner Banham, Lawrence Alloway, Nigel Henderson and both Alison and Peter Smithson. The art critic Lawrence Alloway chaired a series of meetings in which the impact of mass culture began to be appraised. Nowadays we are completely comfortable with the idea that both high and low culture can be legitimately and seriously investigated. In the 1950s in Britain, the critical framework was still dominated by the ideas of John Ruskin, William Morris and Roger Fry. The pioneering efforts of the Frankfurt School, based

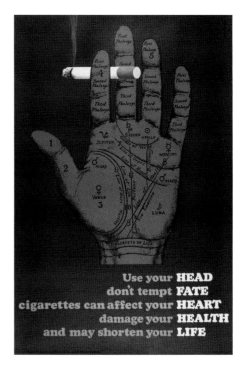

Above *Use your HEAD*, Reginald Mount and Eileen Evans, 1960s, DC (30 x 20"), Department of Health.

Opposite *Don't Ask A Man To Drink And Drive*, Anon., 1960s, DC (30 x 20"), Department of Transport.

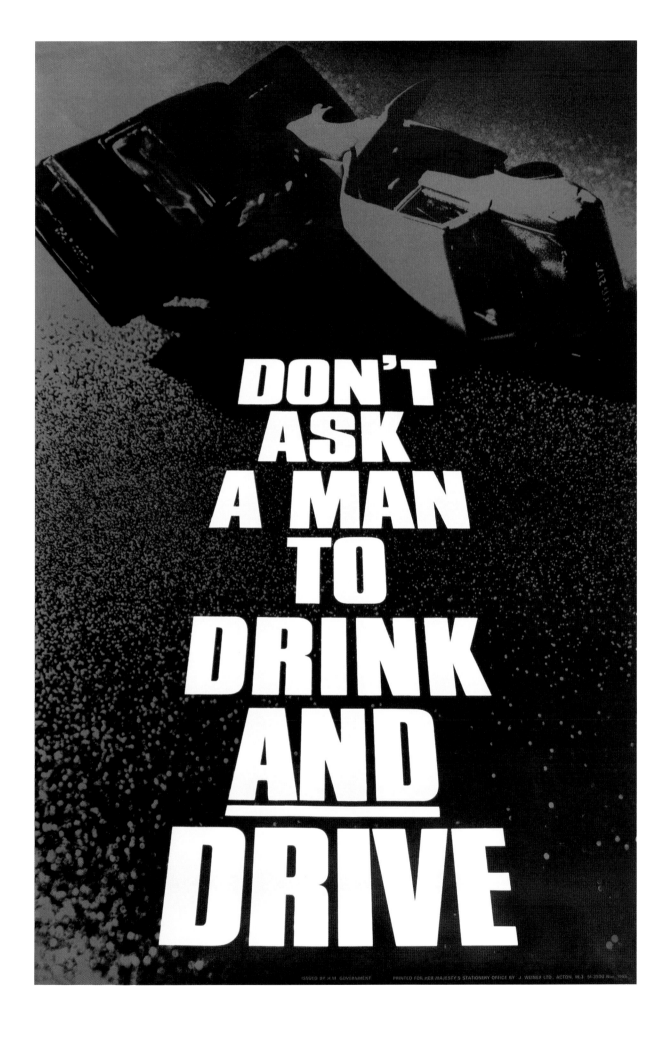

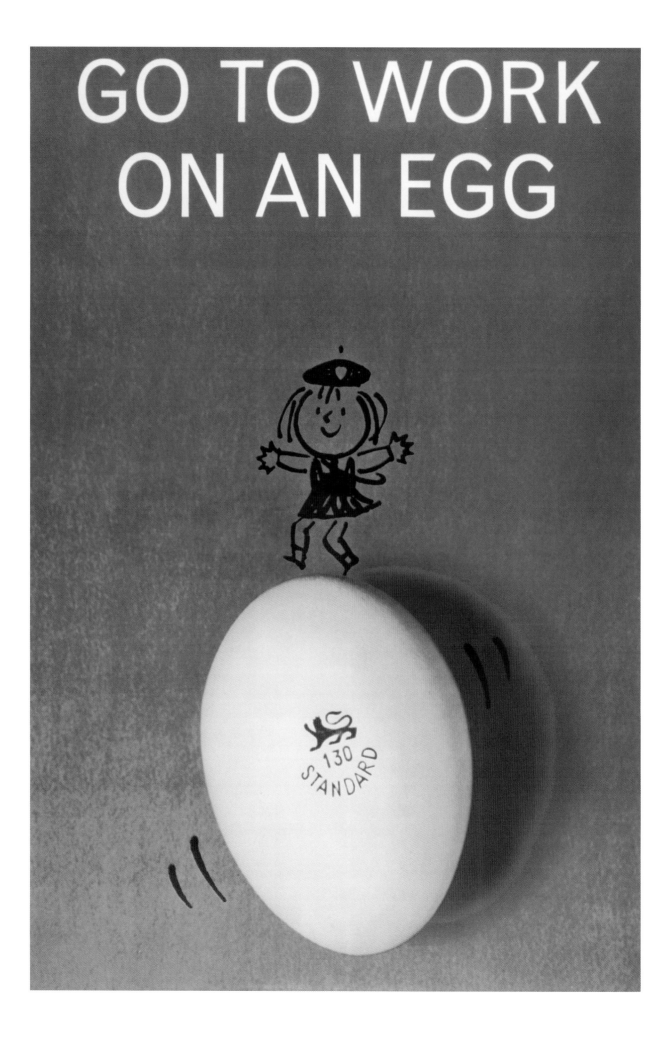

on an understanding of aesthetics, sociology and ideology, remained largely unknown. The ICA project was an attempt to elaborate these tools and introduce them to Britain.

The ICA produced posters, catalogues and invitations for its events. FHK Henrion designed many of these objects. The association with the ICA had introduced Henrion to a range of ideas beyond those usually associated with the integrated design systems of corporate identity.

FHK Henrion was a German émigré who had worked as a textile, exhibition and poster designer in France during the 1930s. During World War Two, Henrion worked as an exhibition designer for the Ministry of Information and produced many posters for Home Front and cultural propaganda.

After the war, it was natural that Henrion should associate himself with the European design movement and alignments of consistency and rationalism that it promoted. Nevertheless, his work for the ICA and the posters he designed for London Transport clearly anticipate the psychologically diverse realities of 1960s London. The swinging sixties began in 1956 with the exhibition, at the Whitechapel Art Gallery, entitled This is Tomorrow.

At the Royal College of Art, Pop Art was an opportunity to look at the less controlled environments of popular entertainments as an alternative to the workshops and laboratories associated with scientific and design progress. The result was an eclectic mixture of typographic styles presented in the 'rough and ready'. The willingness to abandon the standard finessing of art school crafts traditions laid the foundations for the explosion of pop culture during the 1960s and of Punk in the 1970s.

The proliferation of media channels available to advertisers and communicators inevitably reduced the significance of the poster. A great many advertising and information messages migrated to television and magazines. The cultural significance of the poster retreated, but the activities of graphic design and communication were massively extended.

Above *towards art?*, David Hockney, 1962, DC (30 x 20"), Royal College of Art.

Opposite *Go To Work On An Egg*, Ogilvy, Benson & Mather, 1960s, DC (30 x 20"), British Egg Marketing Board.

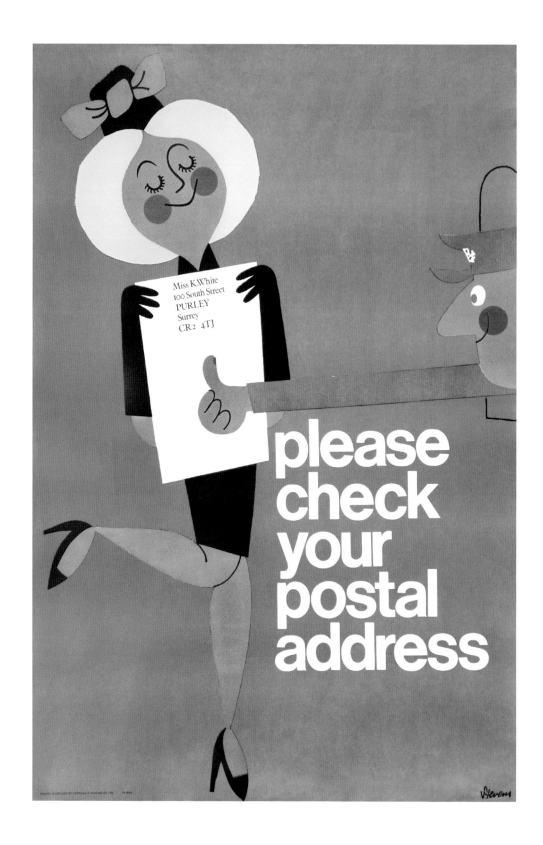

Above *please check your postal address*, Stevens, 1960s, DC (30 x 20"), General Post Office.

Opposite *Lunchtime*, Anon., 1967, DC (30 x 20"), Institute of Contemporary Arts.

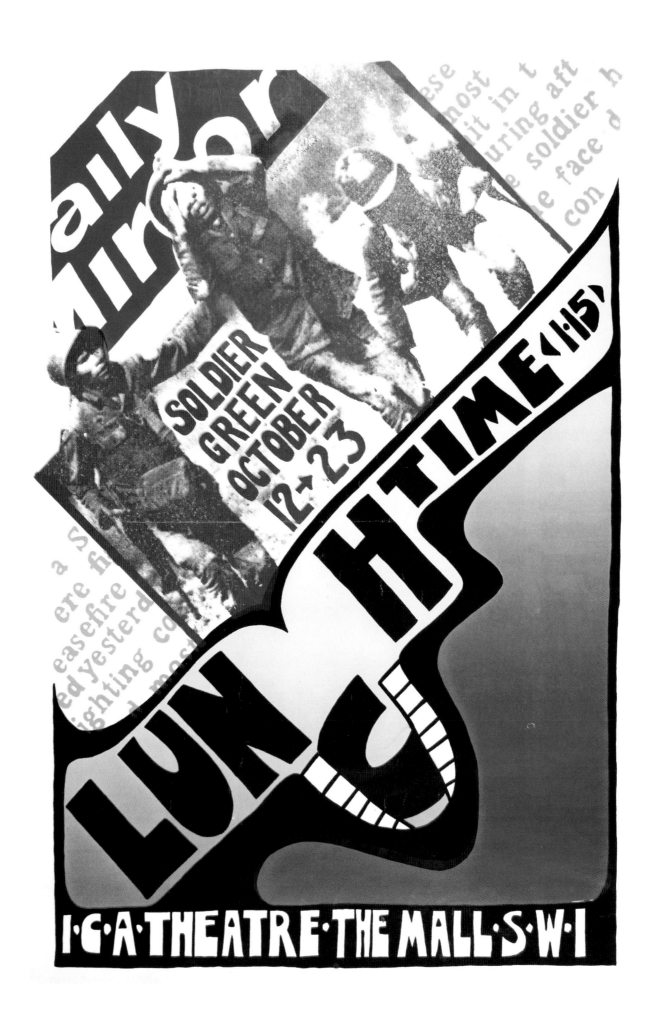

The networks of patronage allowed a wide variety of artists and designers to contribute to the evolution of the modern British poster. This chapter will introduce the major figures behind the visual development of the poster in Britain and briefly describe how these personalities succeed one another and how they introduce and combine ideas and techniques in poster design.

The crucial personalities in this regard are, Edward McKnight Kauffer, Paul Nash, Abram Games and Tom Eckersley. There are many other significant designers and they appear elsewhere in this story. At this stage, I want to show how each of these figures integrated new ideas into visual communication. These individuals combined, within the specific contexts of British modernity, to create a consistent and meaningful visual language.

EDWARD MCKNIGHT KAUFFER

The American artist and poster designer, Edward McKnight Kauffer (1890–1954), made a crucial contribution to design in Britain during the period before World War Two.

Kauffer was born into the relative isolation of the American mid-west. His precocious artistic talent first expressed itself through sketching and painting. In 1907, Kauffer joined an itinerant theatrical troupe as a kind of factotum with responsibilities extending from scenery painting, to sales and advertising. Kauffer was persuaded in 1910 to travel westward, to California, by an actor colleague and friend Frank Bacon. In San Francisco, Kauffer was introduced, through Bacon, to the artistic circle of the bookseller and art-dealer Paul Elder. It was whilst working in Elder's gallery that Kauffer met Professor Joseph McKnight, the Professor of Elementary Education at the University of Utah.

ART AND DESIGN OF THE MODERN POSTER

Winter Sale (detail), Edward McKnight Kauffer, 1919, 4S (60 x 40"), Derry & Toms.

WINTER SALE

McKnight quickly recognised Kauffer as a promising, but unformed, artistic talent and resolved to help. His motives appear to have been entirely generous and derived from a combination of religious conviction and belief in the transforming power of education. McKnight sponsored Kauffer, in 1912, to study in Chicago and to travel to Paris and in Europe to advance his artistic development. In gratitude, Kauffer changed his name to McKnight Kauffer.

Whilst in Chicago, McKnight Kauffer was able to visit the Armory Show, which after its notorious debut in New York, had travelled into the American heartland. The Armory Show introduced America to the major artistic developments of European painting and sculpture ranging from Eugène Delacroix to Marcel Duchamp and from Pablo Picasso and Georges Braque to Vassily Kandinsky.

The response to the show amongst McKnight Kauffer's colleagues in Chicago was one of cultural outrage. For McKnight Kauffer, and based on what he had seen at the Armory Show, Europe offered a compelling combination of artistic ferment and advanced cultural tolerance. In 1913 he travelled to Europe, where his itinerary took him to Venice, Munich and Paris. In the end, his stay

Left *El Progreso* cotton label, Edward McKnight Kauffer, 1916–1928, 6 x 4", Steinthal & Co..

Right *El Valle* cotton label, Edward McKnight Kauffer, 1916–1928, 6 x 4", Steinthal & Co..

REGISTERED TRADE MARK NO. 136959.

in Paris was curtailed by the beginning of World War One. In 1914, McKnight Kauffer moved to London, expecting to return to America without delay.

A combination of factors made Britain seem especially attractive to McKnight Kauffer. The general cultural atmosphere in London was more advanced and adventurous than in Chicago whilst, at the same time, appearing less obviously intimidating than that which he had encountered in Munich and Paris.

McKnight Kauffer resolved to commit himself to an artistic career in Britain and to stay, by his own efforts, for as long as possible. His interest in both landscape painting and formal experiment allowed him to join both Roger Fry's Bloomsbury group and the more obviously avant-garde grouping of Vorticist artists around Wyndham Lewis.

The response to McKnight Kauffer's painting was not encouraging. In an effort to support himself he began to search out poster commissions and other design work. A meeting with John Hassall, in 1915, provided him with an introduction to Frank Pick. The circuitous route by which McKnight Kauffer and Pick came to meet is important because it describes the combination of influences that McKnight Kauffer brought to poster design after 1915. His

Left *Majestuoso* cotton label, Edward McKnight Kauffer, 1916–1928, 6 x 4", Steinthal & Co..

Right *Presidencial* cotton label, Edward McKnight Kauffer, 1916–1928, 6 x 4", Steinthal & Co..

CALLING YOU

AIR RAID PRECAUTIONS

A R P

GET IN TOUCH

WITH YOUR LOCAL COUNCIL

E McKnight Kauffer '38

Issued by the Air Raid Precautions Department, Home Office.

Printed for H.M. Stationery Office by Fosh & Cross Ltd., London. (51/1661)

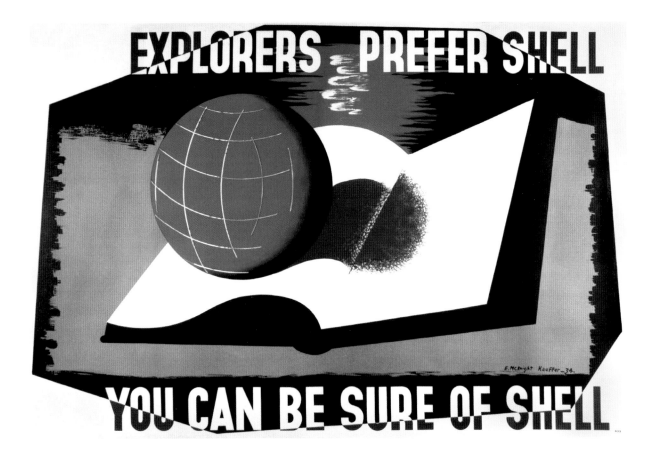

beginnings as a theatrical scenery painter, in America, provided him with a clear
sense of how scale, colour and simplification could be combined effectively.
In Europe, McKnight Kauffer immediately responded to the sophisticated
simplifications of Ludwig Hohlwein's poster designs in Munich. By the time
McKnight Kauffer reached Britain, he was familiar with a wide range of artistic
ideas from across Europe.

McKnight Kauffer's instinctive disposition towards the scale and drama of
the poster, along with his conceptual and artistic sophistication, was unusual
in Britain. The combination was attractive to Pick who, as a founder member
of the Design and Industries Association (DIA), was committed to improving
general standards of design. Pick immediately began to commission poster
designs from the young American. In the end, McKnight Kauffer and Pick
worked together until 1939.

McKnight Kauffer provided a new kind of bridge between the separate
worlds of fine art and poster design. The first artists to attempt poster design
had, typically, simply produced their usual work in poster form. McKnight Kauffer
was able, by temperament and opportunity, to develop a visual language that
synthesised a number of different visual elements from modern art into poster
design. By producing, over time, a coherent visual language that combined
colour, scale, abstraction, simplification, and integration, McKnight Kauffer was
able to advance the scope of poster communication beyond the prosaic demands
of the advertising industry. Suddenly, posters appeared bigger and brighter and
more audacious.

Opposite *ARP*, Edward McKnight Kauffer, 1938, DC (30 x 20"),
Air Raid Precautions Department, Home Office.
Above *Explorers Prefer Shell*, Edward McKnight Kauffer, 1934, 30 x 45", Shell Mex & BP.

New Shell Lubricating Oils, Edward McKnight Kauffer, 1937, 30 x 45", Shell Mex & BP.

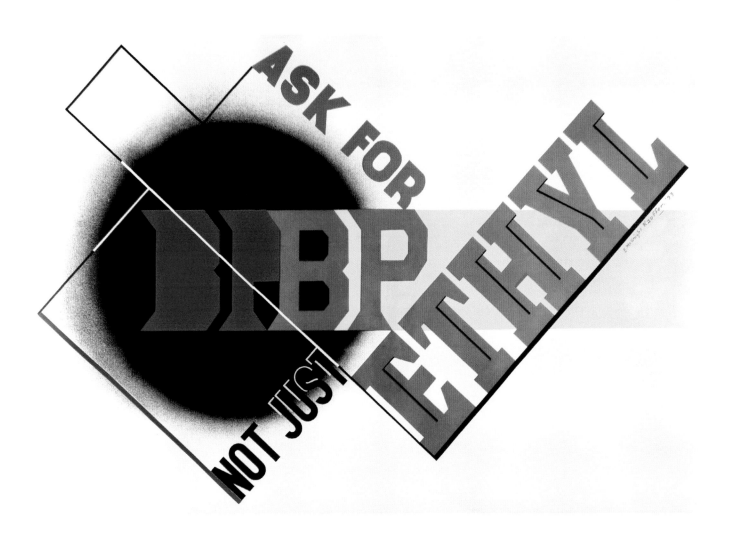

Ask For BP Not Just Ethyl, Edward McKnight Kauffer, 1933, 30 x 45", Shell Mex & BP.

In 1924, McKnight Kauffer wrote *Art of the Poster*, an important book that established the historical and aesthetic developments that defined the modern poster. This intelligent and rigorous engagement with the activities of graphic design began to establish a new standard of professionalism and conceptual sophistication for the industry.

During the 1920s and 30s McKnight Kauffer established himself as the most important poster and graphic designer in Britain. He worked for Frank Pick and Stephen Tallents at the Post Office and for many other clients. McKnight Kauffer forged an especially productive relationship with the sophisticated Jack Beddington of Shell. A more-or-less continuous stream of Kauffer posters contributed to the Shell campaigns from 1929 onwards. The posters show the constant experiment and range of influences that drove McKnight Kauffer onwards.

In addition to the consistent patronage offered him by these figures, McKnight Kauffer was also helped by the support of Peter Gregory, a director of the printing firm Lund Humphries. The printers were also the publishers of *The Penrose Annual*. The book was the trade annual in which were combined writings and examples of technical innovation, aesthetic experiment and cultural engagement. Gregory was conscious of the relationship between modern technological development in the print industry and the opportunity for new forms of visual communication. Lund Humphries positioned themselves, within the print industry, as pioneers of both technological development and innovation and also of design and visual invention. In practical terms, this meant attempting to understand how photographic elements could be integrated into the existing visual language of the print economy.

In order to drive this project forward, Gregory gave McKnight Kauffer a studio at the firm's London offices in Bedford Square. With the resources of the printing firm behind him, the studio became a kind of visual laboratory. The space was a bigger and more collective environment in which to work. The implicit direction, across every activity of the studio and its resources, was towards experimentation and problem-solving in creative design. The offices also included a gallery space where exhibitions of international and new work were presented to the public. These spaces became, by the end of the 1930s, the main entry point for émigré artists and designers into London's creative economy.

By the 1930s, McKnight Kauffer had become established, by reputation and work, as the major modernist designer in Britain. His work for Shell provided him with a direct association with one of Britain's largest companies. The campaign was understood as the most sophisticated of artistic advertising and the work was seen and recognised at local and international level. In addition, his studio at Lund Humphries became the starting point for a dialogue, with other designers, about efforts to integrate Surrealist and photographic elements into the visual repertoire of poster design.

The Tower Of London, Edward McKnight Kauffer, 1934, DR (40 x 25"), London Transport.

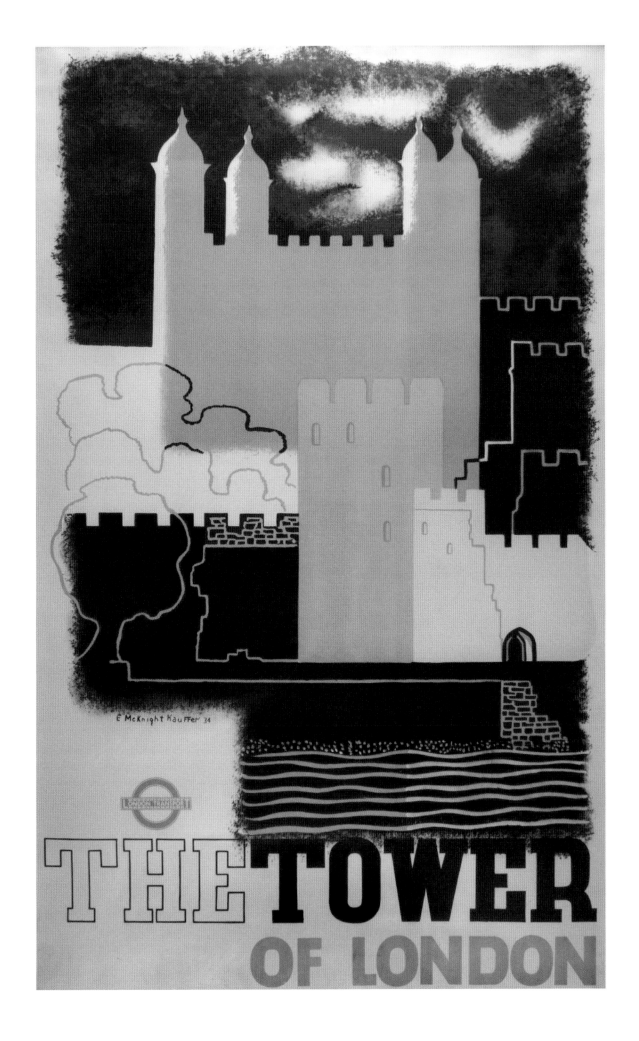

PAUL NASH

The traumatic human and environmental legacy of World War One was a powerful creative force for the artist Paul Nash (1889–1946). In the first instance, Nash created a series of large retrospective paintings of the battlefields. These paintings were not simply topographical, they were symbolic representations of deep feelings of anger, trauma and desolation. The effect on Nash, of producing these paintings, was far from therapeutic. In these circumstances, and against a backdrop of economic crisis, Nash began to teach at the Royal College of Art and to practice across a range of activities beyond painting.

Nash quickly established himself as a very significant and able artist designer. By the 1930s, he was amongst the best of poster designers, working for London Transport and Shell. In addition to posters, Nash made book illustrations, pattern papers, glass, ceramic decoration and textiles, and even designed a bathroom for the celebrity actress Tilly Losch. It was inevitable, given Nash's interest in symbolism and the complex psychological reaction to World War One, that the artist should be drawn to the emerging potential of Surrealism.

The exact and detailed origins of Surrealism are complex. For the purposes of our study, we need only acknowledge that Surrealism provided a powerful range of new visual symbols derived from psychology and psychoanalysis.

The range of Surrealist imagery greatly extended the visual possibilities and meanings of the modern poster. Suddenly, visual context was understood as aspirationally meaningful rather than simply as a means of locating and identifying a product or service. This additional range of meaning allowed the poster to address broader and more allusive themes of communication than before. The landscape poster, a staple of the travel industry, was transformed from a representation of a specific view into the representation of complex feelings associated with place. This was especially useful to Jack Beddington's advertising campaign for Shell, which combined posters and guidebooks in a projection of antiquarian sensibility to buildings and landscapes.

The Surrealist movement in Britain was responsible for a number of significant contributions to the wider cultural picture of Britain between the wars. The first was a direct consequence of the link with continental intellectuals in Paris and beyond. The Surrealist exhibition of 1936, at Burlington House, London, caused a sensation. The number of visitors recorded was over 23,000 in total. Public interest in the relatively complex ideas associated with Surrealism was even more widespread and revealed a popular intellectual curiosity that confounded the cultural and political establishment.

The success of the exhibition was interpreted, in part at least, as evidence of a growing dislocation between the establishment class and the wider population with its affiliations to popular-front politics and dangerous continental ideas.

The formation of Mass Observation, in 1937, was an attempt to connect with and record the views of the wider population. Mass Observation was formed by the social anthropologist Tom Harrisson, the poet Charles Madge, and the poet, artist and filmmaker, Humphrey Jennings. Mass Observation played a crucial role in mobilising the voice of popular-front politics in Britain. At first this was expressed as widespread solidarity for the Spanish Republicans. Later and in the context of World War Two, this manifested itself

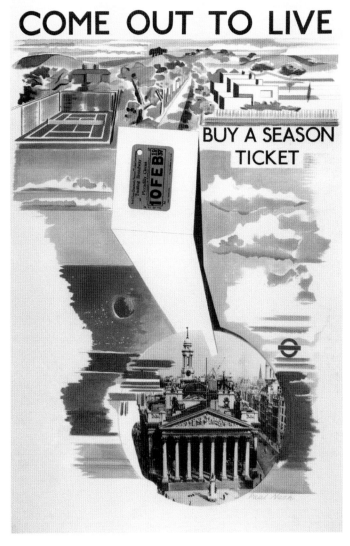

Left *Come In To Play*, Paul Nash, 1936, DR (40 x 25"), London Transport.

Right *Come Out To Live*, Paul Nash, 1936, DR (40 x 25"), London Transport.

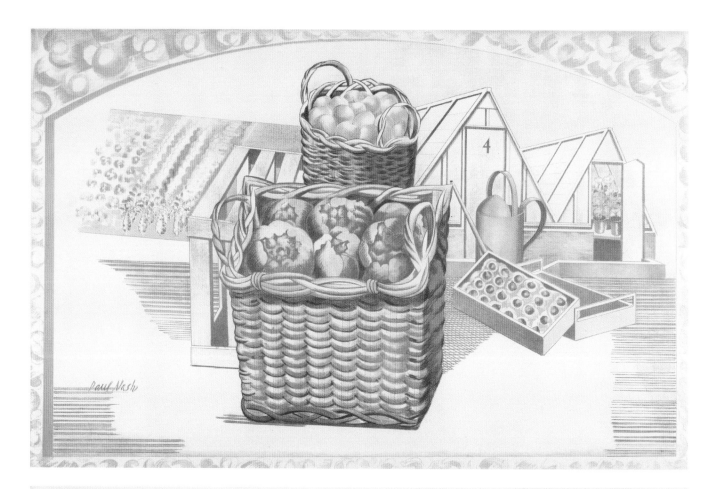

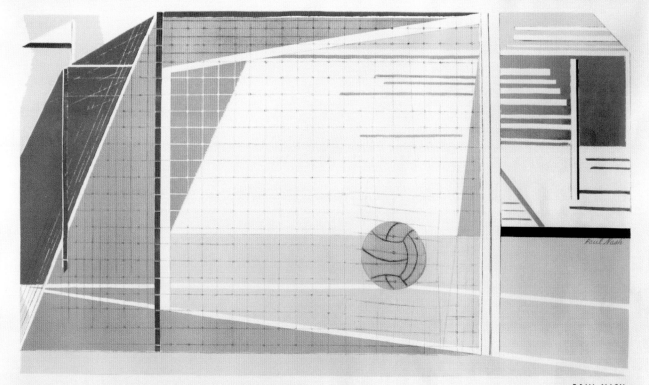

as a desire to attach issues of social justice to post-war reconstruction and to those of military war aims.

One of the most significant expressions of British Surrealism was the formation, in 1933, of Unit One, founded by artists Paul Nash and Ben Nicholson. The group expanded to include the sculptors Henry Moore and Barbara Hepworth and the architects Wells Coates and Colin Lucas, as well as artists John Armstrong, John Bigge, Edward Burra, Tristram Hillier and Edward Wadsworth. Beyond the influence of the founders, the group reflected the intellectual influence of Herbert Read who was introduced by Henry Moore. Read was a poet, writer and critic who, in the early 1930s, was developing an understanding of modernity as an increasingly intertextual experience. The combination of artists, sculptors and architects within Unit One anticipated the post-war integrations of art, architecture and design promoted through the Festival of Britain in 1951.

The range of personalities associated with Unit One make the group difficult to categorise. The original ambition of the founders had been to unify the two great currents of modern art, abstraction and Surrealism. This objective remained beyond the relatively short-lived group. The group seems, with hindsight, less coherent and more eclectic than suggested by either Nash or Read. Indeed, even amongst those artists with a Surrealist tendency towards imaginative figuration there was a clear divide between those willing to attach the label Surrealist to themselves and those who refused. Each of the artists associated with Unit One, except for John Bigge, was able to further this project through the patronage of Frank Pick at London Transport and Jack Beddington at Shell.

Nash's influence extends far beyond the individual paintings, objects and posters that he produced. As a teacher, he influenced a generation of artists who were his students at the Royal College of Art. As a writer and intellectual, Nash was at the forefront of efforts to introduce complex ideas associated with abstraction, Surrealism and modernity and to make them intelligible within a British context. Nash's ability to synthesise opposing ideas helped to create a modernist environment, in Britain, distinguished by humane scale and values.

Visual representation has always been both literal and symbolic. So, the Surrealists cannot claim to have invented this semiotic distinction between appearance and meaning. However, they greatly extended the range of available symbols by providing a context in which objects could be representative of feelings, both darker and more complex, than previously acknowledged.

In terms of the poster, the Surrealists established the connection between objects (products) and the psychological feelings of pleasure, desire and anxiety. The psychoanalytical association between desire and anxiety, theorised by Sigmund Freud, became the means of unifying the more basic instincts of fear and greed. Not surprisingly, the advertising industry was quick to embrace Surrealist techniques of juxtaposition, association and transformation.

Opposite top *Market Gardens*, Paul Nash, 1930, DC (20 x 30"), Empire Marketing Board.

Opposite bottom *Footballers Prefer Shell*, Paul Nash, 1932, 30 x 45", Shell Mex & BP.

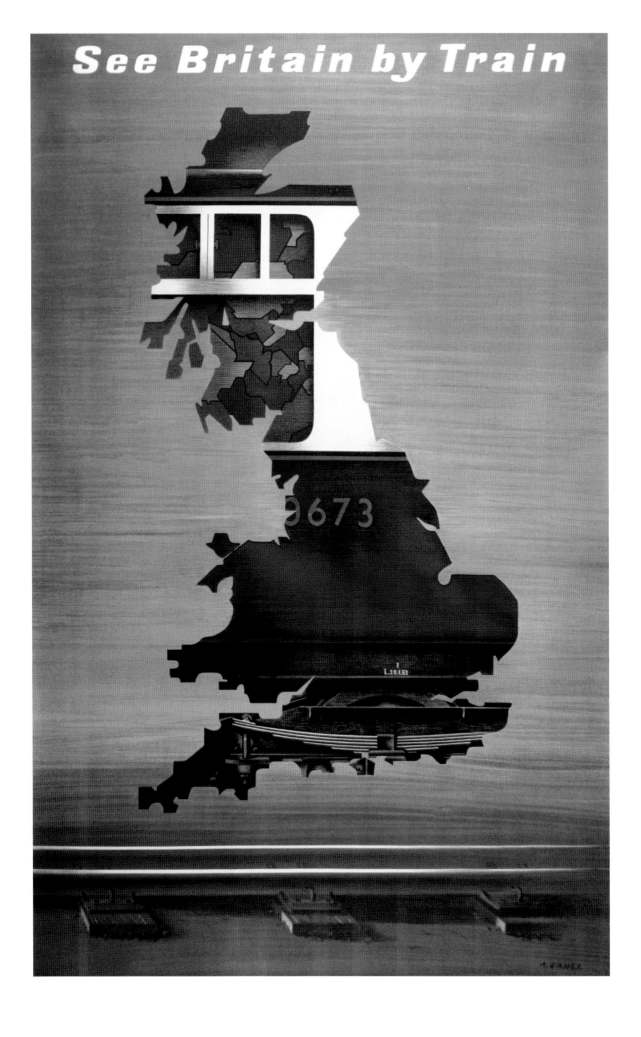

ABRAM GAMES

The advent of World War Two transformed the context of graphic communication. In the first instance, the scale and scope of Total War required all kinds of messages associated with the urgency of the situation and the implementation of military discipline.

The first stages of the war were chaotic. The retreat from Dunkirk produced a context in which the army became a defensive force. The loss of military equipment had to be restored and training given so as to better prepare soldiers for future conflict. These more static military environments provided a context in which communication and military education were prioritised.

Abram Games (1914–1996) was the designer who made the biggest contribution to the development of these new forms. Games began his career as a poster designer in the 1930s. He was quickly recognised as a poster artist with strong visual ideas and as a master of the airbrush. The desperate circumstances of war convinced Games that the military authorities required new forms of visual communication as a matter of urgency. His proposals, drafted as a memorandum with Jack Beddington, were accepted and Games was appointed Official War Office Poster Designer in 1941. The eventual promotion to the commissioned rank of Captain was an acknowledgement, by the military, of his contribution.

Throughout the war, Games produced a prodigious number of designs aimed at helping his fellow soldiers. Some of the messages are prosaic and deal with the practicalities of military life. Others are more idealistic and point to the political and democratic consequences of the war. In either case, Games always attempted to combine minimum means to maximum effect.

The desire for maximum efficiency, evident throughout the military, was visually expressed by Games in his technique of combining and synthesising several ideas. The procedure was an evolution of the Surrealist techniques of transformation that had been introduced to the visual language of poster design by Paul Nash. Generally though, Surrealist transformations were too allusive for the immediate military contexts of communication. So, Games combined transformation with visual simplification, based on the example of McKnight Kauffer. Games understood the visual impact of scaling, colour and simplification that McKnight Kauffer had introduced in the 1930s. The result was a new and powerful extension to the visual language and intellectual range of poster communication.

This was especially visible after 1940, when the circumstances of war began to allow for the expression of an extended set of war aims. These went beyond the military defeat of the enemy and attached themselves to the idealist themes of post-war reconstruction. These images articulate a future distinguished by social justice, meritocracy and egalitarianism.

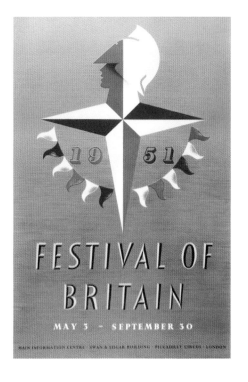

Opposite *See Britain by Train*, Abram Games, 1951, DR (40 x 25"), British Railways.

Above *Festival Of Britain*, Abram Games, 1951, DC (30 x 20"), Festival of Britain.

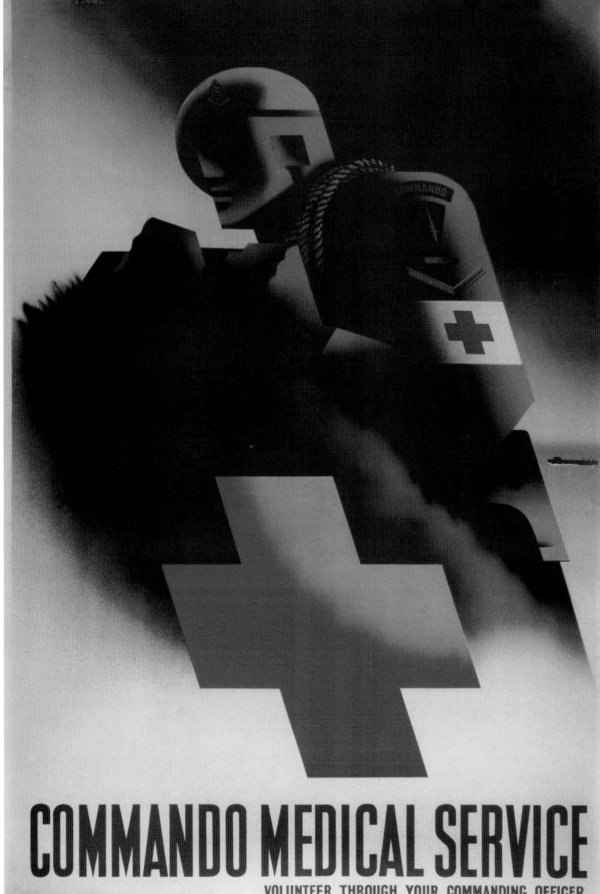

COMMANDO MEDICAL SERVICE

VOLUNTEER THROUGH YOUR COMMANDING OFFICER

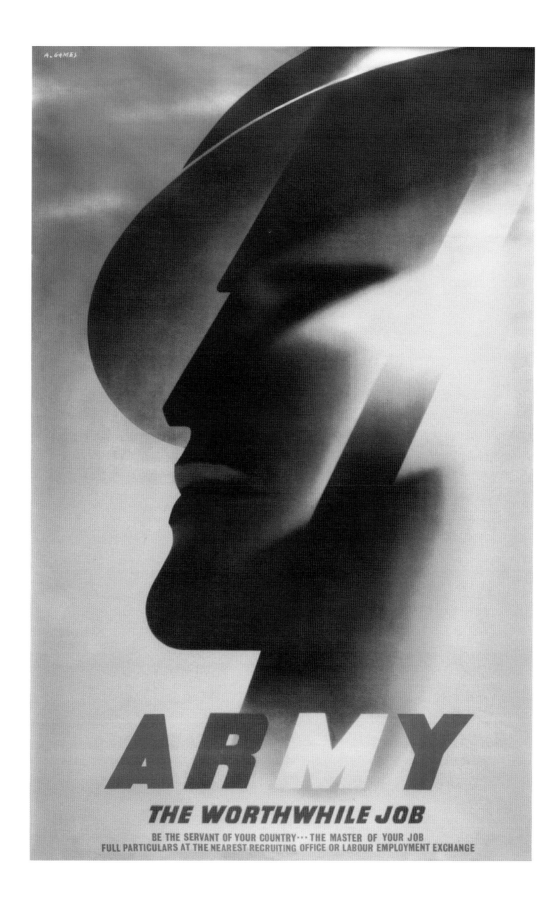

Opposite *Commando Medical Service*, Abram Games, 1945, DC (30 x 20"), War Office.

Above *ARMY*, Abram Games, 1946, DR (40 x 25"), War Office.

Overleaf left *at London's Service (Bowing Ticket)*, Abram Games, 1947, DR (40 x 25"), London Transport.

Overleaf right *at London's Service (Bowing Roundel)*, Abram Games, 1947, DR (40 x 25"), London Transport.

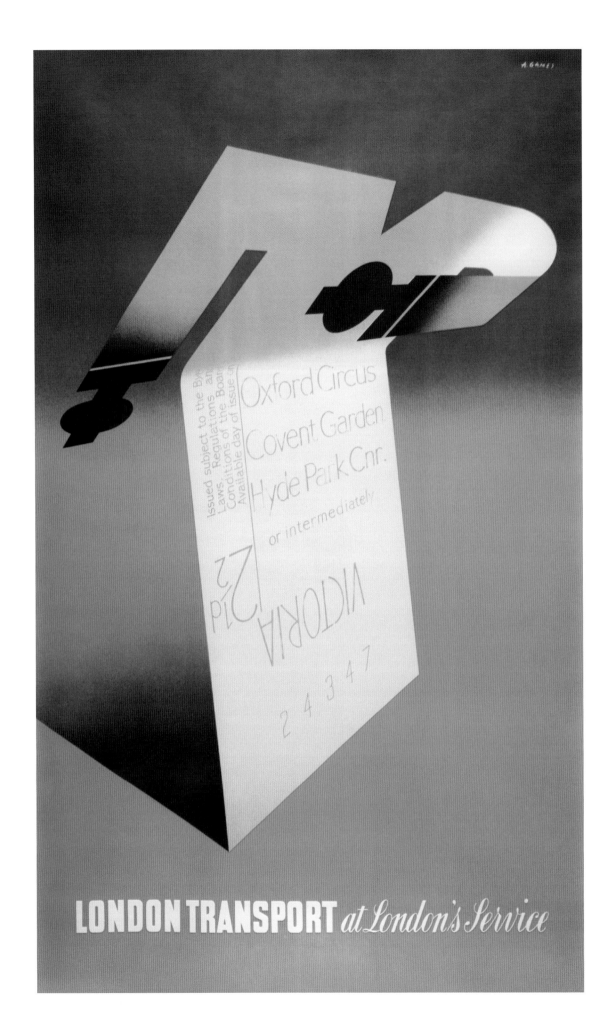

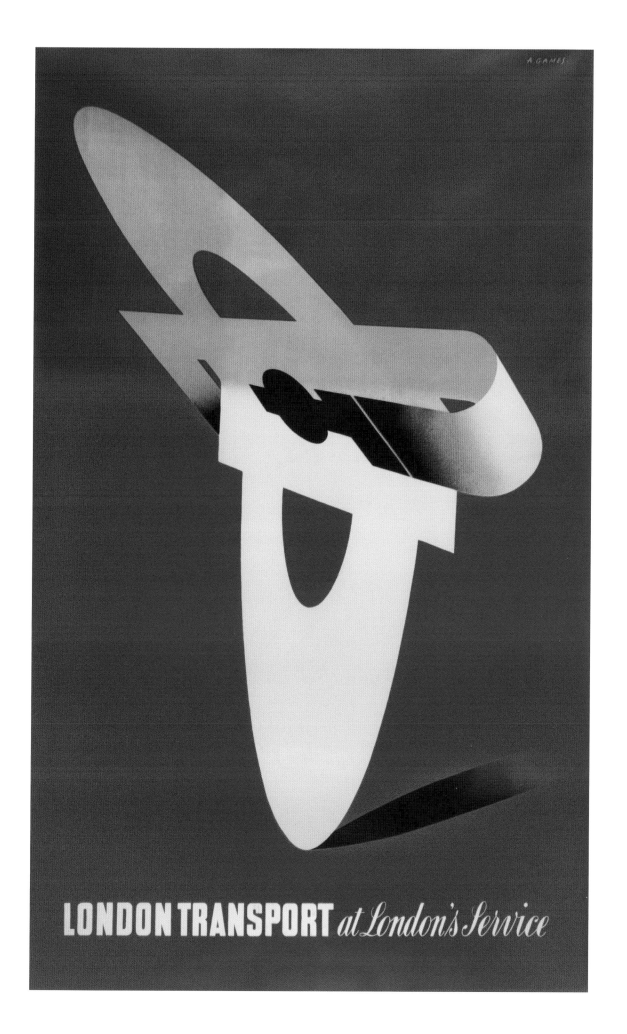

LONDON TRANSPORT *at London's Service*

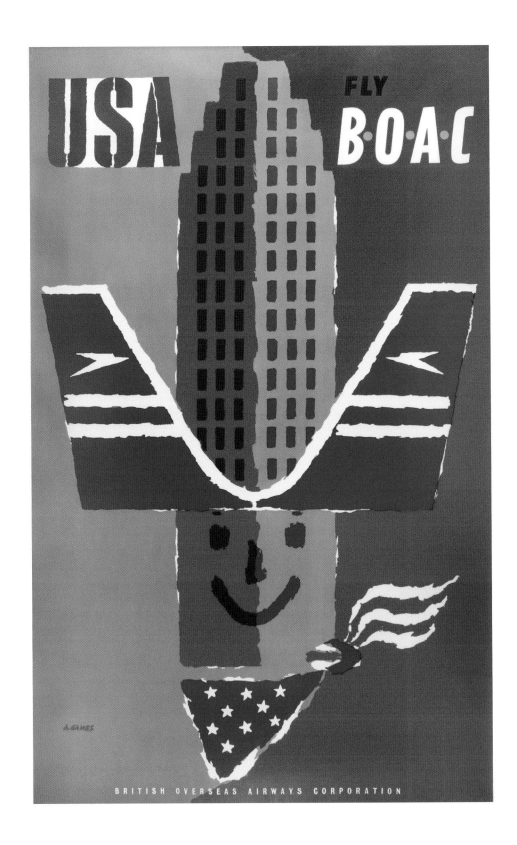

Above *USA—Fly BOAC*, Abram Games, 1959, DR (40 x 25"), British Overseas Airways Corporation.

Opposite *BOAC Flies To All Six Continents* (detail), Abram Games, 1956, DC (30 x 20"),

British Overseas Airways Corporation.

B·O·A·C FLIES TO ALL SIX CONTINENTS

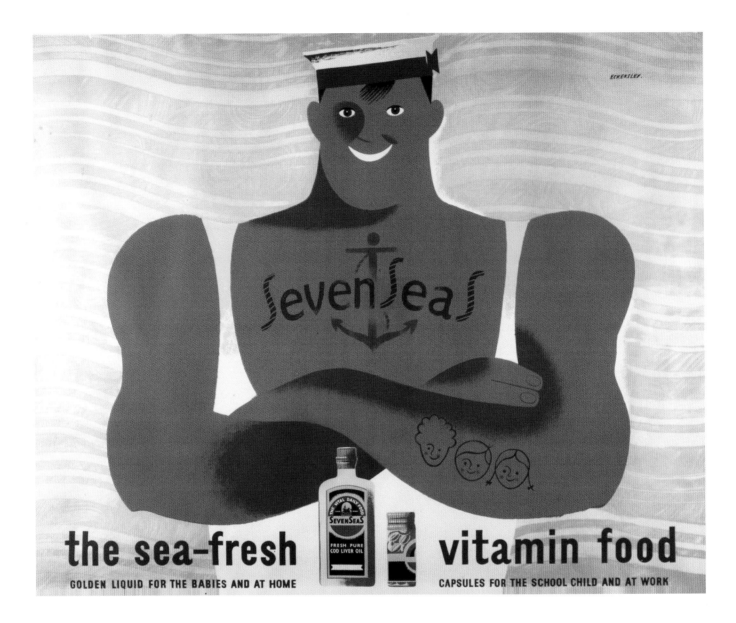

TOM ECKERSLEY

Abram Games and Tom Eckersley (1914–1997) were contemporaries. Eckersley was able, through the various opportunities of his long career, to make several distinct contributions to the development of graphic design in Britain. He was born into a nonconformist family in Manchester. As a young child, and perhaps because of the relative conditions of his upbringing, Eckersley was often unwell. His interest in drawing came, in part at least, as a benefit of this occupational therapy.

The combination of nonconformism, illness and art is not as unusual as it sounds. In the period before art education was widely available, a number of artists developed their first interest in drawing as a consequence of illness. The practicalities of that connection are relatively straightforward. It is more difficult to describe the connections between nonconformism and the development of design.

Above the sea-fresh vitamin food, Tom Eckersley, 1947, QC (30 x 40"), Seven Seas Cod Liver Oil.

Opposite mind that door, Tom Eckersley, 1960s, DR (40 x 25"), British Railways.

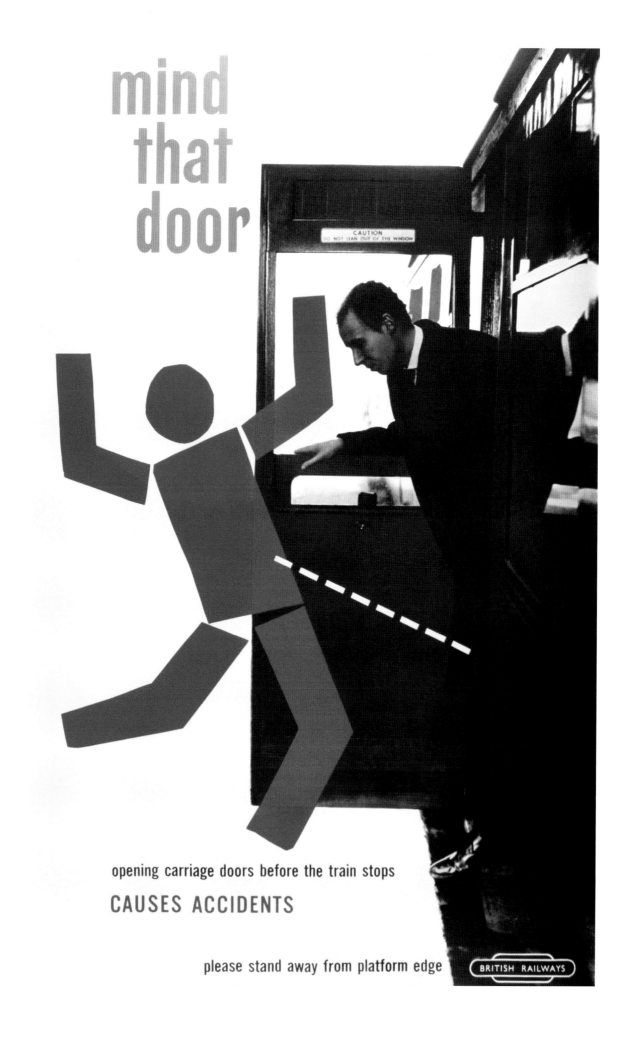

mind
that
door

opening carriage doors before the train stops

CAUSES ACCIDENTS

please stand away from platform edge

BRITISH RAILWAYS

The impact of émigré and continental designers is well-known. The contribution of British nonconformists is much less known. Philosophically speaking, it is possible to attach ideas about design to the protestant and nonconformist projects of redemption through work and the perfectibility of man.

Eckersley enjoyed a long and distinguished career in graphic design. Eckersley designed his first posters in 1935 and continued until 1995. If Eckersley had only designed posters his contribution would, by virtue of its longevity, have been remarkable. During World War Two, Eckersley designed a number of posters that helped extend the potential of graphic communication to issues of welfare and citizenship. After World War Two, he was amongst the first British designers to join the pan-European design network Alliance Graphique International (AGI). In addition to designing posters, Eckersley also made an important contribution to design education at the London College of Printing (LCP).

Eckersley attended Salford School of Art from 1930 to 1934 where he met Eric Lombers. The two began to design posters together and they were awarded the Heywood Medal at the school. Eckersley and Lombers quickly established themselves as poster designers in London. From 1935 onwards, they received a steady flow of commissions from the major patrons of poster art.

The advent of World War Two caused the design partnership to break up. Eckersley joined the RAF where his drawing skills were used in cartography. He found that he could visualise a poster design whilst drawing for the RAF and produce it whilst on leave. By this means he was able to fulfil various commissions.

Notwithstanding the extensive patronage of the 1930s, the outbreak of war created an immediate surge in demand for graphic design. The period of post-war economic austerity effectively reduced the size and scope of the design industry in Britain. For the duration, and because of rationing, the usual arrangements of the advertising economy were suspended. The end of the war and the economic austerity that followed actually caused the creative economy, as it was, to contract. It took a while for commercial demand, especially at home, to grow to previous levels.

It was not surprising, in these circumstances, that many designers moved into the less uncertain environments of technical education. Eckersley joined the London College of Printing in 1954 where he was instrumental in establishing the first course in graphic design. The term "graphic design" seems to have been first used, in Britain, by Richard Guyatt. The term was used to identify a new kind of design practice that combined the technical skills of typography and photography to supersede those associated with the craft skills of commercial art. The new educational environment re-cast McKnight Kauffer's studio at Lund Humphries as a kind of educational laboratory.

The physical proximity between photography and design at LCP facilitated the integration of photographic processes into design and make-ready. Suddenly, pre-production, make-ready and printing were distinguished by a consistent mechanical process devolving from photography. This was the creative methodology that forced the stylistic developments the 1960s and 70s and is exemplified by Saatchi's 'Pregnant Man' poster of 1969.

However, the old ways were not supplanted immediately. The process of mechanical reproduction only became an imperative once demand, within the

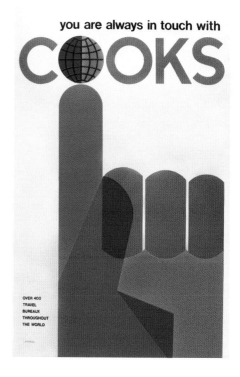

Opposite *Extension of the Piccadilly Line to Heathrow Airport,* Tom Eckersley, 1971, DR (40 x 25"), London Transport.
Above *Cooks,* Tom Eckersley, 1960s, DR (40 x 25"), Thomas Cook.

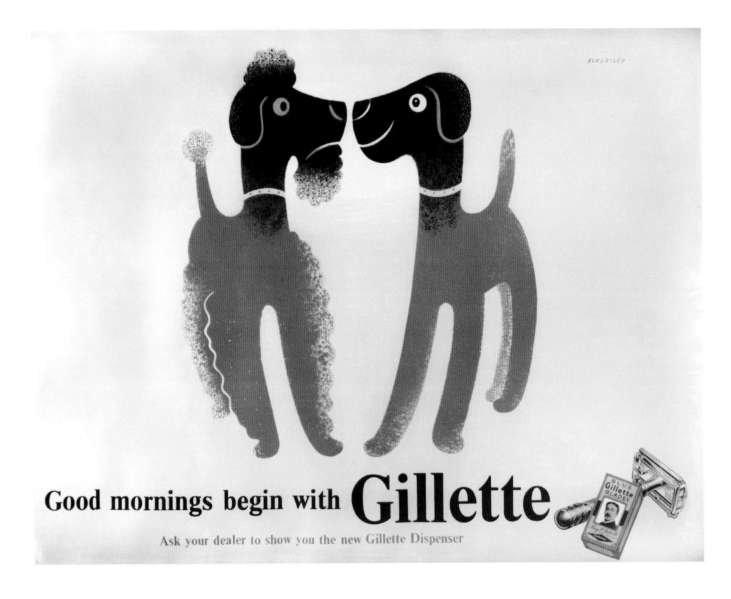

visual print economy, had reached a certain size. The increased capacity of the visual print economy began to impact from the mid-1960s onwards and when, by coincidence, the early teaching of graphic design had produced the first cohort of professional graphic designers.

Eckersley was also involved in pan-European developments. The pre-war conceptualisation of Modernism as an international phenomenon was retained, and applied to its post-war and reconstructive forms. Alliance Graphique International, established in 1951, was incorporated the following year with a membership of 65 from across Europe. The invitation to join this group was an important recognition of Eckersley's international standing.

Above *Good mornings begin with Gillette*, Tom Eckersley, 1948, QC (30 x 40"), Gillette.

Opposite *Post Early*, Tom Eckersley, 1950, DC (30 x 20"), General Post Office.

ECKERSLEY

BE FIRST NOT LAST

POST EARLY

Parcels·Packets by Dec 19 Letters·Cards by Dec 21

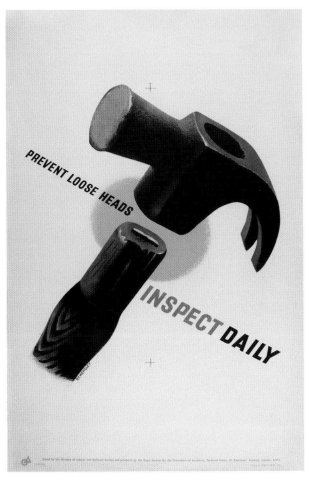

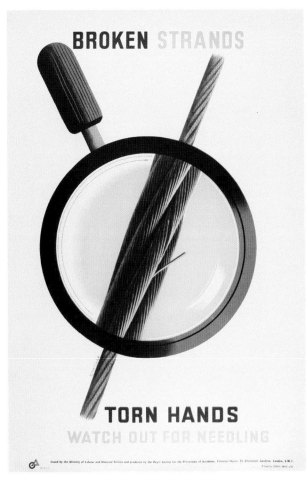

Top left to right *Inspect Daily, Prevent Falls* and *Examine Ladders.*

Bottom left to right *Torn Hands, Wear Goggles* and *Stow Tools Safely,*

Tom Eckersley, 1940s, each poster DC (30 x 20"),

The Royal Society for the Prevention of Accidents.

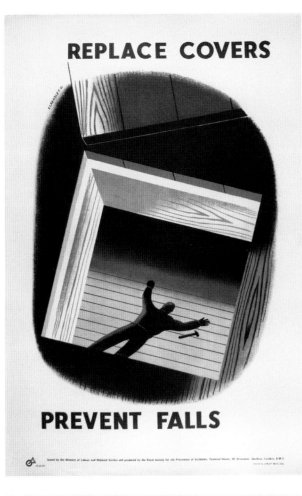

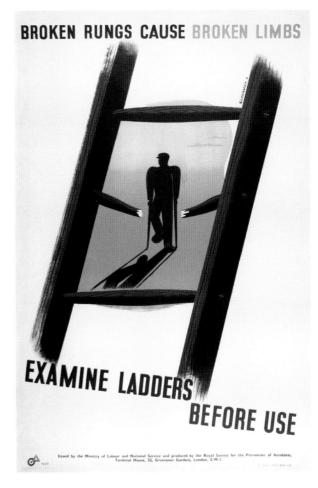

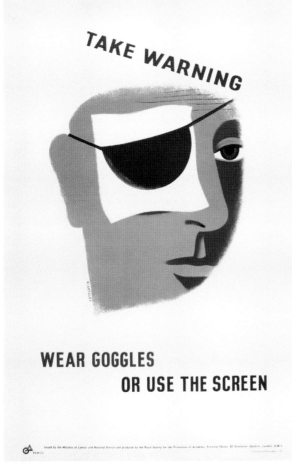

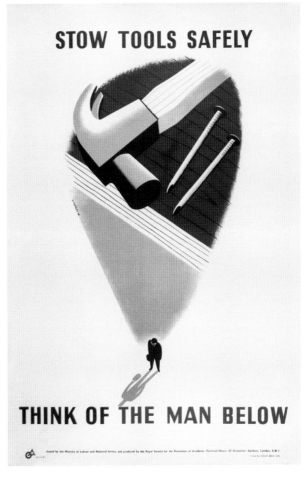

The historical origins of the poster were, to a very large extent, determined by the invention and development of colour lithographic printing during the nineteenth century. The further development of the poster, during the twentieth century, was linked to both technological improvement and in the shifting cultural position of lithography between art and commerce.

At the end of the nineteenth century, the processes of lithography remained mysterious. The skills of machine minding and lithographic draughtsmanship were fiercely guarded within the printing trade. The factory and workshop-based organisation of printing enterprises allowed for a system of formation through apprentice training.

The specific training of professional formation shaped the trade through identification with the primary skills of accuracy. The result was that, at this point in its history, the general standard of lithographic work was distinguished by the faithfulness of reproduction. No space was allowed for the expressive use of lithography, or for artistic interpretation.

From an aesthetic perspective, this produced a peculiar kind of image that was both accurate and lifeless. It is surprising that lithography, of all printing processes, should have ended up in this position. The act of drawing on stone was recognised, quite early in the nineteenth century, as one of expressive potential. It was quite usual, between 1830 and 1850, for artists to draw from life and directly onto the stone. There are a number of important topographical projects expressed through lithography that attest to this. At a less elevated level, it was straightforward for amateur artists to hire a lithographic stone and to carry it on drawing expeditions into the country.

SYSTEMS AND STRUCTURES OF THE MODERN POSTER

Aid The Wounded, (detail), FHK Henrion, 1943, DC (30 x 20"), Joint Committee for Soviet Aid.

The commercial success of lithography within the industrial economy of the late nineteenth century seems to have removed the process from the public domain. In any event, the medium was conspicuous by its absence from the curriculum of the nineteenth century art school.

This began to change with the establishment, by William Lethaby, of the Central School of Arts and Crafts in 1896. Lethaby established the Central, so as to address the various shortcomings that he had observed in his role as Inspector of Schools, for the London County Council. From the start, the Central included lithography within its printmaking syllabus.

The centenary of Senefelder's discovery prompted a number of artists to join forces so as to promote lithography as a legitimate means of artistic expression. The American, James Whistler, had been a pioneer of artistic lithography through his association with the London printers, Thomas Way.

Joseph Pennell established the Senefelder Club in 1909. From the beginning, the Central was represented amongst the membership through AS Hartrick and various colleagues. The club promoted its efforts through a series of exhibitions and by the various members accepting commissions from Frank Pick at the Underground Railway. Whistler and Pennell provided the inspiration for a number of artists, including Frank Brangwyn and Spencer Pryse to develop a particular style of expressive and spontaneous drawing on stone. The result was a group of images that used expressive power to communicate a sense of immediacy. Brangwyn's World War One posters and those for the British Empire Exhibition at Wembley in 1924 by Spencer Pryse helped establish the artistic poster in Britain.

The Curwen Press and Baynard Press both played a crucial role in developing closer associations between artists and printing workshops. Harold Curwen and Oliver Simon were able, through their contact with artist and teacher Paul Nash, to recruit a number of young artists to their enterprise. The names of Eric Ravilious, Edward Bawden and Barnett Freedman are the best known of this group. Curwen asked that a "Spirit of Joy" should be evident in all the work of his press. The young artists were delighted to oblige with a series of lively and witty designs.

One of Nash's students at the Royal College of Art had been Barnett Freedman. Freedman rapidly established himself as an important member of a small group of artists working with lithography. The formation of this group had been facilitated by Nash's introduction to Harold Curwen and to the workshops of the Curwen Press.

Freedman was quickly recognised as a supremely able lithographic draughtsman and became a prominent promoter of auto-lithography. The expressive potential of lithography has become more widely appreciated through the efforts of Frank Brangwyn and Spencer Pryse. Freedman was able to combine the quick and spontaneous gesture with a level of precision and control in his lithographic drawing.

Freedman loved working at the printers and took a close interest in all aspects of lithographic make-ready and printing. Accordingly, he built up a remarkable level of expertise. His poster designs for London Transport are dramatic and experimental in their use of drawing techniques and in new printing inks. Freedman enjoyed a friendly and productive relationship with Thomas Griffits, the master lithographic printer at the Baynard Press.

Opposite top *Theatre*, Barnett Freedman, 1936, each poster DR (40 x 25"), London Transport.
Opposite bottom *Circus*, Barnett Freedman, 1936, each poster DR (40 x 25"), London Transport.

go by
Underground

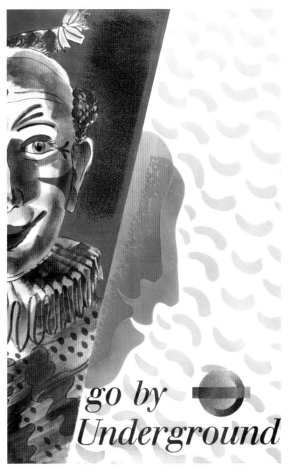

go by
Underground

God Save our Queen (original artwork), Barnett Freedman, 1953, 19 x 39", Shell Mex & BP.

Designed for Shell-Mex & B.P. Ltd
by James Fitton 1953

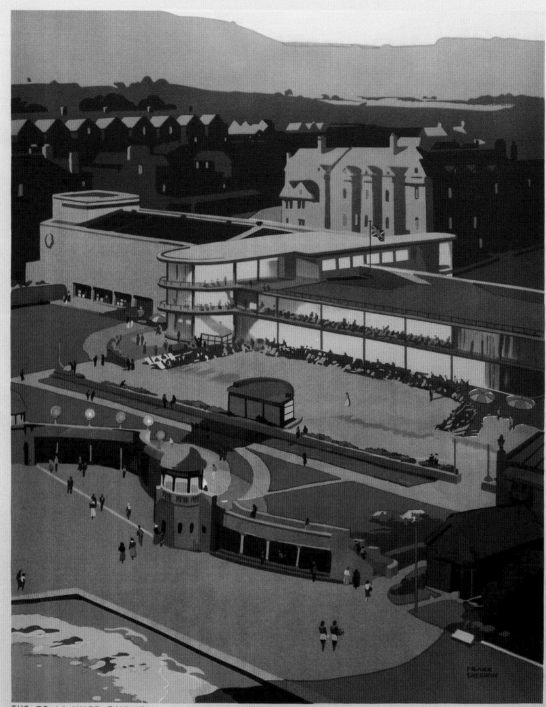

THE DE LA WARR PAVILION

BEXHILL
ON THE SUNNY SUSSEX COAST

THROUGH TRAINS
FROM THE NORTH
AND MIDLANDS

BRITISH RAILWAYS

FREQUENT TRAINS
FROM LONDON AND
ALONG THE COAST

FOR TOWN GUIDE APPLY DEPT. B.R.I. DE LA WARR PAVILION

The original conception of lithography was a flatbed process. The action of bringing the paper and plate together was mechanically complicated and time consuming. The intervention of a rubber offset, between plate and paper allowed for the action of the press to become rotational. This greatly increased the mechanical efficiency and speed of the press. In addition, the offset roller had another advantage. It removed the necessity for origination from the negative of an image. The press could be set up as a positive, negative, positive process. So, the development of offset also reduced the make-ready for printing.

The manpower and machinery required by the large lithographic stones of the nineteenth century provided for a very substantial part of the costs of printing. The substitution of metal plates greatly reduced the bulk of machinery and the complexity of make-ready around the printing factory.

The first powered litho presses were big machines defined by the requirement to support large blocks of stone. Colour lithographic printing required, in these kinds of machines, a separate run of the press for each colour printed.

The close association between lithography and industrial manufacturing in the nineteenth century also defined the poster printing industry through a sort of geography. The same names appear on posters from the end of the nineteenth century through to the end of the 1930s. Generally, these were large firms with the mechanical and human resources to undertake the specialised tasks of poster printing. Beyond London, the major printing firms with these resources had tended to grow in association with specific regional businesses.

For example, the name of Jarrold, in Norwich, appears upon many printed posters. The firm was closely associated with the mustard manufacturers Coleman, also based in the town. The steady work of printing labels, packaging and Coleman advertising supported the firm and allowed it to grow.

The same kinds of association held with businesses across the industrial heartland of Britain. The railways, shipping, commodities and service all provided an important impetus, at different times, for the printing industry. A number of names repeatedly appear in the margins of posters: Waddington, Waterlow, Dangerfield, Vincent Brooks, Day, Weiner, Baynard and Curwen are all familiar, but there are many others.

The close association between art and lithography continued through the various efforts of Pick, Tallents and Beddington. By the end of the 1930s, lithography had become accepted as a legitimate means of artistic expression and identified as auto-lithography.

All of these efforts combined to transform the general quality of lithography, from something constrained by accuracy in 1900, to an altogether more varied form of visual communication. This material began to define a different cultural space.

SEASIDE POSTERS

Nowhere were these associations more evident than in the organisation of advertising for Britain's seaside resorts. From the end of the nineteenth century onwards, the seaside holiday became an integral part of popular experience. By the 1930s, the popular seaside resorts, Brighton and Blackpool for

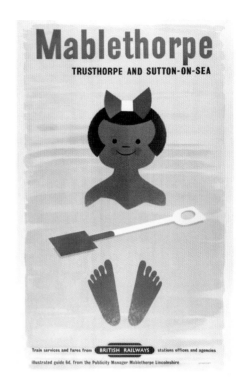

Opposite *Bexhill*, Frank Sherwin, c. 1950, DR (40 x 25"), British Railways.
Above *Mablethorpe*, Tom Eckersley, 1950s, DR (40 x 25"), British Railways.

example, were recognised as entirely modern environments. This modernity was exemplified by the development of new facilities devoted to health, leisure and pleasure, and aimed at an entirely democratic mass-market.

The development of mass-market facilities necessarily increased the capacities of these large seaside resorts. The use of advertising was quickly adopted as a way of maintaining and increasing market share in this competitive market.

It made sense, in these circumstances, for the railway companies, seaside resorts and printers to collaborate in the design, printing and display of these advertising images.

This particular arrangement needs explaining. Seaside posters were usually displayed on railway platforms. The railway traffic associated with the development of seaside holidays provided an important source of revenue for the railway companies. It was natural, in these circumstances, for the railway companies to advertise their services in relation to seaside holidays and to offer special terms to the resort destinations featured on the posters.

The elaboration of the poster image was, in practical terms, a collaboration between the resort, railway, artist and printer. Resorts were understandably anxious to show the widest range of facilities in order to be attractive to the largest number of people. So, many posters portray the towns and facilities of the British seaside as a kind of fantasy.

The large formats of seaside posters, typically quad royal size before World War Two and measuring 50 x 40 inches, placed the printing of these posters beyond all but the largest concerns. The same printers' names appear in the margins of these posters. The cultural significance of these posters attached an importance to these images that expressed itself through careful attention to detail and print quality.

The advent of World War Two began to change these arrangements. The propaganda work associated with war communications began to be given to a wider range of firms and to those with newer equipment.

In the first instance, zinc plates were prepared in the same way as their stone counterparts. However it became possible, after about 1910, to transfer designs through a photo optical process. This began the transformation of commercial lithography from craft process into one of mechanical reproduction.

By the 1920s, the thin metal plates and rotary action of mechanical offset had allowed for smaller and faster machines. A two-colour press, for instance, combined these elements into a vertical arrangement of rollers. The paper was stacked at the bottom and pulled up through the press. The development of coated papers and the careful control of inks allowed for the quicker printing of larger editions.

After World War Two, this arrangement was extended to a four-colour, CMYK process. This effectively integrated the improvements in press design with those of make-ready. Thenceforth, almost any design could be reproduced through a series of mechanically specified steps. The recent advent of digital technologies has simply made this process even more rapid and accurate.

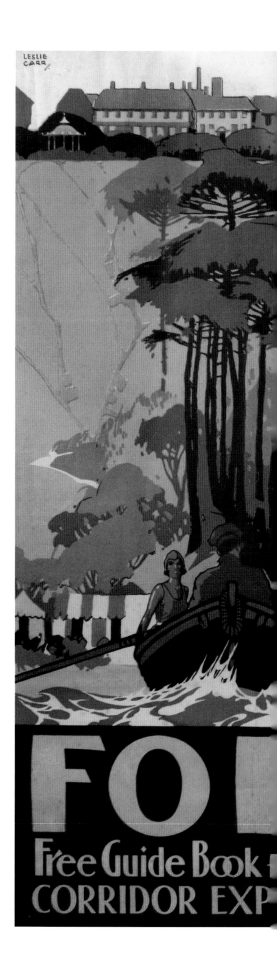

Folkestone, Leslie Carr, 1927, QR (40 x 50"), Southern Railways.

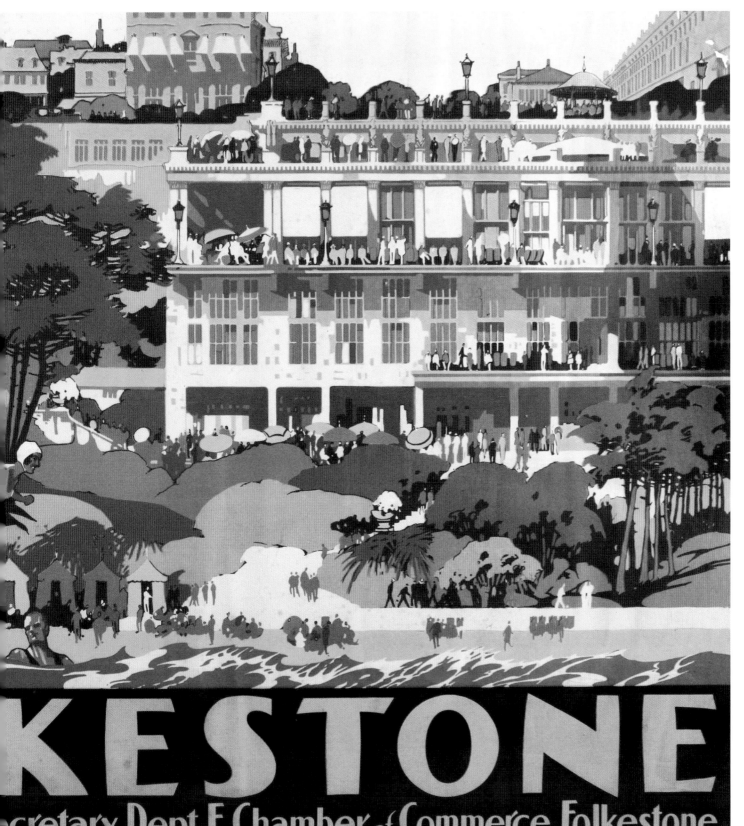

KESTONE

cretary, Dept E, Chamber of Commerce, Folkestone

ES and CHEAP FARES by SOUTHERN RAILWAY

PHOTOGRAPHY

The technical development of lithography continued in incremental steps. The halftone screen became progressively more finely ground. This allowed for a greater level of photographic detail to be transferred to the lithographic plate and for the resulting image to be made bigger without the usual degradations of quality associated with photo enlargements. Nevertheless, the use of photographic elements in poster design remained limited before 1939. It is possible to observe, across various posters, the slow improvement of halftone during this period.

The use of photography in poster design developed entirely from the use of the halftone screen. The halftone screen allowed for the transfer of photographic tone, usually expressed through the range of greys associated with black and white photography, into the contrasting blacks and whites of lithographic printing. This was achieved through breaking the image up and through the device of the screen into an arrangement of dots. The density and distribution of these dots was an effective way of reproducing the graded tones associated with the photographic image.

Photography was attractive to poster designers for a variety of reasons. These were mostly associated with the convenience and economy of producing images mechanically. In addition, the scientific associations attached to the observational discourse of the mechanical image allowed photography a special status of verisimilitude in design.

For a long time the screens were not fine enough to give the appropriate level of photographic detail when enlarged to poster size. Designers developed a variety of strategies to overcome this problem. Smaller photographic elements could be brought together through the process of montage. Alternatively, the smaller photographic elements could be framed within the existing language of

Left *Like mother… like daughter*, Arpad Elfer, 1948, QC (30 x 40"), DH Evans.

Right *Fashion wise*, Arpad Elfer, 1954, QC (30 x 40"), DH Evans.

Opposite *Volunteer For The Parachute Regiment*, Reginald Mount and Eileen Evans, 1960s, DC (30 x 20"), British Army Recruiting Office.

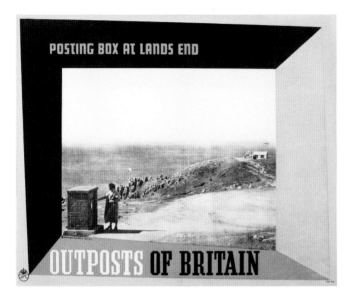

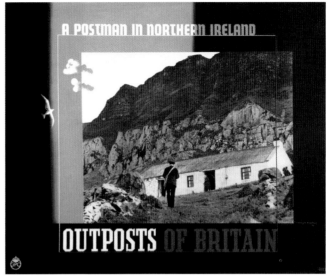

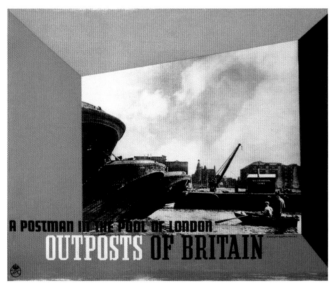

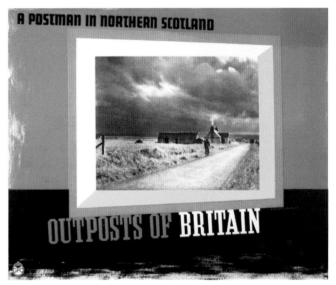

Opposite *Keep Death Off The Track*, Anon., 1940s, 20 x 12", British Railways.

Above *Outposts Of Britain*, Edward McKnight Kauffer, 1938, each R (20 x 25"), General Post Office.

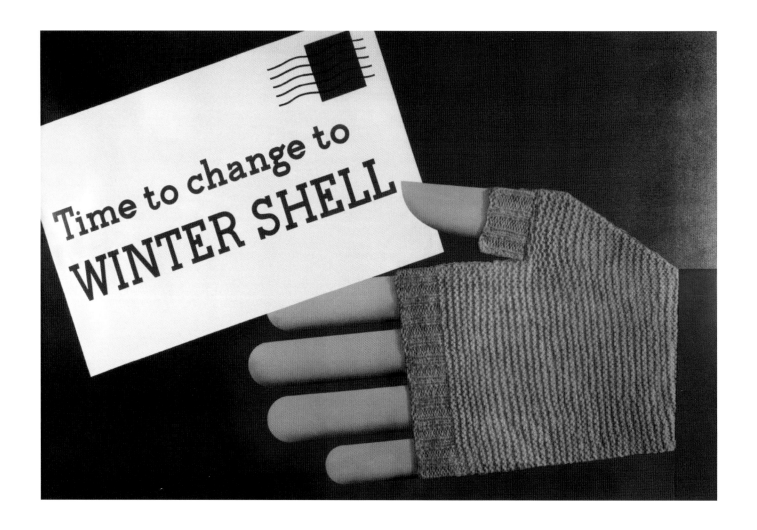

Winter Shell, Tom Eckersley and Eric Lombers, 1938, 30 x 45", Shell Mex & BP.

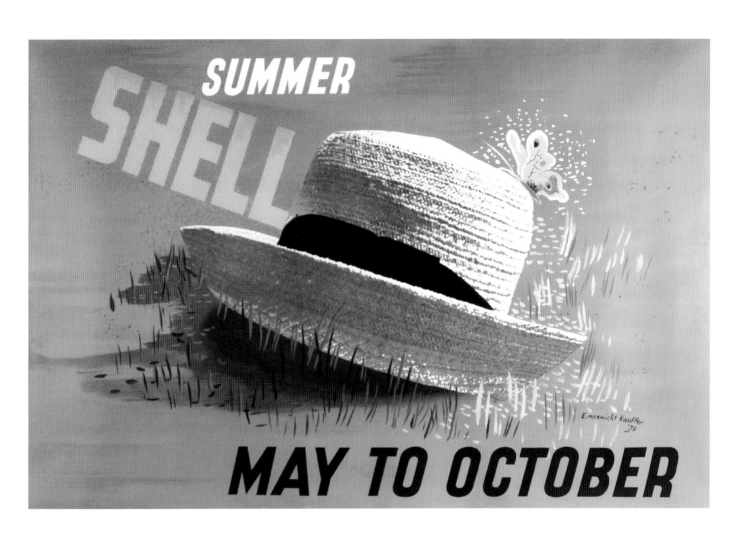

Summer Shell, Edward McKnight Kauffer, 1939, 30 x 45", Shell Mex & BP.

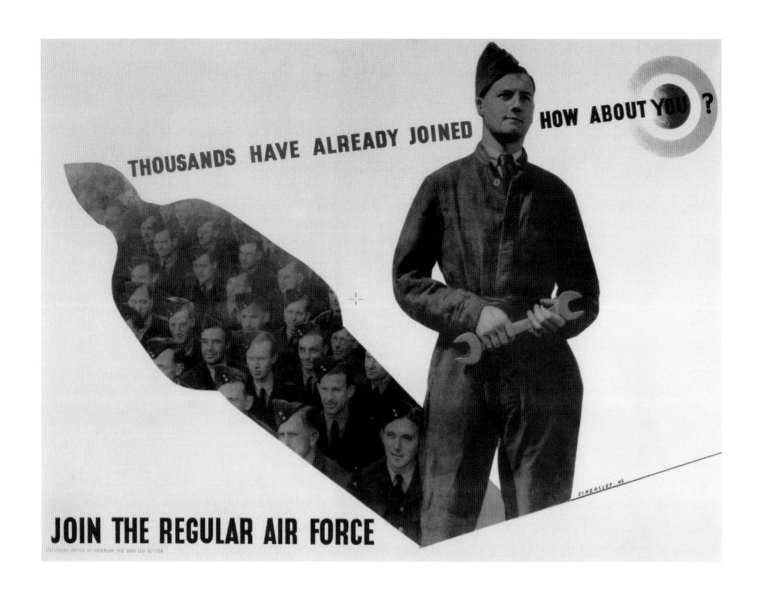

Join The Regular Air Force, Tom Eckersley, 1945, DC (20 x 30"), Royal Air Force Recruiting Office.

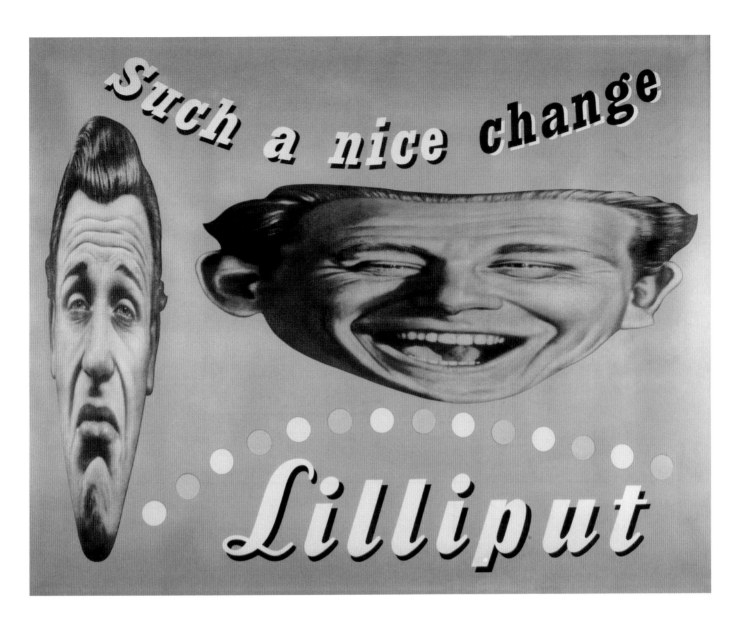

Such a nice change, Arpad Elfer, 1946, QC (30 x 40"), Lilliput.

graphic design. Edward McKnight Kauffer was an important figure, throughout the 1930s in these efforts.

Despite the rapid progress of mechanical reproduction it remained difficult to produce coherent and large-scale photographic advertisements. Elfer continued the visual experiments, begun before the war by McKnight Kauffer, in how best to frame photographic elements within the existing parameters of lithographic printing. Elfer exploited the rapid post-war development of new printing inks in bright colours and created posters where photographic elements are framed within fields of colour or against Op Art dazzle effects. By the 1960s, the technical development of mechanical reproduction in poster printing was complete.

DISPLAYS

In addition to the technologies of poster printing, the environments of display have shaped the development of the poster. As mentioned earlier, there was a sharp contrast between the cultural enthusiasm that greeted the invention of the poster in France during the nineteenth century and its general reception in Britain. In France, the poster was recognised as a genuine artistic and cultural phenomenon. In Britain, this fascination was more ambivalent. The enormous popularity of poster exhibitions in the 1890s and the development of a specialised literature of posters attest to enthusiastic public interest.

Various cultural trends bestowed from the Victorian aestheticism of John Ruskin, along with an intellectual distaste for trade, conspired to control the poster from the beginning. The unchecked spread of advertising could not be allowed and systems of organisation and display were demanded.

The Society for Checking the Abuses of Public Advertising was formed in 1893 to promote a code of conduct amongst advertisers and to ensure its enforcement. The code advised the preference for an artistic and harmonious display. The convergence of aesthetic consideration and architectural conservation implicit in this code shaped the development of the advertising industry in Britain.

Beyond the expected harmonisation of the display environment, the campaign had several profound and unexpected consequences. The most significant of which was that the displays gained impact by limiting the number of posters. This, in turn, imposed the rules of supply-and-demand on advertising display spaces and drove rents up. The rents were used, by the fledgling advertising industry, to justify its own relatively high fees. In some obscure way, the control of advertising reassured cultural conservatives by imposing neatness and order.

When the Design and Industries Association (DIA) was formed, in 1915, it espoused a regime of self-regulation and responsibility amongst its members. It was relatively easy for Frank Pick, at the Underground Electric Railways of London, to rationalise the display environments of station platforms. Furthermore, Pick could arrange to display his own advertisements in spaces that had not been commercially let, so as to further enhance the impression of order and neatness. The standard sizes and regular spaces of the new displays imposed neatness in place of visual disorder. Furthermore, the structural rationalisation of display regularised the administration and accounting systems.

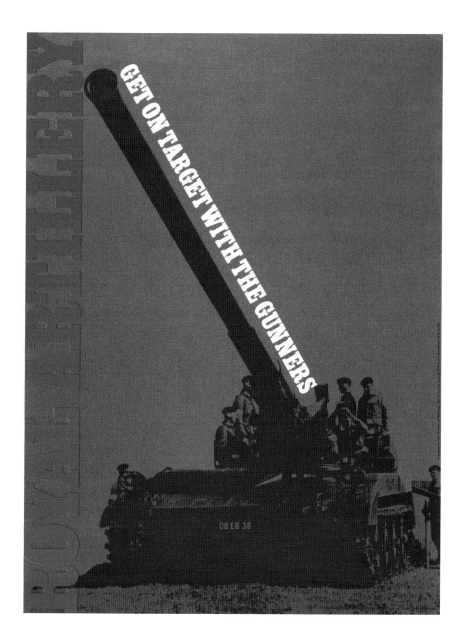

The problem above ground was much more extensive and complex. Pick began by issuing clear guidance on the displays around the ticket office and entry to the station. The consolidations and expansions of the transport system, involving the integration of both railway and bus routes, quickly took the poster beyond its natural metropolitan habitat and into the suburbs and countryside.

By the 1920s, conservationists were concerned that market forces, if left unchecked, would despoil the countryside. In 1926, the newly established Campaign for the Protection of Rural England began to lobby against the unchecked expansion of urban sprawl and ribbon development across Britain. In 1929, and with the

Royal Artillery, Geoffrey Marsden, 1960s, C (20 x 15"), British Army Recruiting Office.

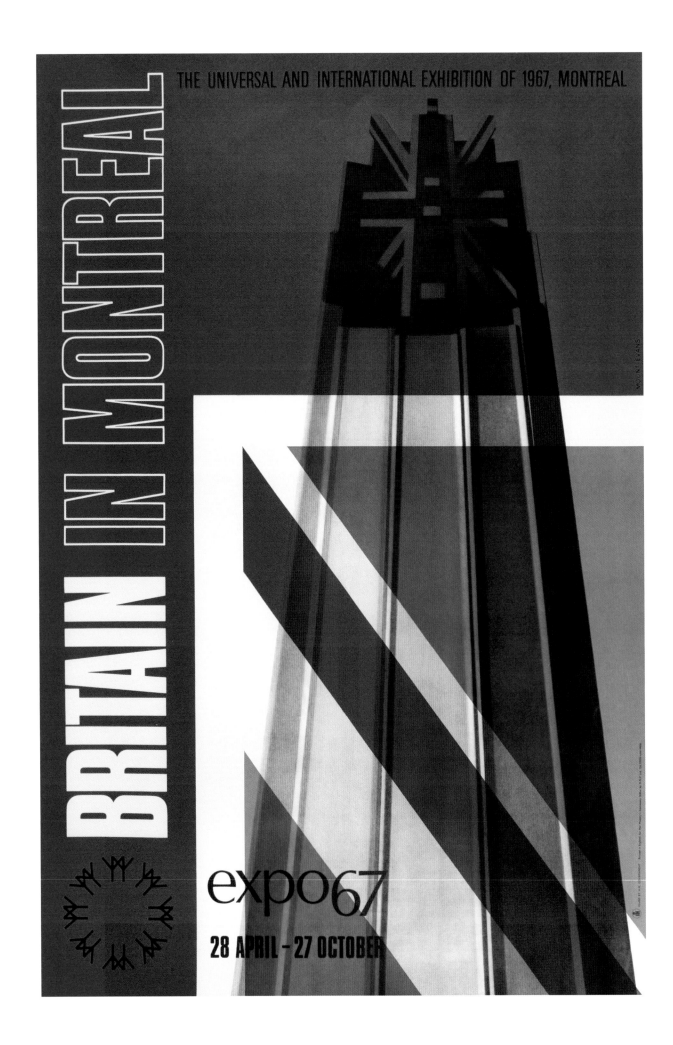

architect Clough Williams-Ellis as President, the DIA allied itself to this cause through the publication of its *Cautionary Guide to St Albans*. The guide helped define the prevailing architectural and planning response to urban expansion in Britain. In cultural terms, the *Guide* established a template for the architectural critique of Osbert Lancaster, John Betjeman and, later, Ian Nairn's subtopia, published as "Outrage", in *The Architectural Review*, 1955. These views were enshrined as policy in *The County of London Plan*, 1943, and in the various templates for reconstruction, the Festival of Britain and the creation of Britain's post-war new towns. It was only in the 1960s, that Gordon Cullen's Townscape theories began to celebrate a less doctrinaire architectural engagement with the varied textures of urban signage, communication and advertising.

Against this cultural background, membership of the DIA was understood to confer a special responsibility for the considered use of advertising. Pick, Beddington and Tallents each responded by developing their own quasi-private display environments: Pick on London Transport property in stations, Tallents within the offices of the Post Office and Beddington on the sides of delivery lorries and at petrol stations. Later the information communications associated with war, reconstruction and welfare were increasingly positioned indoors.

The combination of forces that shaped the British poster environment was both economic and cultural. The environmental neatness favoured by conservationists was also economically practical. Britain was the first poster environment to adopt standard sizes across its various display environments.

The standard poster sizes evolve from the single sheet or double crown size. These measure 20 x 30 inches and meant that posters could be printed in multiples. Accordingly, quad crown is 40 x 30 inches and 4 sheet is 40 x 60 inches. Larger outdoor spaces were created for 8 sheet, 80 x 60 inches, and 16 sheet, 80 x 120 inches, displays. These large posters were pasted up in strips and unfolded onto the hoarding. The process of pasting up systematically allowed for bigger displays to be assembled with precision, imposing, again, a level of neatness and order across the poster environment. The smaller poster sizes are usually associated with economy and internal display. The size of these smaller posters is usually a fraction of the standard size. The Shell posters, displayed on Shell's own flat-bed delivery lorries and in the forecourts of their garages, were printed as a non-standard 45 x 30 inches.

The edition size of posters is always much smaller than imagined. Usually, the number of sites on which the poster is to be displayed determines the edition size. The commercial environments of poster display, with their high rents, have tended to concentrate resources into fewer and better locations.

In the slightly different environments of London Transport, Shell and the GPO, the total number of spaces determined the size of poster editions. The smaller poster sizes, for indoor or internal display, had correspondingly more opportunity to be displayed and were printed in larger editions. In any event, no one published posters for them to not be displayed. The combination of economic forces and promotional organisation has usually conspired to display the vast proportion of any edition. In consequence, and despite the relatively large volumes of commercial printing, the number of surviving posters is always fewer than imagined.

Britain In Montreal, Reginald Mount and Eileen Evans, 1967, DC (30 x 20"), Department of Trade.

We are all graphic designers now. Not that we, each and everyone, have the technical education that distinguishes the professional designer. But since the development of the personal computer, the intuitive visual-user-interface and the World Wide Web, our general sensitivity to graphic design has become increasingly heightened. The historical development of the poster has through the techniques of montage, association, and transformation, supported this process of widening visual intelligence.

James Flynn has noted that, judged by the results of standard IQ tests over the course of the twentieth century, the populations of the industrialised economies seem to have become more intelligent. Flynn's research has identified that this increase in intelligence is quite specific and associated with visual and spatial reasoning. This development is most noticeable in the global cities of the developed world where people congregate for social and economic common-cause and where technological change is most immediate. This phenomenon is now identified as "the Flynn effect".

Nowadays, we know from cognitive psychology that the brain learns to process and interpret information through formative repetition. Indeed, cognitive psychologists have identified pattern recognition and repetition as the key steps to developing visual intelligence. Gestalt psychologists began, in the 1930s, to understand that the massive expansion of visual culture, made possible by mechanical processes of production and by the mass media, would transform our understanding of the world. The 'intelligent eye' conceptualised by psychologists is both an optical device and an interpretive tool. We understand and interpret the world in relation to our experience of it.

The implications resulting from this call into question the normative disciplines of social formation that support the established social order. This, in turn, provides the basis for the widespread anxiety that young people are developing alternative patterns of cognitive wiring. It is possible that the extension of visual culture through new technologies will, in time, alter the social formation of identity.

All we can do, in these circumstances, is to look at the events and developments of mass visual culture for evidence to support this thesis or to refute it. The urgent circumstances of war in Britain provided an opportunity for the sudden introduction of new technologies of mechanical reproduction. The mass production of images, within the special circumstances of war, effectively transformed the

PEOPLE AND POSTERS

Above *A clear plate means A clear conscience*, James Fitton, c. 1940, DC (30 x 20"), Ministry of Food.

Opposite *Changing of the Guard* (detail), FHK Henrion, 1956, DR (40 x 25"), London Transport.

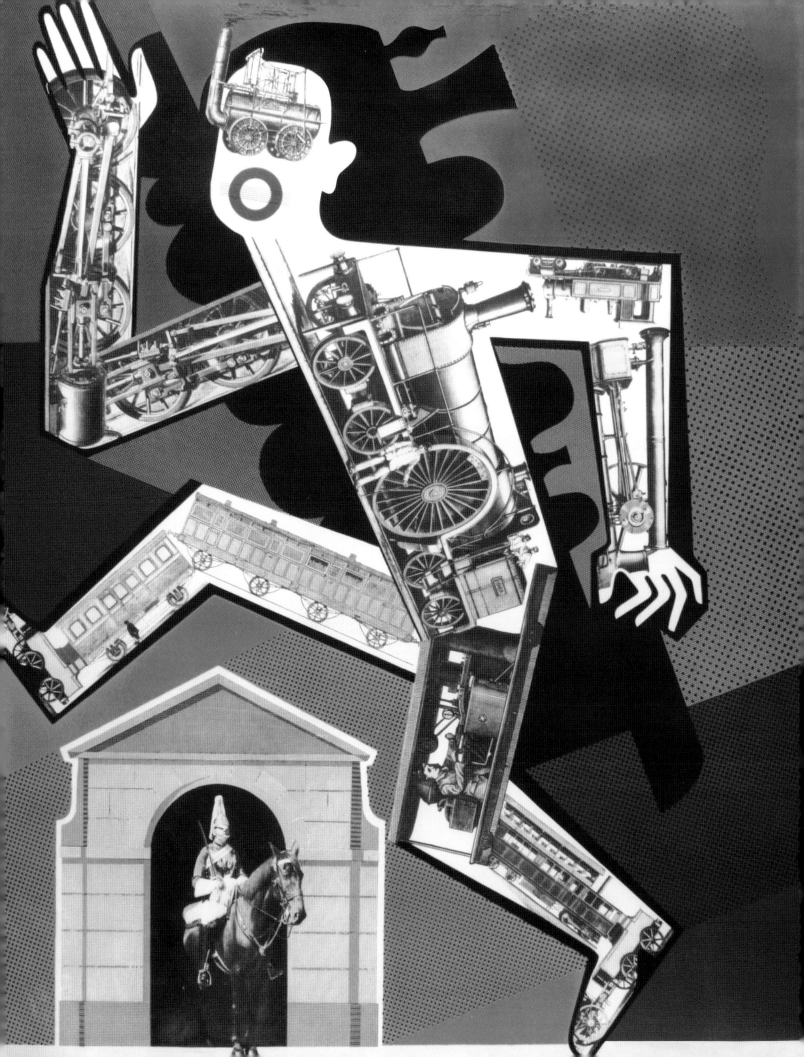

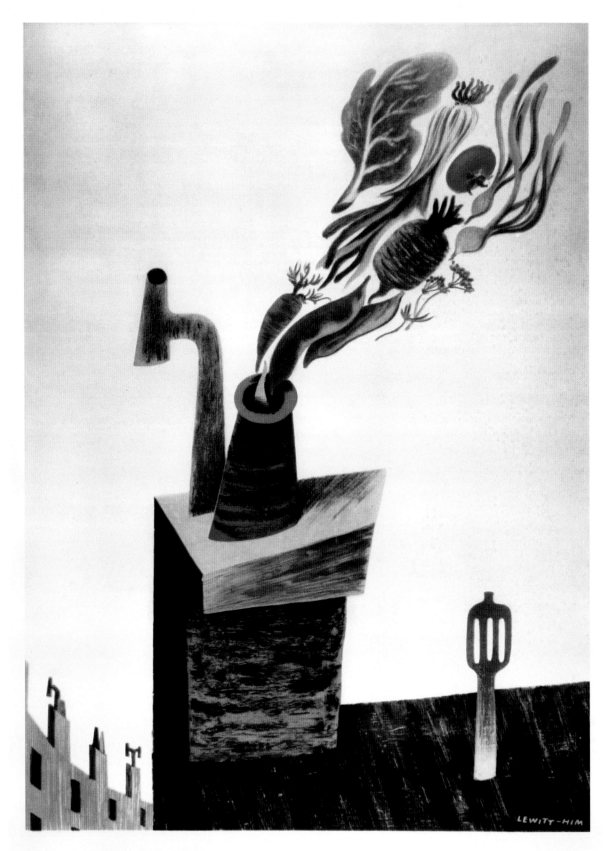

THE EFFECTS OF OVER-COOKING AND KEEPING HOT

Vitamin value, goodness, taste
'go up in smoke'—result is waste

political meaning and impact of those images. In turn, the meaning of these images began to define a new visual identity for British people. This identity was uniquely and powerfully collective.

The general themes of war propaganda are usually those of effort, duty, discipline and sacrifice. The phenomenon of Total War is distinguished by the conjunction of military, economic and industrial contexts. Accordingly, World War Two British war propaganda was able, from 1940 onwards, to address these themes in terms that ranged beyond the usual military context of war.

In practical terms, the war effort was quickly understood as depending on the direction of resources towards prioritised objectives. Thus were materials, food and manpower allocated for maximum effect. In general terms, this process manifest itself through various forms of rationing. It is against this backdrop that these various appeals to economy must be understood.

These messages were widely acknowledged, at the time, as an expression of a new social egalitarianism. This quickly became one of the founding mythologies of the British experience of World War Two. This experience is recalled, even today, through the shared experience of the Blitz.

It was widely believed amongst the administrative and political classes that ordinary people lacked the moral fibre to resist the traumas of enemy bombardment. It was an unexpected surprise to find that ordinary people could espouse the same virtues of effort, duty and sacrifice as the officer classes.

Against the widely perceived background of aristocratic and Conservative political appeasement, during the 1930s, the Blitz also allowed for the rehabilitation of the British social elites.

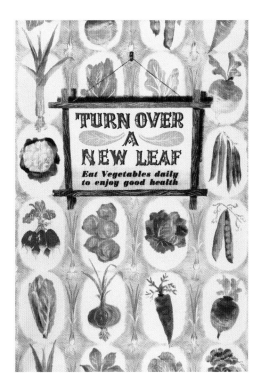

Opposite *The Effects Of Over-Cooking And Keeping Hot,* Jan Lewitt and George Him, 1943, DC (30 x 20"), Ministry of Food.

Above *Turn Over A New Leaf,* James Fitton, 1942, DC (30 x 20"), Ministry of Food.

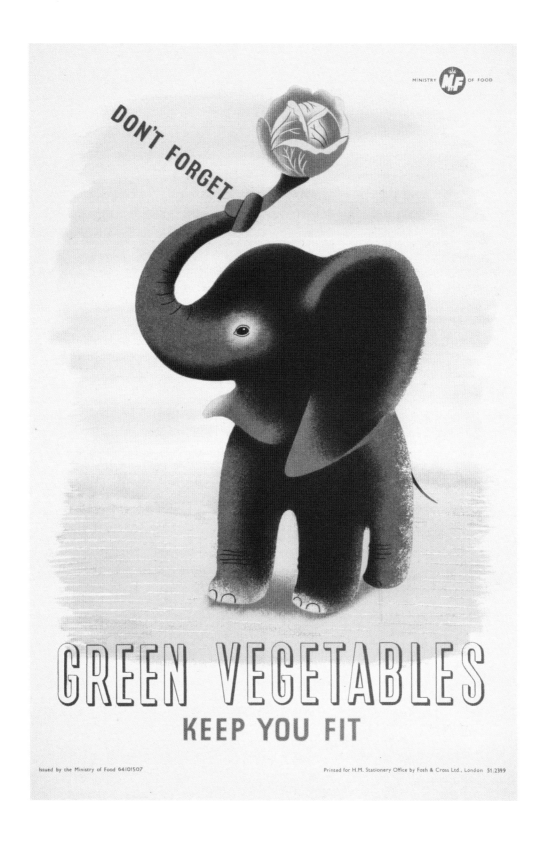

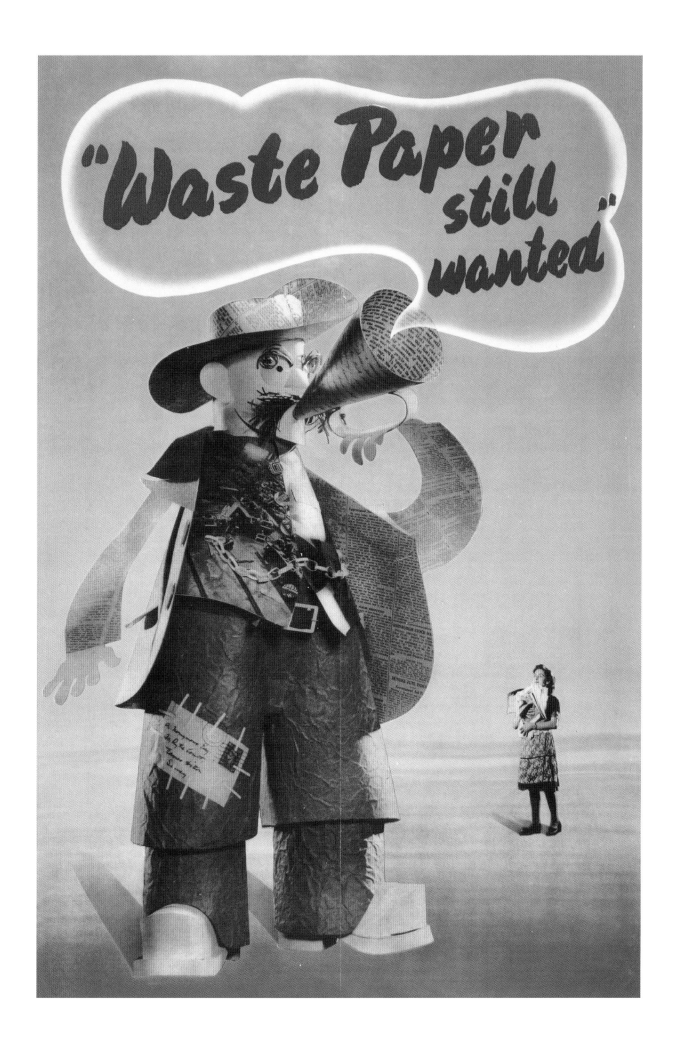

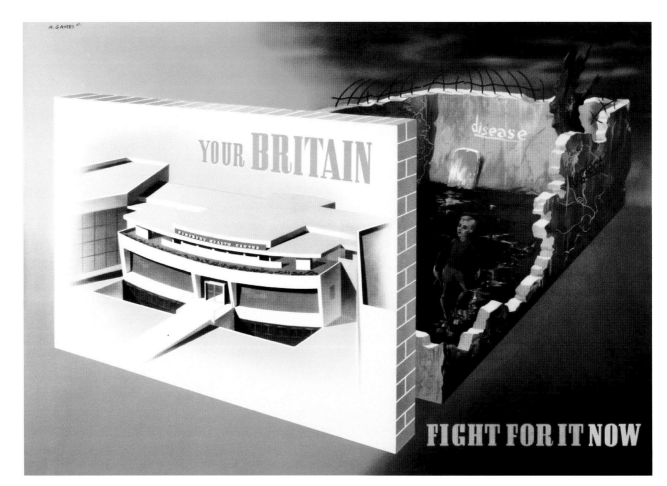

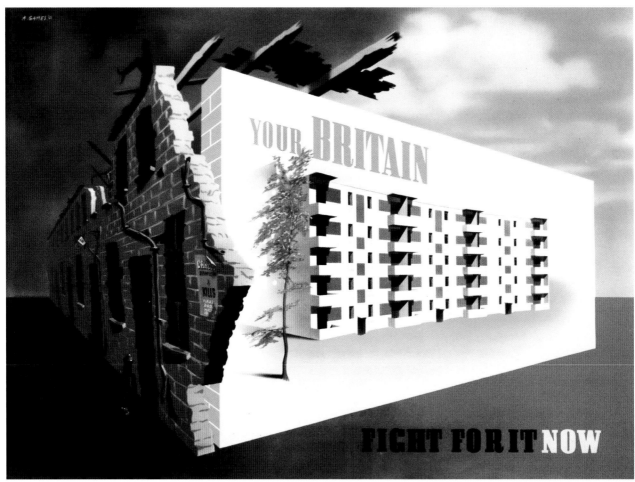

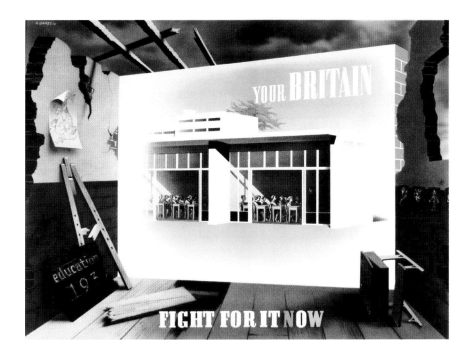

George Orwell described the wider political feeling of Britain in letters to his American colleagues at *The Partisan Review*. He noted, for example, that, for the duration and against expectations, it was possible for the editorial departments of national newspapers to express themselves freely. This was especially the case in relation to consumer issues of lifestyle that had previously, and under the normal arrangement of newspaper ownership, been circumscribed through reference to supporting advertisements and their revenue flows.

The absence of any ordinarily commercial advertising activity was an opportunity, suggested Orwell, for writers to engage actively with a project to recast British society around a cluster of radical and social-democratic ideas. For the record, Orwell noted, in April 1941, that "nearly the whole of the press is now Left compared with what it was".

The point made by Orwell was that the circumstances of war required and supported a different kind of political economy in cultural production. The opportunity, in time of war, to produce new, exciting and radical work against the usual constraints of command, control and thrift may strike us, nowadays, as surprising. The relatively stable circumstances of Britain, after 1940 and with air power secured, provided a suitable platform for the elaboration of a radical agenda with its supporting visual culture.

Stuart Hall has identified *Picture Post* as an exemplar of the process, famously described by Orwell in "The Lion and the Unicorn", 1941, whereby the efforts of war and social transformation are inevitably and inextricably linked. The objective of military victory in World War Two was expressed through the conjunction of military and productive effort with that of wide ranging political reform. Orwell sensed that, for a brief moment at the end of 1940 and at the beginning of 1941, the conditions for successful social change in Britain were in place.

From 1941 onwards, people in Britain began to see the world differently and to place themselves differently in it. The relationships between this social phenomenon, at both an individual and collective level, and the cultural

Opposite top *Your Britain—Health*, Abram Games, 1942, DC (20 x 30"), Army Bureau of Current Affairs.

Opposite bottom *Your Britain—Housing*, Abram Games, 1942, DC (20 x 30"), Army Bureau of Current Affairs.

Above *Your Britain—Education*, Abram Games, 1942, DC (20 x 30"), Army Bureau of Current Affairs.

production that supported it raise important questions of personal identity, subjectivity and collective citizenship.

Picture Post's publication of "A Plan for Britain", 1941, described the alignment of military objectives and those of social justice placing education, health and housing at the forefront of post-war planning. These objectives became the model for post-war reconstruction generally. The template for post-war reconstruction combined art, design and architecture into a single, coherent, whole. This unification was expressed through the Festival of Britain during 1951.

For the first time, the architecture of urban regeneration was laid out around large public spaces with new types of public art and sculpture. Painted murals, super sized typography, printed textiles and sculpture extended the range of experiences associated with modern art. The widespread use of public art greatly increased the opportunities for artists to contribute to these new environments. In some ways, this was a vindication of the strategies of integration pioneered by Frank Pick and London Transport before World War Two.

If we accept the cognitive conjunction of technology and visual culture in the case of fine art, we should expect changes in graphic design, with its more extensive circulation of images, to have the critical mass to make an even more profound impact.

The increasingly sophisticated objects associated with graphic design and communication attest to a developing visual intelligence amongst the whole population. This visual intelligence was based on interpretation and recognition. The development of these skills and intelligence were a necessary part of modern war. So within the context of Britain and World War Two, this visual material provides compelling evidence as to the convergence of visual acuity, politics and action.

I want to substantiate this connection by briefly considering the use of humour and wit in graphic communication and by considering the impact of safety messages across the population.

HUMOUR

The use of humour in poster design was crucial in defining the specific development of a uniquely British graphic language. The English sense of humour established itself as a characteristic expression of stoicism during World War Two.

In graphic terms, the use of humour was attached to various important campaigns associated with Home Front anxieties. Cyril Kenneth Bird, known as Fougasse, made the most significant contribution to these developments.

Fougasse was an accidental humourist. His own career as an engineer was cut short through injury in World War One. Thereafter, he began to work for Punch and for a variety of good causes. Fougasse made important contributions to the development of road safety advice, animal welfare and to sportsmanship in bridge and rugby.

At the beginning of World War Two, Fougasse produced a series of images aimed at alerting the public to the potential dangers of fifth columnists. These 'Careless Talk' posters were produced in enormous numbers and in a variety

Opposite How Are Your Brakes—& Tyres?, Fougasse, 1938, DC (30 x 20"), National Safety First Association.

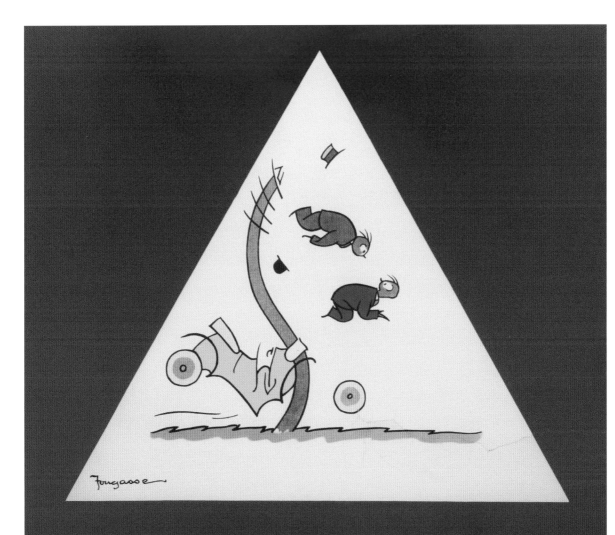

"I told you I could pull up in a car-length"

HOW ARE <u>YOUR</u> BRAKES —— & TYRES?

Issued by the National Safety First Association
Terminal House, 52 Grosvenor Gardens, London. S.W.1

Give her a big hand
——— with (if possible)
the exact fare in it!

of formats. The series was so successful that Fougasse was able to apply the same principles of social consideration to campaigns for London Transport and against noise pollution in hospitals.

After the war, the widespread use of humour allowed British design to distinguish itself from the prevailing functionality of American and continental modernity.

The graphic expression of humour has moved beyond the kinds of illustration traditionally associated with cartoons. In the 1960s and beyond, humour became the mechanism for developing a graphic language able to play with double meanings, puns and eccentricity. This has been understood as providing for the potential of wit, as an expression of intelligence and sophistication, in graphic communication.

The posters designed by Fougasse exemplify the popular and widespread use of humour in the visual propaganda of World War Two. Fougasse described this approach in detail during a broadcast talk in 1940 and in his essay, "A School of Purposes", 1946.

He began by noting that the conditions for successful propaganda are not auspicious—people are disinclined to read any notice and are further disinclined to believe that anything read applies to them. Lastly, they are unwilling to recall any message long enough to act upon it.

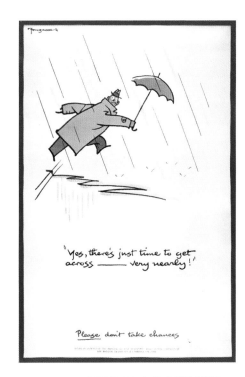

Fougasse identified the strategy most likely to succeed, in relation to these observations, as one of attraction, persuasion and action. In order to succeed, each of these elements must be addressed in a coherent and functional manner and, crucially, together.

The appeal, through sophisticated humour, of the 'Careless Talk' messages is crucial because they depend, for their effectiveness, on their widespread distribution and display. As Fougasse rightly notes, it is unreasonable to expect "the owners of teashops, restaurants or public houses to put up horror propaganda for their clients' comfort". The success of the campaign depended, in the first instance, on the goodwill of factory managers and shopkeepers to display the posters. Finally, Fougasse notes that, given the choice between gruesome pictorial warnings and the opportunity to entertain their clients, most will usually choose the entertaining and humorous and, if given a selection of both, will usually display the humourous.

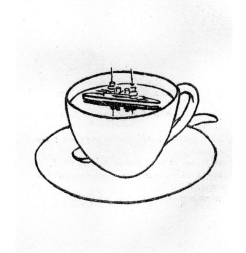

It was natural for Fougasse, as a comic illustrator, to prioritise humour as a vehicle for successful communication. Indeed, Fougasse contrasts the use of humour, against realistic horror propaganda, as both a practical and pragmatic choice. The contrast was effectively made by briefly considering the usual anti-rumour posters that use the fear of fifth columnists and spies to create a widespread public anxiety.

The 'Careless Talk' anti-rumour posters were the most famous of Bird's designs. These were designed in 1939 and offered, free of charge, to the Ministry of Information.

The eight designs show Hitler and Goering materialising, as fifth columnists, from manhole openings and telephone boxes, in clubs, pubs and teashops and from the luggage racks and back seats of public transport. The posters are designed with a bright red border and with Hitler drawn, in comic style, as a pipsqueak in Ruritanian uniform with medals and Goering as his overweight side-kick.

Opposite *Give her a big hand* (detail), Fougasse, c. 1940, DC (30 x 20"), Ministry of War Transports' Road Safety Campaign.

Top *Yes, there's just time to get across*, Fougasse, c. 1940, DC (30 x 20"), Ministry of War Transports' Road Safety Campaign.

Bottom *Battleships and Tea*, Illustration by Fougasse from *The Little Less*, 1941, Ministry of Information.

Together, they are represented as a 'little-and-large' comic double-act recognisable to anyone as a staple of British music hall and comic theatre.

During the 1930s, Fougasse produced a series of drawings used to illustrate the emerging protocols of safe and courteous driving. The National Safety First Campaign published these documents in the days before widespread and professional driving tuition. The first edition of the Highway Code was published in 1931.

The drawings reveal sensitivity to the slightly ridiculous nature of the many rules and regulations that govern British life and, especially, middle-class society. The Fougasse treatment of these social protocols was more benign than that favoured by HM Bateman or David Low, for example.

Fougasse extended his system of presentation, pioneered in relation to the emerging rules of the road, to apply variously to the protocols of bridge parties and of behaviour in London's Underground.

The impact of these slight drawings should not be underestimated. In the period defined by Bird's professional career (up to 1953), the British public began to see the world differently and to understand their place in the world in other ways. In some small part, the 'Careless Talk' images allowed the British people to understand the victory of World War Two as something beyond military power and organisation. Accordingly, the personal stoicism and good humour of the Home Front in Britain became enshrined into a powerful collective perception of egalitarian national identity.

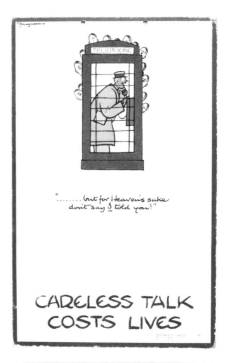

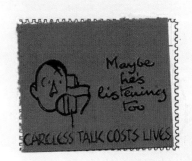

Top *Careless Talk Costs Lives*, Fougasse, 1939, 12 x 8", Ministry of Information.

Bottom Telephone label, Illustration by Fougasse from *And the Gatepost*, 1940, Ministry of Information.

Opposite *Wild or Savage* (detail), Betty Swanwick, 1954, DR (40 x 25"), London Transport.

EALING FILM POSTERS

These themes also inform the films made at the Ealing studios during the 1940s and 50s. Ealing is synonymous with a distinctively English form of light-hearted comedy satire in cinema. The force of these films comes from them being simple exaggerated extensions, in the tradition of Dean Swift, of everyday realities. The circumstances of war, austerity and reconstruction provided plenty of scope for satire. This was especially the case in relation to the extension of state powers in the guise of welfare provision. This extension was often presented as well-intentioned but muddled and, as always, unlikely to deliver the benefit as planned. Usually, the muddle is resolved by appeal to common sense. Nowadays some of this survives in the concept of the 'nanny state'.

The posters for these Ealing films are remarkable. The posters were produced, from 1943 onwards, under the direction of Sidney John Woods who reported directly to Michael Balcon. Woods had trained as an artist and graphic designer. He assembled a stable of artists and designers to make posters for the studio's films. The process was made possible by Woods' extensive list of friends and contacts and his ability to match artist and theme.

Some of the artists recruited by Woods include John Piper, Edward Bawden, Barnet Freedman, John Minton, Mervyn Peake, Edward Ardizzone, James Boswell and James Fitton.

Fitton and Boswell were interesting recruits. In the 1930s they helped establish, along with Ardizzone, The Artists' International Association (AIA). As the name implies, the group provided a framework that encouraged artists to explore the visual projection of left political values. The AIA used the Whitechapel gallery as a base and were active throughout east London. They played a key role, after 1937, in political consciousness-raising in relation to the Spanish Civil War.

Above *Painted Boats*, John Piper, 1945, QC (30 x 40"), Ealing Studios.

Opposite *Hue & Cry*, Edward Bawden, 1947, QC (30 x 40"), Ealing Studios.

Overleaf *The Titfield Thunderbolt*, Edward Bawden, 1953, QC (30 x 40"), Ealing Studios.

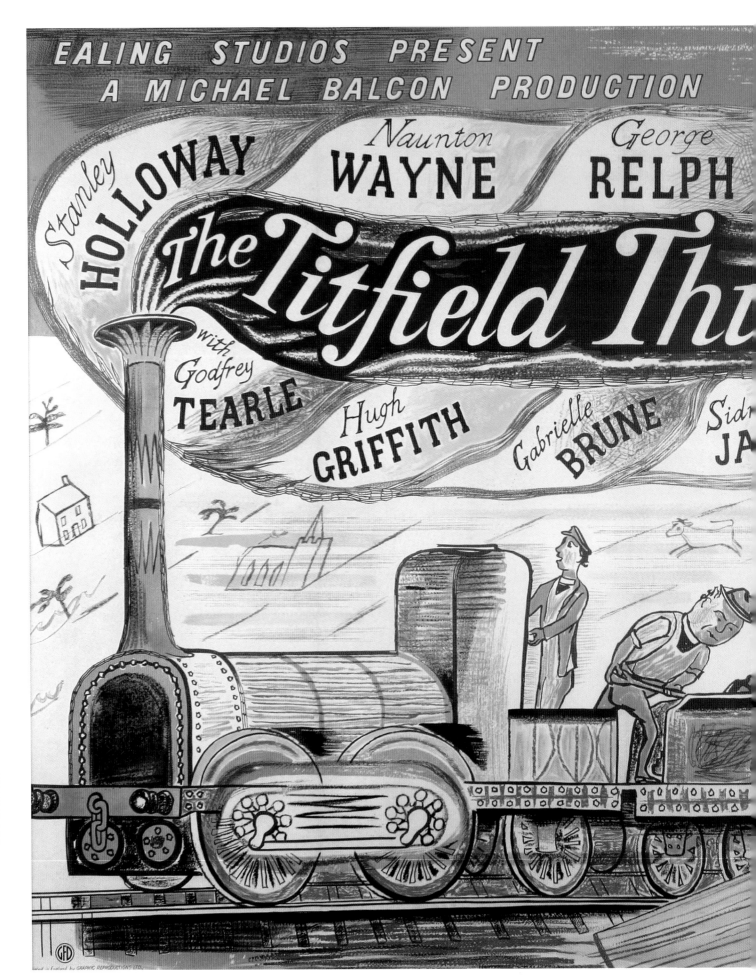

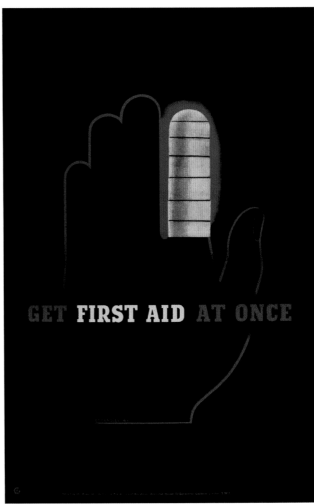

SAFETY

We have already seen how graphic design and mechanical reproduction were able, in the context of World War Two, to play a part in presenting radical political ideas. The same engagement may be seen within the context of safety propaganda.

The origins of the Royal Society for the Prevention of Accidents (RoSPA) are to be found at the end of World War One. Metropolitan areas came under air attack and a blackout was enforced. The changed environment immediately caused an increase in accidents between motor vehicles and pedestrians and the London Safety First Association (LSFA) was formed to address the issue through education and propaganda. Other metropolitan areas formed their own safety associations and these were merged to form the National Safety First Association (NSFA) and subsequently into RoSPA.

The administrators of the RoSPA campaign recognised that the use of shocking and disturbing images were unlikely to have the desired effect of altering behaviour. Accordingly, they concentrated their efforts in creating a coherent framework for the visual expression of a threat. These threats could be minimised through education, and by the observation of simple, commonsense rules.

Left *Eyes cannot be replaced*, GR Morris, 1943, DC (30 x 20"), The Royal Society for the Prevention of Accidents.

Right *Get First Aid*, Tom Eckersley, 1943, DC (30 x 20"), The Royal Society for the Prevention of Accidents.

Opposite *Fire* (detail), Leonard Cusden, c. 1940, DC (30 x 20"), The Royal Society for the Prevention of Accidents.

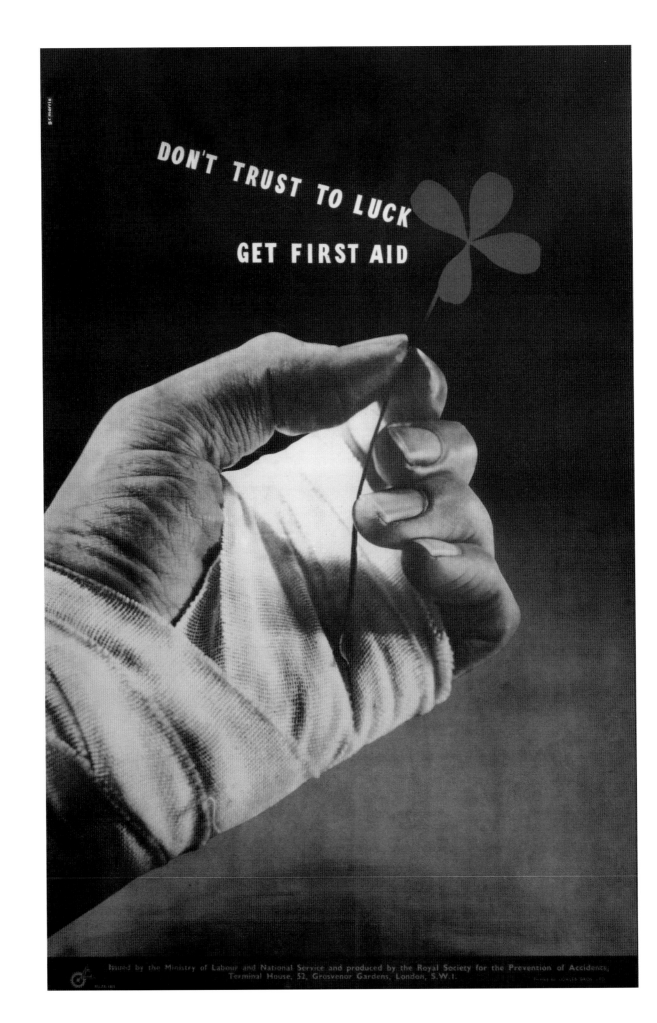

INDUSTRIAL SAFETY

The outbreak of World War Two altered the context of RoSPA's activities so that safety issues were integrated into a discourse of national survival. This was especially true of industrial safety where issues of war production, efficiency and victory converged. The issue of industrial safety became, in the context of war production, a matter of military and political significance. Indeed, the loss of production resulting from the disturbance and trauma of industrial injury were understood in the same terms as military losses. The leadership of RoSPA were conscious of these altered priorities and President Lord McGowan, expressed the importance of safety work by observing that, "an accident in the works is as much a gain to the enemy as a casualty in the armed forces".

RoSPA's industrial safety activities were co-opted within the Ministry of Labour and National Service. The Ministry had been placed, in May 1940, under the leadership of the Trade Unionist, Ernest Bevin. He recognised that RoSPA's activities in accident prevention could advance issues of worker welfare decisively.

Bevin realised that if he could establish an effective projection of these ideas through his Welfare Division he could effect a permanent change, in Britain, between the relations of capital and labour. This change would be based on the idea of a safe, civilised and secure working environment.

This was especially important where industrial expansion, brought about by war, conspired to bring an influx of new workers, including women, into the factories. These circumstances gave Bevin an opportunity to accelerate his project and to establish worker welfare as a primary responsibility of capital. Bevin understood that these conditions would, inevitably, carry-over to the politics of the post-war settlement.

The industrial safety campaign was strengthened, within the RoSPA administration, by the presence of Ashley Havinden and Tom Eckersley on the Publicity Committee. Havinden was a pioneer advertising executive who had worked for the Crawford agency in Berlin during the 1920s. Havinden became, in consequence, one of a relatively small number of English business people with any knowledge of German, Russian and Dutch experimentation in the graphic arts.

The visual language that emerged to express these ideas was sophisticated in its communication and wide ranging in its visual references. Within the campaign, there are several groups of images that deserve to be better known. There are images that use the Surrealist strategies of transformation. Others use the cracked lens of safety goggles to communicate an implicit reference to the International Left through association with Sergei Eisenstein's Odessa Steps sequence from *The Battleship Potemkin*, 1925. At a more prosaic level, much of RoSPA's campaign makes its point through the use and appeal of humour.

For wartime workers, this visual propaganda placed their productive effort within a context of progressive industrial relations and social change. The poster images express this through the visual juxtaposition of ideas. So, these changes became visible to workers who attached these changes to their own productive effort. Loxley Brothers, the RoSPA printers, prepared the colour separations for each poster as glass plates. These could be stored and reissued as required.

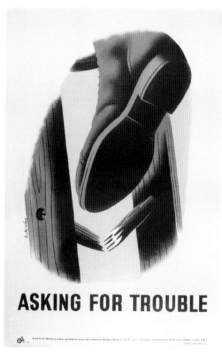

Opposite *Don't Trust To Luck*, GR Morris, 1944, DC (30 x 20"),
The Royal Society for the Prevention of Accidents.

Top *Save Rubber*, Tom Eckersley, 1945, R (25 x 20"), London Transport.

Bottom *Asking For Trouble*, Tom Eckersley, c. 1943, DC (30 x 20"),
The Royal Society for the Prevention of Accidents.

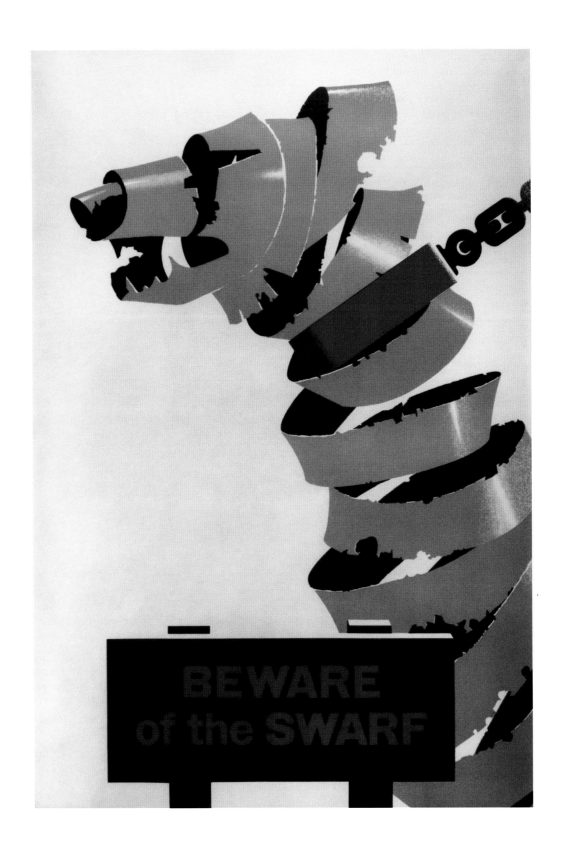

Above *Beware of the Swarf*, Leonard Cusden, c. 1940, DC (30 x 20"),

The Royal Society for the Prevention of Accidents.

Opposite *Wrong/Right*, HA Rothholz, 1940s, DC (30 x 20"),

The Royal Society for the Prevention of Accidents.

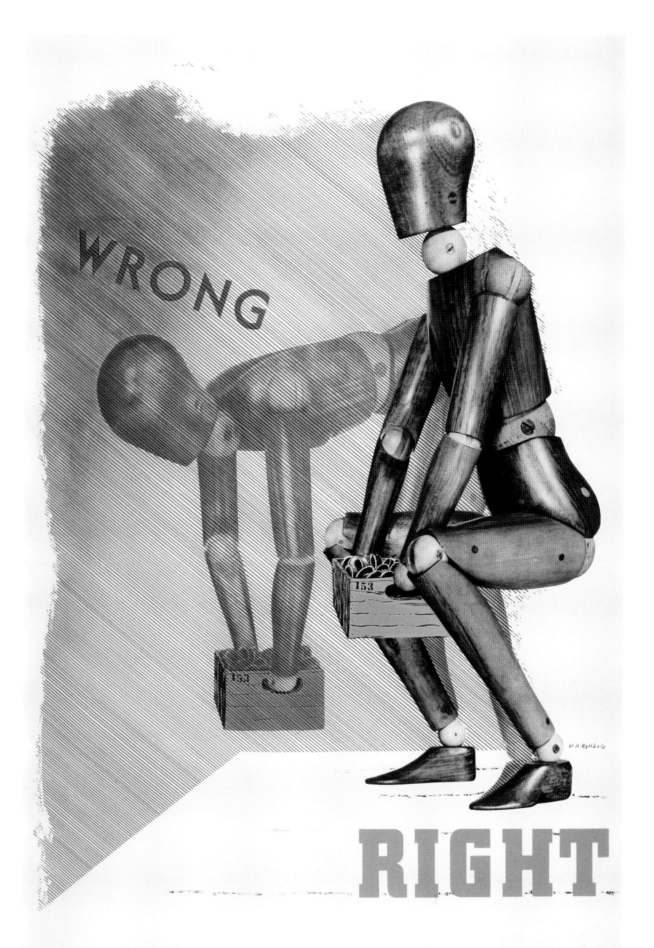

WRONG

RIGHT

Issued by the Ministry of Labour and National Service and produced by the Royal Society for the Prevention of Accidents, Terminal House, 52 Grosvenor Gardens, London, S.W.I.

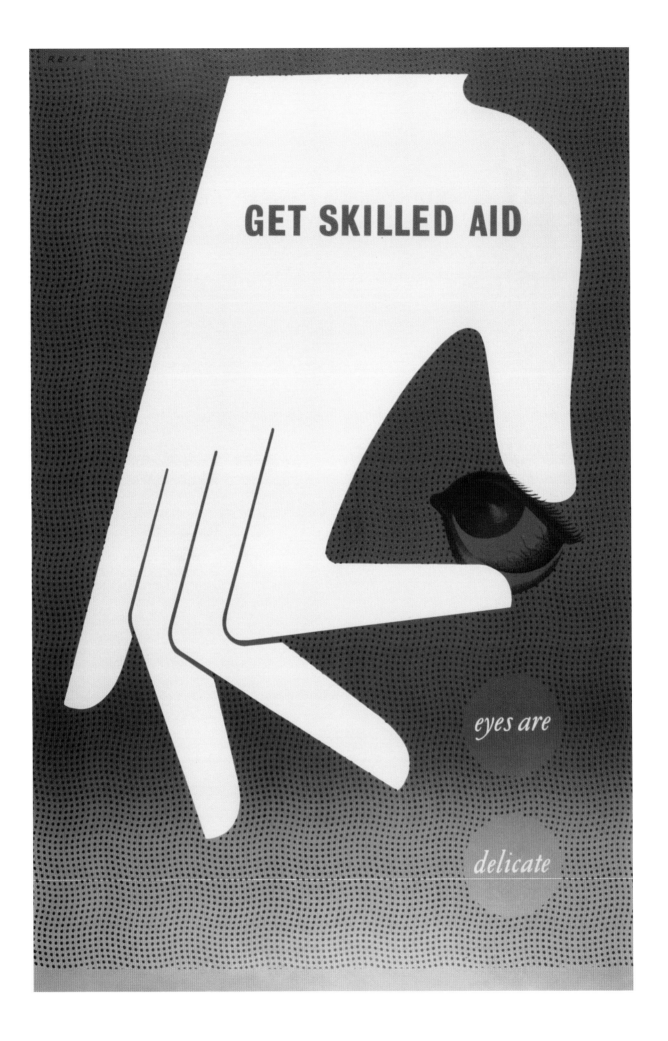

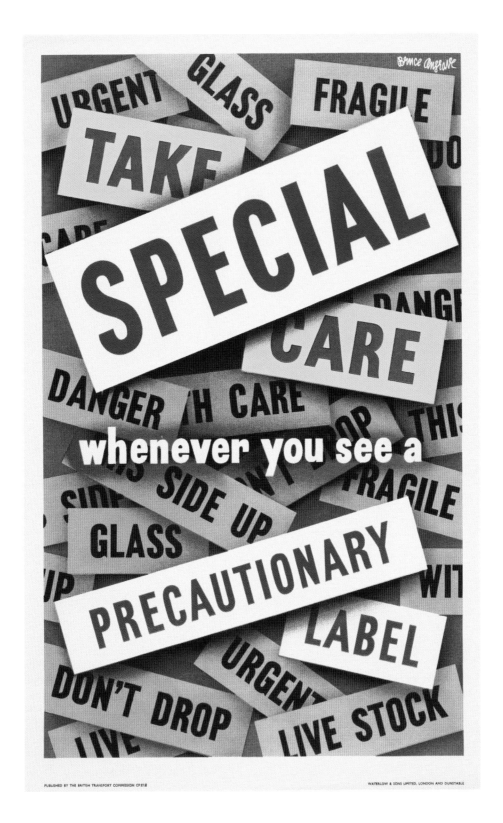

Opposite *Get Skilled Aid*, Manfred Reiss, 1940s, DC (30 x 20"),

The Royal Society for the Prevention of Accidents.

Above *Take Special Care*, Bruce Angrave, c. 1950, 15 x 10", British Railways.

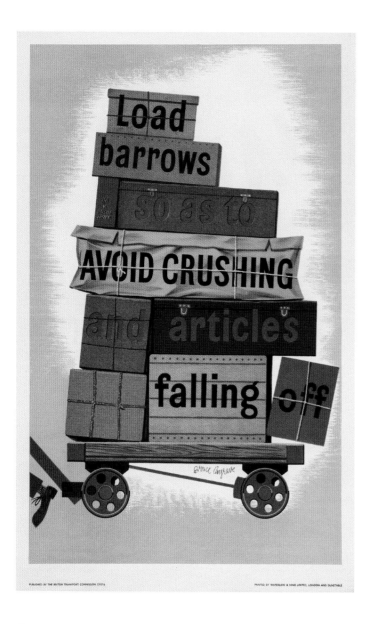

RAILWAY SAFETY

Elsewhere, the characteristics of the railway produced an environment of heavy machinery, loads, and speed, where industrial accidents were commonplace. Indeed, the situation was so bad that the railway companies had their own homes for the orphans of railway workers. The advent of World War Two exacerbated the problem by the application of a strict and total blackout.

From the 1940s onwards, the railway authorities produced visual propaganda to address issues of safety on railway property and in the working practices associated with the industry. Sets of posters were produced at regular intervals. Generally, photographic imagery was rejected in favour of a simplified graphic style. Photography was considered too upsetting in its graphic representation of injury. Frank Newbould, Leonard Cusden, Bruce Angrave and HA Rothholz each produced sets of posters for railway safety.

Above *Load barrows*, Bruce Angrave, c. 1950, 15 x 10", British Railways.

Opposite *Rope Loads Securely* (detail), Frank Newbould, c. 1940, 15 x 10", British Railways.

ROPE LOADS SECURELY

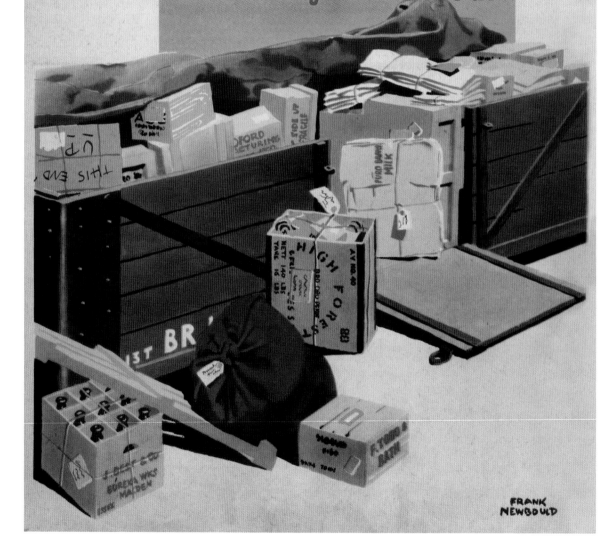

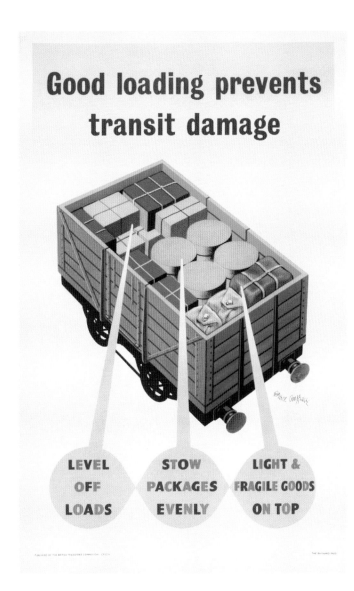

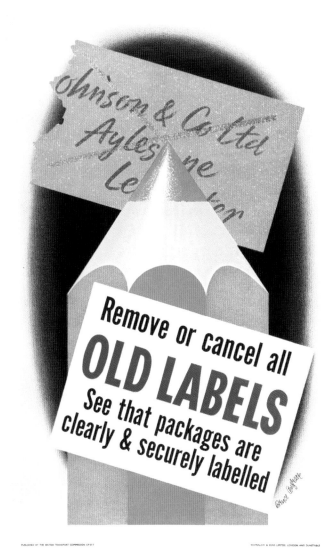

Opposite *Empties are vital*, Frank Newbould, 1940s, 15 x 10", British Railways.

Left *Good loading*, Bruce Angrave, c. 1950, 15 x 10", British Railways.

Right *Old Labels*, Bruce Angrave, c. 1950, 15 x 10", British Railways.

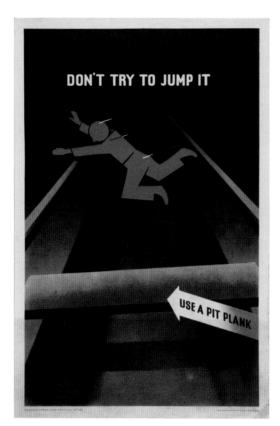

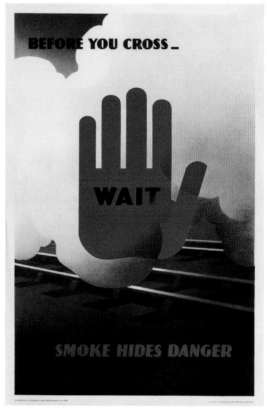

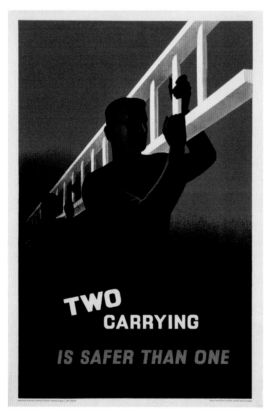

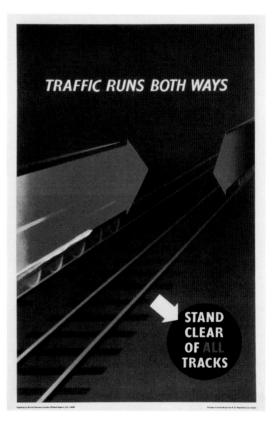

Top left *Don't Try To Jump It*, Leonard Cusden, 1940s, 15 x 10", British Railways.

Top right *Wait Before You Cross*, Leonard Cusden, 1940s, 15 x 10", British Railways.

Bottom left *Two Carrying Is Safer than One*, Leonard Cusden, 1940s, 15 x 10", British Railways.

Bottom right *Traffic Runs Both Ways*, Leonard Cusden, 1940s, 15 x 10", British Railways.

Opposite *Face On-Coming Traffic*, Leonard Cusden, 1940s, 15 x 10", British Railways.

ON THE TRACK _

FACE
ON-COMING
TRAFFIC

Published by British Railways (London Midland Region) LM 1145SC

Printed in Great Britain by R. B. Macmillan Ltd. Derby

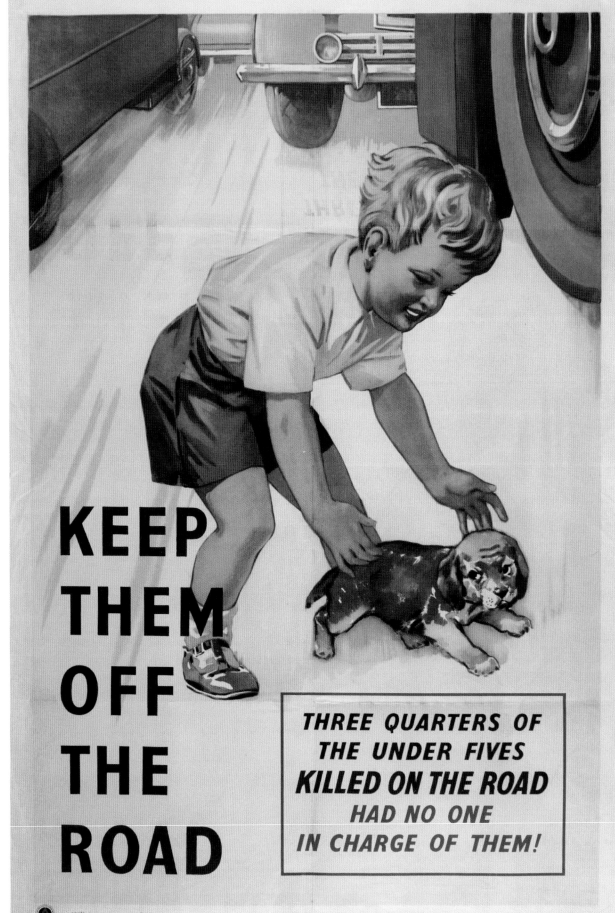

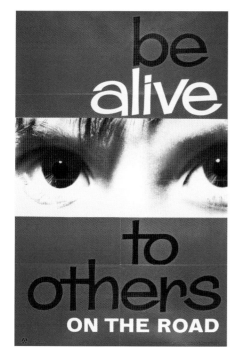
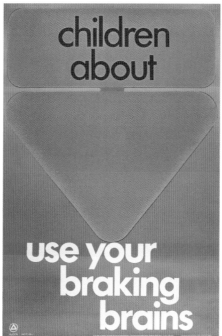

ROAD SAFETY

RoSPA's efforts after World War Two were increasingly directed towards safety issues on the road and within the home. The enormous expansion of the scope and responsibilities attached to health and safety legislation are testimony to the powerful feelings of collective security that attach to this framework of social and economic interdependence.

Traditionally, road safety has been the organisation's most important division. The issue of road safety was first noticed as a consequence of the blackout at the end of World War One. The Safety First Association was established to address the issue of road safety through the education of pedestrians. The consolidation of regional and civic associations into a single body created the National Safety First Association (NSFA), later renamed RoSPA.

During the 1930s, the Association produced safety propaganda at regular intervals and advised drivers on mechanical safety and reliability. In its earliest period, the NSFA tended to assume that motorists were naturally sensible and responsible. This, in some sense, reflected the perception that motoring was an activity associated in the main with professional and busy people. As the number of cars on the road grew, the organisation reluctantly accepted that responsible motoring was by no means a naturally occurring phenomenon.

Nowadays, many of the issues addressed by RoSPA have been subsumed into TV narratives. RoSPA's message is that by intelligent thinking, anticipation and by looking ahead, most situations in which accidents occur can be avoided.

It is worth acknowledging that these campaigns have been broadly successful. The issue of safety and welfare in the workplace has, as Bevin imagined, been acknowledged as a responsibility and duty-of-care entrusted upon the employers. The resulting sense of safety and security, across the various parts of all our lives, has transformed the experience of everyday life for the better.

Opposite *Keep Them Off The Road*, Anon., 1950s, DC (30 x 20"),

The Royal Society for the Prevention of Accidents.

Left *be alive to others*, Anon., 1960s, DC (30 x 20"), The Royal Society for the Prevention of Accidents.

Right *children about*, Anon., 1970s, DC (30 x 20"), The Royal Society for the Prevention of Accidents.

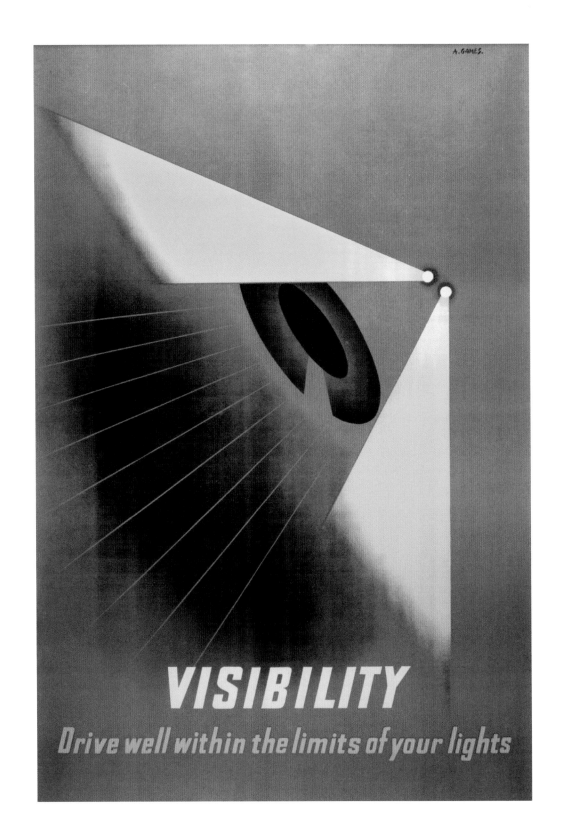

Above *Visibility*, Abram Games, 1946, DC (30 x 20"), The Royal Society for the Prevention of Accidents.

Opposite *Keep Alert*, Leonard Cusden, 1950s, DC (30 x 20"), The Royal Society for the Prevention of Accidents.

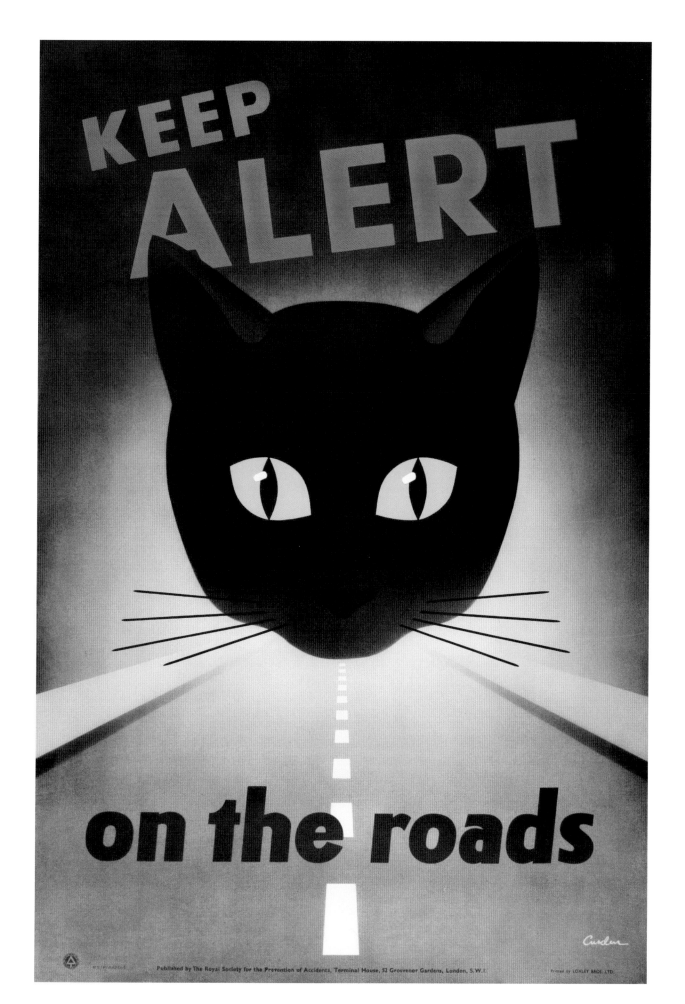

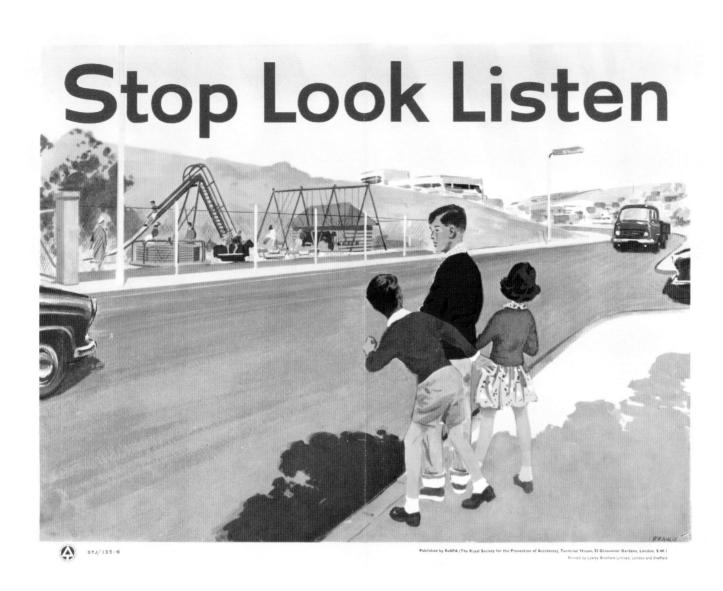

Stop Look Listen, Francis, 1960s, C (15 x 20"), The Royal Society for the Prevention of Accidents.

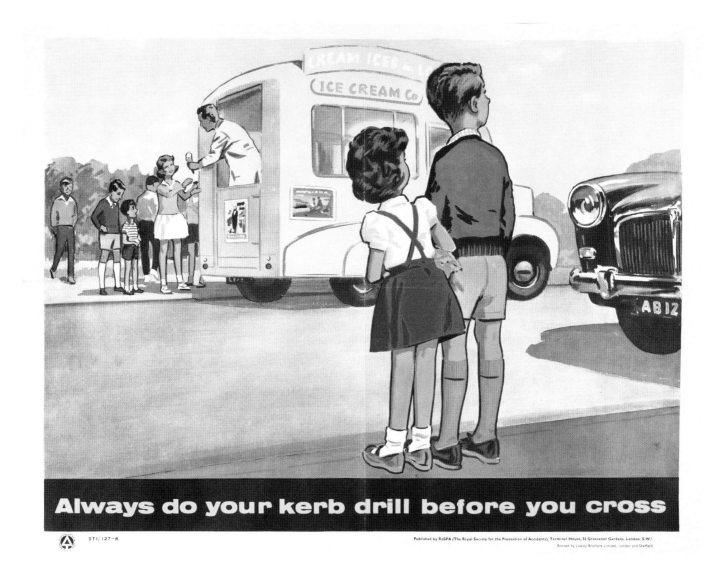

STI/127-6

Published by RoSPA (The Royal Society for the Prevention of Accidents), Terminal House, 52 Grosvenor Gardens, London, S.W.1

Printed by Loxley Brothers Limited, London and Sheffield

Always do your kerb drill before you cross, Anon., 1960s, C (15 x 20"),

The Royal Society for the Prevention of Accidents.

Look! Before Opening!, Roland Davies, 1950s, DC (30 x 20"),

The Royal Society for the Prevention of Accidents.

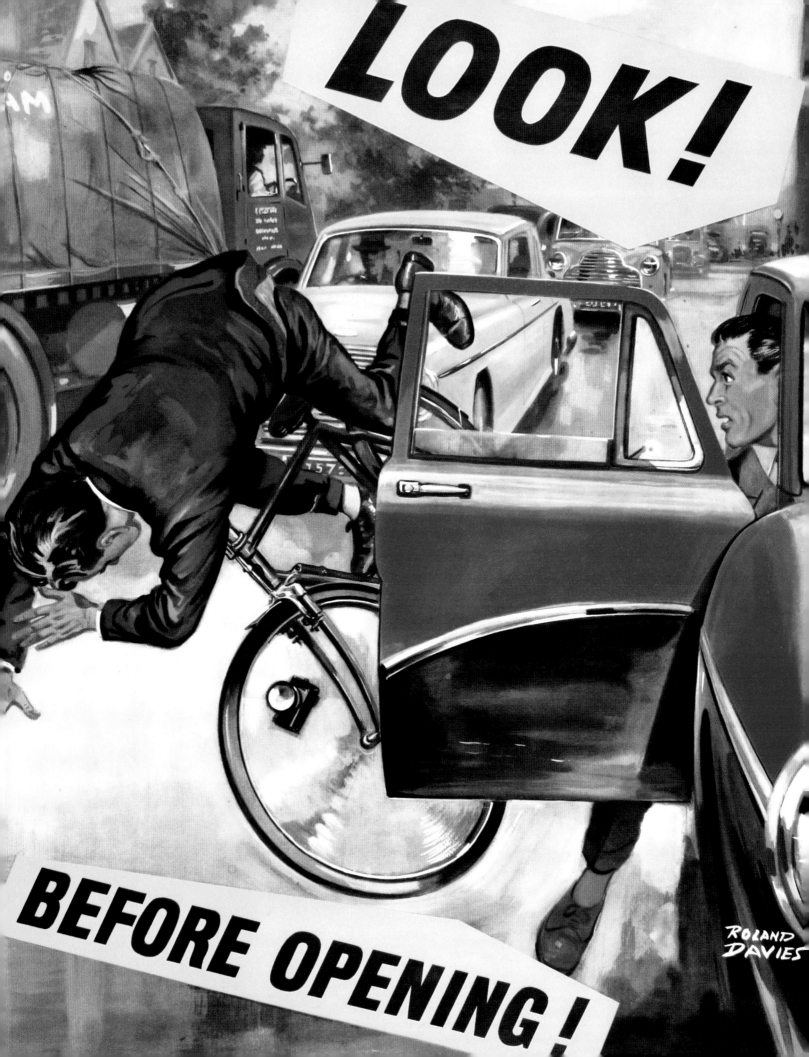

Issued by The Royal Society for the Prevention of Accidents.

I've got 9 lives—You haven't, Leonard Cusden, 1940s, 10 x 24",

The Royal Society for the Prevention of Accidents.

Left *built up area*, Anon., 1970s, DC (30 x 20"), The Royal Society for the Prevention of Accidents.

Right *learning to drive?*, Geoffrey Marsden, 1960s, DC (30 x 20"), Department of Transport.

Left *Find a safe place to cross*, Anon., 1960s, DC (30 x 20"), The Royal Society for the Prevention of Accidents.

Right *wait for the traffic stop*, Anon., 1960s, DC (30 x 20"), The Royal Society for the Prevention of Accidents.

Above *Use The Proper Crossings*, Abram Games, 1939, DC (30 x 20"), National Safety First Association.

Opposite *Train Your Pets* (detail), Anon., 1960s, DC (30 x 20"),

The Royal Society for the Prevention of Accidents.

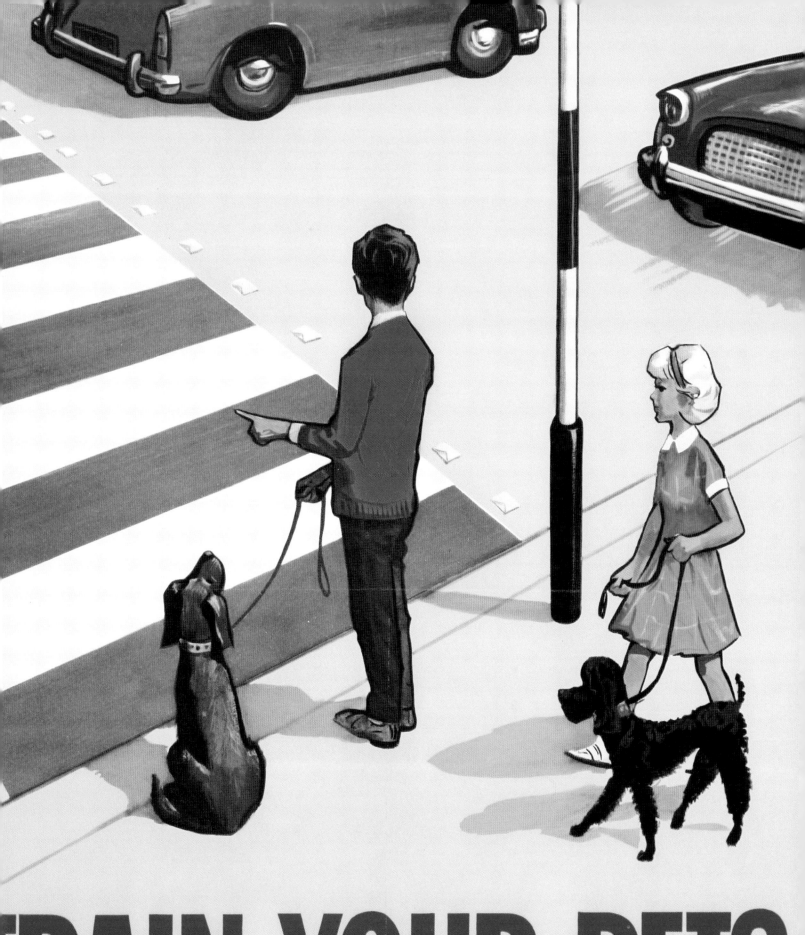

TRAIN YOUR PETS

Journey's End!

JOURNEY'S END

This text is an attempt to bring together a number of ideas about the structures and contexts of mass communication and graphic design. Within the specific context of poster design in Britain during the twentieth century, we have seen how issues of patronage, technology, environment, security and psychology interact and provide a platform for the individual contribution of the designer. In addition, the poster has played a crucial role in the elaboration of the urban spectacular that supports our leisure activities and consumption.

If posters were simply bits of printed paper, they would be beautiful but not necessarily significant. Their status as historical artefacts and their connection to these larger themes of social progress and collective identity combine to present a bigger story.

Looking at the Modern British Poster reveals the forces and structures that, in part at least, have shaped our society.

From the 1970s onwards, the poster began to lose its special status as the exemplar of graphic communication. The proliferation of the illustrated press and of televisual images provided an alternative to the poster. In the end, the activities associated with graphic design were displaced onto the new technologies. The advent of digital media, associated with the end of print, have created a graphic experience of reality that is dynamic, interactive and more-or-less continuous.

The history of posters provides us with reassuring evidence that these transformations are not new. Indeed, they may be understood as evidence of a long process of social progress.

Opposite *Journey's End!*, Roland Davies, 1950s, DC (30 x 20"),
The Royal Society for the Prevention of Accidents.
Overleaf *always wear a safety helmet*, Anon., 1970s, C (15 x 20"),
The Royal Society for the Prevention of Accidents.

always wear a safety helmet

safety helmets...
and seat belts...
make injuries less severe
and save lives

SEP/S 187-6

RoSPA

Published by RoSPA, The Royal

Accidents, Terminal House, 52 Grosvenor Gardens, London, S.W.I Printed by Loxley Brothers Limited, London and Sheffield

P osters have always been collected. They were recognised, at the moment of their invention, as an exciting new form of cultural product and have always been solicited and written about. The present international market in posters re-emerged during the 1960s as a consequence of an important find of posters by Henri de Toulouse-Lautrec in Paris.

It was natural that, during the 1960s, people should again become interested in posters. The rediscovery of the organic forms of nineteenth century art nouveau seemed, at the time, a useful visual precedent for the expression of various counter-cultural ideas. In these circumstances, the nineteenth century form of the poster was rediscovered as an object replete with meanings and associations for the international 'swinging sixties' and of Pop art.

There are several kinds of resources available to would-be collectors. The most important of which is the international group of auctioneers, dealers and collectors that make up the poster community. This community has been the force in driving research and publications about poster history and its cultural significance. Merrill Berman, in America, has been exemplary in sharing his enthusiasm for the avant-garde through exhibitions and publications.

Then, there are the surviving posters themselves. For various historical reasons associated with the local development of the poster and with the cultural status in which it is held, there is a wide variety in the number of posters that survive from different countries and from different times. The largest number of surviving posters come from France. The origins of the poster and the development of the printing industry mean that there are large quantities of material. These provide the bedrock of the international poster market. There are quantities of posters in Germany, Switzerland and Holland. Each of these countries played a crucial role in the later development of graphic design and it was entirely natural that this should be acknowledged through the safekeeping of the archive.

The international collectors market for posters is dominated by the USA. Nowadays, and because Americans were the first group of enthusiastic collectors in the 1960s, there are many great things to be found in America. The global community of poster enthusiasts is accessible via the internet. Rene Wanner's poster resource is a good place to start, *www.posterpage.ch*.

International poster dealers belong to the International Vintage Poster Dealers Association, *www.ivpda.com*. Quad Royal, a blog about British poster design is available at *www.vintageposterblog.com*.

Posters in Britain tend to survive by having been retained by the designers, printers or administrators associated with their production and display. They survive in small quantities but appear at regular intervals. Usually, these collections emerge from under a bed, or behind a sofa, and reflect the professional

COLLECTING

Opposite *Keep Our Secrets Secret* (detail), Reginald Mount and Eileen Evans, 1960s, DC (30 x 20"), Central Office of Information for the Civil Service.

FESTIVAL OF BRITAIN

1951

MAY 3 - SEPTEMBER 30

association, to print production, of the original owners. So, railway and transport posters come in groups and at roughly four yearly intervals. I don't recall, for example, ever seeing a collection that was both extensive and eclectic.

The recent discovery and sale of the Malcolm Guest collection typifies this. Malcolm Guest worked, throughout the 1960s and 70s, in the publicity department of British Railways, Western Region. He was ideally placed to save material discarded through the process of railway modernisation during the 1960s. In addition, and as a fanatical collector, he was part of a group who were able to purchase the surviving remnants of the poster stocks associated with the great railway and transport stores. It turns out, and looking back through various catalogues, that most of the recent British travel posters to come to market have come from this same source.

Over the years, there have been discoveries of London and North Eastern Railway (LNER), London Transport and Shell posters. Every now and then, an organisation decides to sell posters. There have been sales from Shell and from the Architectural Association. These sales also occur at regular intervals.

The quantities of material available in Britain are small by international standards and the market remains one for enthusiasts. In these circumstances, it takes time to build a collection. The recent market-making in collecting has been associated with areas where there are larger surviving stocks of material. In addition to the material itself and the community of collectors, there is an extensive quantity of published material about posters and their historical development. There were books and magazines published to support the emerging activity of poster design. These kinds of texts appear consistently from the 1890s onwards and with clusters of material during the 1920s, 30s, 40s and 60s. This phenomenon exactly matches the period in which the poster was a dominant cultural and graphic form. From the 1970s onwards, there have been a growing number of books and catalogues that present the history of the poster within its cultural or sociological context.

The specialist books and magazines associated with the development of the printing and design industries are especially interesting. In international terms, the key publications of the twentieth century are *Das Plakat, Gebrauchsgraphik, Arts et Métiers Graphiques*, and *Graphis*. In Britain *Commercial Art, Modern Publicity* and *Art and Industry* provide a consistent commentary on developments from the 1920s onwards.

The Penrose Annual, published from the end of the nineteenth century onwards, was a printing industry review of cultural and technical developments. The large books are embellished with the addition of colour plate examples and many advertisements for printing products. The Penrose Annual and Modern Publicity continued until the 1980s.

More recently, the massive expansion of graphic design and visual communication has supported the emergence of a new specialist press. The titles associated with this in Britain are *Baseline, eye* and *Graphik*.

Many poster designers have written textbooks that explain the development of the poster and the specialist techniques elaborated for its design. The most important of these, within a British context, are by Edward McKnight Kauffer, 1924, Tom Purvis, 1939, Austin Cooper, 1938, Tom Eckersley, 1954, and Abram Games, 1960.

Opposite *May 3–September 30*, Anon., 1951, DC (30 x 20"), Festival of Britain.

Above *Make Sure They're Safe*, Anon., 1950s, DC (30 x 20"), The Royal Society for the Prevention of Accidents.

The most comprehensive introduction to the international poster remains the catalogue for the Victoria and Albert Museum's Power of the Poster exhibition.

It is also worth mentioning the major museum archives of posters in Britain: the Victoria and Albert Museum, London; the London Transport Museum, London; the Imperial War Museum, London; the National Railway Museum, York; the National Motor Museum, Beaulieu; and the National Archive, Kew.

It is obvious that, under the terms of institutional specialisation, these archives will be naturally focussed on particular themes. The Victoria and Albert Museum casts its net wider and provides, for practical purposes, the national collection.

PAUL AND KAREN RENNIE COLLECTION

This book is based on our personal collection of posters and as such it reflects our interests. The first thing to acknowledge is that there are several important parts of the story that are missing. Product advertising is conspicuous by its absence. There are relatively few railway posters and there are many great artists who are counted as absent friends. In mitigation, I can only say that the collection remains a work-in-progress.

On a more positive note, the collection has allowed us to present the development of the modern British poster across a number of genres. Usually, these are have remained separate. Our interest in the relatively abstract notion of 'graphic design', has allowed us an eclectic collection, comprising posters by many different artists and designers, for many clients and for many purposes.

It was rather surprising to find that, after 25 years of collecting, we had been able to do something unique and different from our institutional colleagues. Of course, we didn't plan to do this. It just turned out that way. Our collecting began, back in about 1982, with an interest in modern design. We discovered that, where the market existed, it was conceptualised around an idea of modernism as an international phenomenon of people, ideas and products that connected Moscow, Berlin, Paris and New York. In 1982, the words British and Modernism seemed like a contradiction in terms.

The direction of our collecting was formed in relation to this widespread, and misguided, perception of British resistance to modernity. Conveniently, it turned out that British items were generally of little interest to international collectors and were, accordingly, less expensive to purchase.

We began by looking at the Festival of Britain of 1951. My father had worked, in a very junior capacity and as part of his National Service, at the Festival, and the early pages of our family photograph album contained views of the South Bank site. Even as a small boy, I could tell that the promise and reality of post-war reconstruction had been very different.

Karen was the first person that I'd met who knew about the Festival. Henceforth, we joined forces and trawled the markets and fairs for Festival souvenirs.

The Festival promoted an integration of architecture, art and design as the template for the post-war reconstruction of Britain. New materials and technologies would provide the basis for the emancipatory structures of meritocracy and social progress.

<div>

182 MODERN BRITISH POSTERS

</div>

Above *How Are Your Brakes—& Tyres?*, Fougasse, 1938, DC (30 x 20"), National Safety First Association.

Below *Ride Safely*, Blake, 1950s, DC (30 x 20"), The Royal Society for the Prevention of Accidents.

Opposite *Dig A Footing*, Leonard Cusden, 1940s, 15 x 10", British Railways.

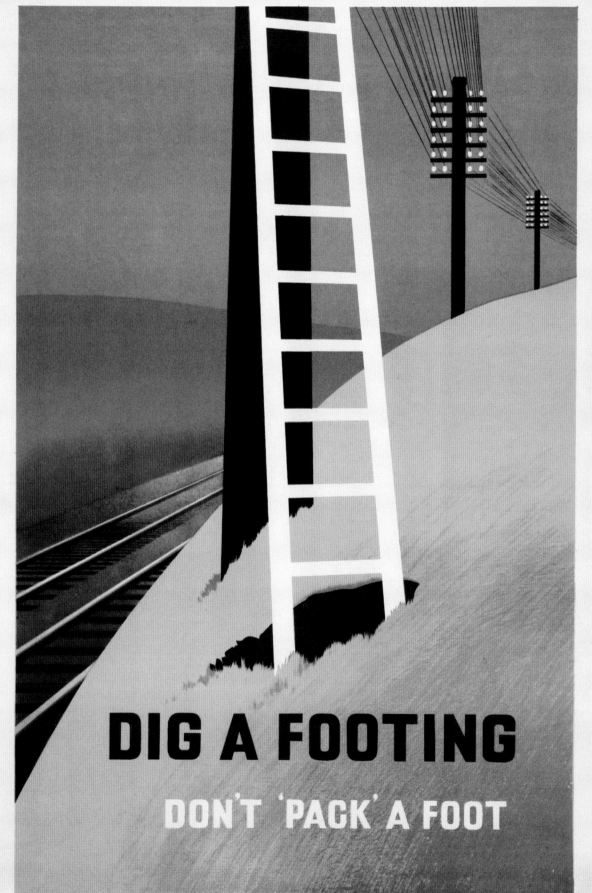

Abram Games designed the brilliant emblem of the Festival. His jaunty Britannia compass, with bunting, was placed on a multitude of objects. It is not surprising that Abram Games produced an outstanding design for the Festival. He was the foremost British poster designer of his generation and was a master of combinatory design that produced clever, witty and powerful images. The link, for us, from the Festival to graphic communication and poster design was made.

Next, we began to explore the antecedents of the Festival. We discovered that the Festival was a manifestation of a long tradition of design reform that was attached to social progress in Britain. We became especially interested in a group of artist designers who, for a variety of reasons and after World War One, had the opportunity to work in forms beyond painting and drawing. Poster design, graphic communication, textile design and ceramic design thus came into our collecting orbit.

Our interest in graphic design quickly began to define itself as an attempt to gather together irrefutable material evidence of British Modernism.

Nowadays, the idea of a single homogenous Modernism, identified as "The International Style", has been replaced by a more subtle and differentiated sense of local modernities. As such, we have become increasingly interested in the modest structures of the village hall, garden shed and beach hut as particular expressions of British Modernity.

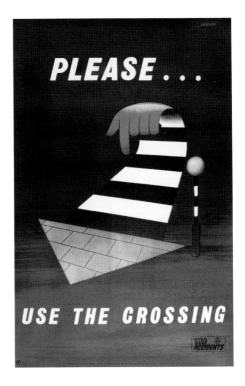

Above *Please Use The Crossing*, Bracken, 1960s, DC (30 x 20"),
The Royal Society for the Prevention of Accidents.
Opposite *Don't Do It!*, Roland Davies, 1950s, DC (30 x 20"),
The Royal Society for the Prevention of Accidents.

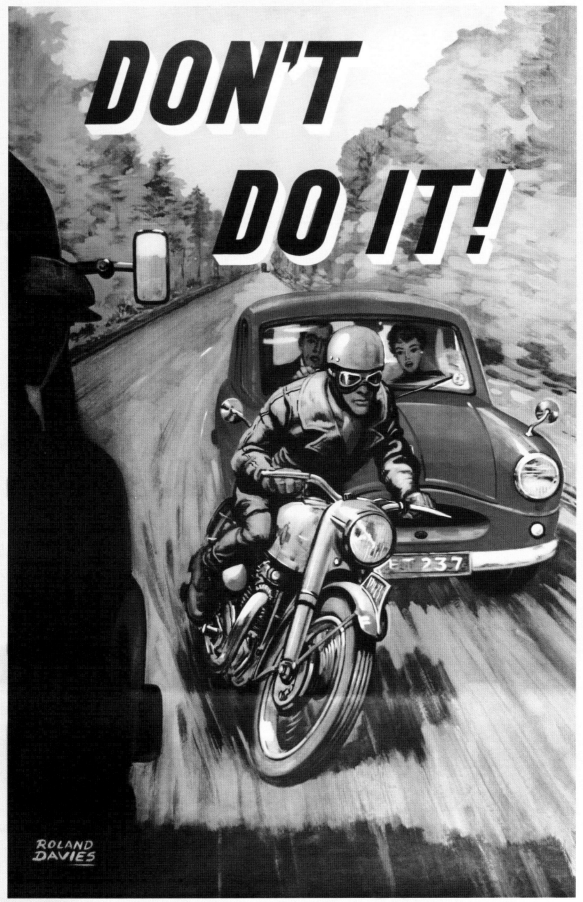

Ades, Dawn, Richard Peterson and Robert Brown, *The 20th-Century Poster—Design of the Avant-Garde*, New York: Abbeville Press, 1985.

Anthony, Scott, *Night Mail*, London: BFI Publishing, 2007.

Artmonsky, Ruth, *Jack Beddington, The Footnote Man*, London: Artmonsky Arts, 2006.

Aulich, Jim, *War Posters: Weapons of Mass Communication*, London: Thames & Hudson, 2007.

Barden, Mike, *Post Early: GPO Posters 1920–1960*, London: Camberwell Press, 1993.

Barnicoat, John, *Posters: A Concise History*, London: Thames & Hudson, 1972.

Barman, Christian, *Man Who Built London Transport: A Biography of Frank Pick*, Newton Abbot: David & Charles, 1979.

Barthes, Roland, *L'Affiche Anglaise: des années 90*, Paris: Museé des Arts Décoratifs, 1972.

Benjamin, Walter, *Illuminations: Essays and Reflections*, Hannah Arendt ed., Harry Zohn trans., New York: Schocken Books, 1969.

Benjamin, Walter, *Reflections: Essays, Aphorisms, Autobiographical Writings*, Peter Bemetz ed., Edmund Jephcott trans., New York: Schocken Books, 1986.

Benjamin, Walter, "Paris, Capital of the 19th Century [1935]," in Benjamin, *Reflections: Essays, Aphorisms, Autobiographical Writings*.

Benjamin, Walter, *The Arcades Project*, Rolf Tiedemann ed., Howard Eiland and Kevin McLaughlin trans., Cambridge, MA: Belknap Press of Harvard University Press, 2002.

Bernstein, David, *The Shell Poster Book*, London: Hamish Hamilton, 1992.

Bird, Cyril Kenneth (Fougasse) *A School of Purposes: Fougasse Posters, 1939–45*, London: Methuen, 1946.

Bownes, David and Oliver Green eds., *London Transport Posters: A Century of Art and Design*, London: Lund Humphries, 2008.

Bradshaw, Percy Venner, *Art and Advertising: A Study of British and American Pictorial Publicity*, London: Press Art School, 1925.

Calder, Angus, *The Myth of the Blitz*, London: Jonathan Cape, 1991.

Campbell, Colin, *The Beggarstaff Posters: The Work of James Pryde and William Nicholson*, London: Barrie & Jenkins, 1990.

Chapman, James, *The British at War: Cinema, State and Propaganda, 1939–1945*, London: IB Tauris, 1998.

Constantine, Stephen, *Buy and Build: The Advertising Posters of the Empire Marketing Board*, London: Her Majesty's Stationary Office, 1986.

Cooper, Austin, *Making a Poster*, London: The Studio Ltd., 1938.

Crary, Jonathan, *Techniques of the Observer: On Vision and Modernity in the Nineteenth Century*, Cambridge, MA: MIT Press, 1992.

Crary, Jonathan, *Suspensions of Perception: Attention, Spectacle, and Modern Culture*, Cambridge, MA: MIT Press, 2000.

Curwen, Harold, *Processes of Graphic Reproduction in Printing*, London: Faber and Faber, 1934.

Eckersley, Tom, *Poster Design*, London: The Studio Ltd., 1954.

Fern, Alan M, *Word and Image: Posters and Typography from the Collection of The Museum of Modern Art*, Mildred Constantine ed., New York: Museum of Modern Art, 1968.

Flynn, James Robert, *What is Intelligence? Beyond the Flynn Effect*, Cambridge: Cambridge University Press, 2007.

Gallo, Max, *The Poster in History*, Feltham: Hamlyn, 1974.

Games, Abram, *Over My Shoulder*, London: The Studio Ltd., 1960.

Games, Naomi, Catherine Moriarty and June Rose, *Abram Games, Graphic Designer: Maximum Meaning, Minimum Means*, Aldershot: Lund Humphries, 2003.

Garland, Ken, *Mr Beck's Underground Map*, Harrow Weald: Capital Transport Publishing, 1994.

Garton, Robin ed., *British Printmakers: 1855–1955: A Century of Printmaking from the Etching Revival to St Ives*, Devizes: Garton & Co., 1992.

Gombrich, Ernst Hans, *Art and Illusion: A Study in the Psychology of Pictorial Representation*, London: Phaidon, 1960.

Green, Oliver, *Underground Art: London Transport Posters 1908 to the Present*, London: Studio Vista, 1990.

Green, Oliver and Jeremy Rewse-Davies, *Designed for London: 150 Years of Transport Design*, London: Laurence King, 1995.

Greenfield, Susan, *Tomorrow's People: How 21st Century Technology is Changing the Way We Think and Feel*, London: Allen Lane, 2003.

Gregory, Richard Langton, *Eye and Brain: The Psychology of Seeing*, London: Weidenfeld and Nicolson, 1966.

Griffits, Thomas E, *Technique of Colour Printing by Lithography: A Concise Manual of Drawn Lithography*, London: Crosby Lockwood & Son, 1940.

Griffits, Thomas E, *Colour Printing: A Practical Demonstration of Colour Printing by Letterpress, Photo-offset lithography and Drawn Lithography*, London: Faber and Faber, 1948.

Hardie, Martin, and Arthur K Sabin eds., *War Posters issued by Belligerent and Neutral Nations, 1914–1919*, London: A&C Black, 1920.

BIBLIOGRAPHY

Cover, *Making A Poster* by Austin Cooper, London: The Studio Ltd., 1938.

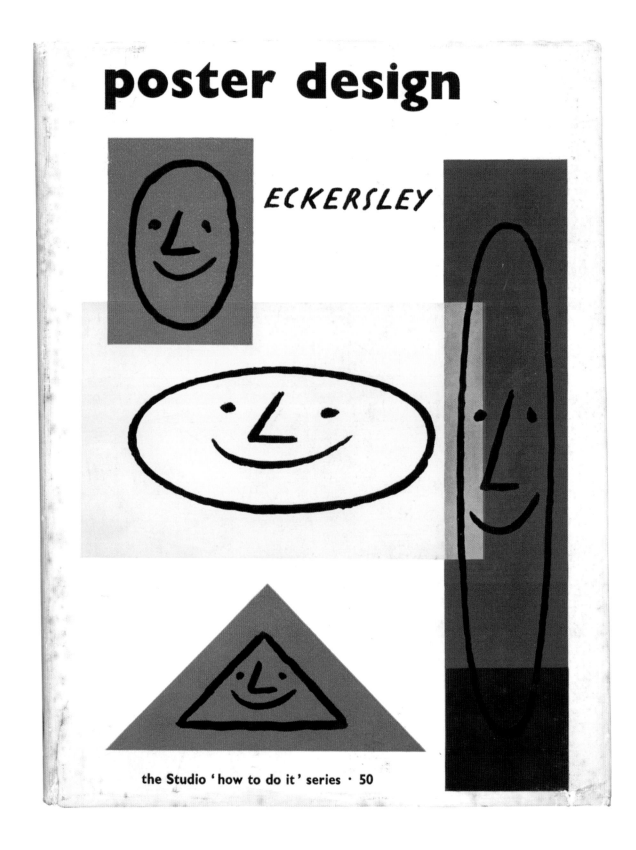

Cover, *Poster Design* by Tom Eckersley, London: The Studio Ltd., 1954.

Haworth-Booth, Mark, *E. McKnight Kauffer: A Designer and His Public*, London: V&A Publications, 2005.

Hayward Gallery, *Thirties: British Art and Design Before the War*, London: Arts Council of Great Britain, 1979.

Higgott, Andrew, *Mediating Modernism: Architectural Cultures in Britain*, London: Routledge: 2006.

Hillier, Bevis, *Posters*, London: Weidenfeld & Nicolson, 1969.

Hillier, Bevis ed., *Fougasse*, London: Elm Tree Books, 1977.

Howes, Justin, *Johnston's Underground Type*, Harrow Weald: Capital Transport Publishing, 2000.

Hutchison, Harold F, *London Transport Posters*, London: London Transport Board, 1963.

Hutchison, Harold F, *The Poster: An Illustrated History from 1860*, London: Studio Vista, 1968.

Joyce, Patrick, *The Rule of Freedom: Liberalism in the Modern City*, London: Verso, 2003.

Laver, John, *Art for All: London Transport Posters, 1908–1949*, London: Art & Technics, 1949.

Lawrence, David, *A Logo for London*, Harrow Weald: Capital Transport Publishing, 2000.

Lewis, John, and John Brinkley, *Graphic Design: with Special Reference to Lettering, Typography and Illustration*, London: Routledge and Kegan Paul, 1954.

Lovell, Alan, and Jim Hillier, *Studies in Documentary*, London: Secker and Warburg, 1972.

Marwick, Arthur, *Britain in the Century of Total War: Peace and Social Change 1900–1967*, London: The Bodley Head, 1968.

Matless, David, *Landscape and Englishness*, London: Reaktion, 1998.

McAlhone, Beryl, and David Stuart, *A Smile in The Mind*, London: Phaidon, 1996.

McKnight Kauffer, Edward, *The Art of the Poster*, London: Cecil Palmer, 1924.

Nead, Lynda, *Victorian Babylon: People, Streets and Images in Nineteenth Century London*, New Haven: Yale University Press, 2005.

Nead, Lynda, *The Haunted Gallery: Painting, Photography and Film around 1900*, New Haven: Yale University Press, 2007.

Newsinger, John, *Orwell's Politics*, Basingstoke: Palgrave Macmillian, 2002.

Orwell, George, "The Lion and the Unicorn: Socialism and the English Genius", *Searchlight Books*, TR Fyvel and George Orwell eds., London: Secker & Warburg, 1941.

Orwell, George, *The English People*, London: Collins, 1947.

Peto, James and Donna Loveday eds., *Modern Britain: 1929–1939*, London: Design Museum, 1999.

Poovey, Mary, *Making a Social Body: British Cultural Formation, 1830–1864*, Chicago: Chicago University Press, 1995.

Poynor, Rick ed., *Communicate: Independent British Graphic Design since the Sixties*, London: Laurence King, 2004.

Purvis, Tom, *Poster Progress*, London: The Studio Ltd., 1939.

Read, Harold ed., *Unit One: The Modern Movement in English Architecture, Painting and Sculpture*, London: Cassell, 1934.

Rennie, Paul, "Social Vision: RoSPA's WWII Safety Posters Challenge Orthodox Views of British Modernism", *eye*, vol. 13, no. 52, London: Quantum Publishing, Summer 2004.

Rennie, Paul, *Festival of Britain 1951: Design*, Woodbridge: Antique Collectors' Club, 2007.

Rennie, Paul, *GPO: Design*, Woodbridge: Antique Collectors' Club, 2010.

Richards, Jeffrey, *Films and British National Identity: from Dickens to Dad's Army*, Manchester: Manchester University Press, 1997.

Richmond, Leonard ed., *The Technique of the Poster*, London: Sir Isaac Pitman & Sons, 1933.

Rossi, John, "'My country, right or left': Orwell's patriotism", *The Cambridge Companion to George Orwell*, John Rodden ed., Cambridge: Cambridge University Press, 2007.

Rothchild, Deborah, Ellen Lupton and Darra Goldstein, *Graphic Design in the Mechanical Age: Selections from the Merrill C. Berman Collection*, New Haven and London: Yale University Press, 1998.

Saler, Michael T, *The Avant-Garde in Interwar England: Medieval Modernism and the London Underground*, New York: Oxford University Press, 1999.

Schwartz, Vanessa R, *Spectacular Realities: Early Mass Culture in Fin-de-Siècle Paris*, Berkeley: University of California, 1998.

Shaw Sparrow, Walter, *Advertising and British Art*, London: The Bodley Head, 1924.

Skipwith, Peyton and Brian Webb, *Paul Nash and John Nash: Design*, Woodbridge: Antique Collectors' Club, 2006.

Skipwith, Peyton and Brian Webb, *E McKnight Kauffer: Design* Woodbridge: Antique Collectors' Club, 2007

Smith, Malcom, *Britain and 1940: History, Myth and Popular Memory*, London: Routledge, 2001.

Thacker, Andrew, *Moving Through Modernity: Space and Geography in Modernism*, Manchester: Manchester University Press, 2003.

Timmers, Margaret ed., *Power of the Poster*, London: V&A Publications, 1998.

Virilio, Paul, *War and Cinema: The Logistics of Perception*, London: Verso, 1989.

Weill, A, *The Poster: A Worldwide Survey and History*, London: Sotheby's Publications, 1985.

Wrede, Stuart, *The Modern Poster*, New York: Museum of Modern Art, 1988.

Wilk, Christopher, *Modernism: Designing a New World*, V&A Publications, 2006.

ACKNOWLEDGMENTS

We wish to thank and acknowledge all those individuals and organisations
that have granted us permission to reproduce the material in this book:

Abram Games posters © The Estate of Abram Games.
Barnett Freedman posters © The Estate of Barnett Freedman.
British Egg Marketing Board Trust.
British European Airways and British Overseas Airways Corporation posters
© The British Airways Archive and Museum.
British Railway posters © The National Railway Museum.
DH Evans posters © House of Fraser.
Ealing Studios posters © Optimum Releasing.
Edward Bawden posters © The Estate of Edward Bawden.
Edward McKnight Kauffer posters © Simon Randall for The Estate of Edward
McKnight Kauffer.
FHK Henrion posters © The Estate of FHK Henrion.
General Post Office posters © The British Postal Museum and Archive.
Gillette poster © Proctor and Gamble.
HMSO and Central Office of Information © The National Archive
and The Office of Public Sector Information.
HA Rothholz posters © The Estate of HA Rothholz.
Institute of Contemporary Art.
Lewitt and Him posters © Estates of Jan Lewitt and George Him.
London Transport posters © Transport for London, The London Transport Museum.
RoSPA posters © The Royal Society for the Prevention of Accidents.
Seven Seas poster © Seven Seas.
Shell Mex & BP posters © The Shell Art Collection at the National Motor Museum.
The British Telecom Archive.
Thomas Cook UK.
Tom Eckerlsey posters © The Estate of Tom Eckerlsey and the Eckersley Archive,
London College of Communication.
Towards art?, 1962 poster © David Hockney and the Royal College of Art.
William Nicholson posters © Elizabeth Banks and the William Nicholson Trust.

THANK YOU

A number of people need to be thanked for their considerable help with this project:

Sophie Hallam for directing the project, Alex Wright for taking the photographs
and to Matt Bucknall for top quality design and art direction. Special thanks
also to Emily Chicken and Johanna Bonnevier (who risked life and limb) and
to Lottie Crumbleholme, Arnoud Verhaeghe, and Arun Golia for their help in
design and to Tom Howells and Adriana Caneva for their editorial precision.

—Paul and Karen Rennie, Folkestone 2010

© 2010 Black Dog Publishing Limited, London, UK,
the author and artists. All rights reserved.

Edited by Sophie Hallam at Black Dog Publishing.

Designed by Matt Bucknall at Black Dog Publishing.

Black Dog Publishing Limited
10A Acton Street
London WC1X 9NG
info@blackdogonline.com

British Library Cataloguing-in-Publication Data. A CIP record
for this book is available from the British Library.

ISBN 978 1 906155 97 1

Black Dog Publishing Limited, London, UK, is an
environmentally responsible company. *Modern British Posters* is
printed on FSC certified paper.

Cover *BEA To Britain*, Kenneth Rowntree, 1950, DR (40 x 25), British European Airways.
Back Cover *May 3–September 30*, Anon., 1951, DC (30 x 20"), Festival of Britain;
USA—Fly BOAC, Abram Games, 1959, DR (40 x 25"), British Overseas Airways
Corporation; *New Shell Lubricating Oils*, Edward McKnight Kauffer, 1937, 30 x 45",
Shell Mex & BP; *Bexhill*, Frank Sherwin, c. 1950, DR (40 x 25"), British Railways;
Aldershot Tattoo, Andrew Power, 1934, DR (40 x 25"), London Transport.
Title page *Stop!... Look! Before Crossing*, Roland Davies, 1960s, DC (30 x 20),
The Royal Society for the Prevention of Accidents.

architecture art design
fashion history photography
theory and things

**black dog
publishing**

www.blackdogonline.com london uk